5-15-2009

To my dear friend, Bill

From: Herb Clark

May God bless you & keep you always!

Spirit engaged,

Herb Clark

CELEBRATION OF

Spirit

KIRK CLARK

IMAS • International Museum of Art and Science
McAllen, Texas • March 2006

Front cover: Kirk Clark, *Shockwave 73*

First Printing, 2007
Text and Photography Copyright© 2006 Kirk A. Clark

ISBN-10: 0-9774935-0-4
ISBN-13: 978-0-9774935-0-0

Published by Kirk A. Clark

Kirk A. Clark
P.O. Box 938
McAllen, Texas 78502
www.kirkclark.com
956-686-4520

Atomic Jesus title ©Copyright Pending

Editor: Marjorie Johnson
Contributing Editors: Anne Clark-Lawson, Yvonamor Palix and Thom Wheeler
English Copy Editors: Mark Bayse, DeAnna Garza, Yvonamor Palix, Dr. Steven Schneider
Spanish Translation: Leticia Consuegra, Tradumex-Mexico City
Spanish Editor: Belarmino Castellanos Ruiseco
Project Coordinator/Research: DeAnna Garza
Photography: Eduardo Luzuriaga, Matamoros, Tamaulipas, Mexico; David De León, McAllen, Texas
Digital Photography Processing: Ruth Hoyt
Book and Cover Design: Esperanza S. Chapa, CopyZone, McAllen, Texas
Printing: Gateway Printing & Office Supply, Inc., Edinburg, Texas

Printed in the U.S.A.

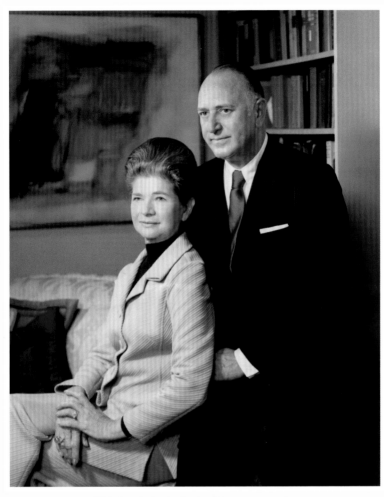

This book is dedicated to my parents,
Charles and Dorothy Clark,
to whom I will always be grateful
for their love and inspiration.

Charles D. Clark
Dorothy Van Gelder Clark

Credits

This book was produced in conjunction with the retrospective exhibition of Kirk Clark at the International Museum of Art and Science of McAllen, Texas, in March 2006.

Texts
Kirk Clark, Yvonamor Palix, Thom Wheeler, Anne Clark-Lawson

English Editor
Marjorie Johnson

Spanish Editor
Belarmino Castellanos Ruiseco

Copy Editors
Mark Bayse, DeAnna Garza, Yvonamor Palix, Dr. Steven Schneider

Translations
Leticia Consuegra, Tradumex

Celebration of Spirit Exhibit Curator
Yvonamor Palix

Project Coordinator/Research
DeAnna Garza

Photography
Eduardo Luzuriaga, David De León

Digital Photography Processing
Ruth Hoyt

Graphic Design
Esperanza Chapa

K.Clark • *Fatal Attraction* - Satori Series • Pen & ink on paper • 10.5 x 11 in.

Contents

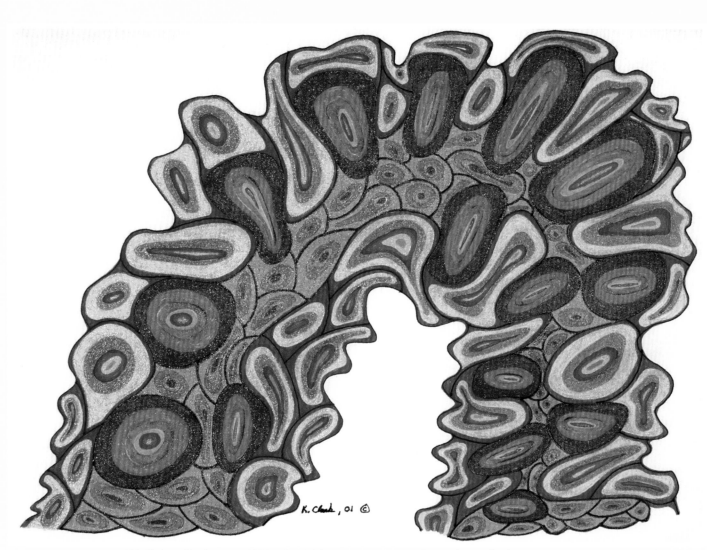

Kirk Clark • *Shockwave* • 2001 • Pen & ink on paper • 8.5 x 11 in. • Private collection, Houston, Texas

Foreword
by Kirk Clark

Celebration of Spirit was inspired by an exhibit of art representing three generations of the Clark family at the International Museum of Art and Science (IMAS) in McAllen, Texas, from March to August, 2006.

Serena Rosenkrantz, director of the museum, surprised me when she called to invite me to show my work at the museum. I said, "yes," without delay. Little did I know what saying yes would really mean in the coming months.

I had met Yvonamor Palix, daughter of a Mexican diplomat who would often visit McAllen, and we became friends. Yvonamor's experience as a gallery owner and curator in Europe and Mexico impressed me, as did her knowledge of the international contemporary art scene. I could not wait to ask her if she would undertake the job of curating the show at IMAS. She accepted my invitation and the museum concurred with my decision to have her undertake this responsibility.

Yvonamor, my Art Assistant DeAnna Garza and I were invited to visit the museum and look at the exhibition space. Yvonamor did not accept the first gallery proposed for the show, nor the second. She asked if a bigger area might be available in order to configure an entire retrospective of my work, as well as exhibit the works that my parents had donated to the museum.

We were then shown an abandoned exhibit gallery of 3,600 square feet that hosted at the time a huge worm installation and a couple of giant whales! This was the space Yvonamor chose. At first we had difficulty getting our minds around the full potential for this gallery. Fortunately, we shared a vision for that space and Yvonamor's experience in museography reassured us.

The museum developed a plan for the removal of the critters and gave me an estimate of what it would take,

physically and financially, to restore the gallery. I decided that it was a project that I wanted to take on, and told Serena to proceed with the project.

I was delighted to know that Yvonamor would include the three generations of the Clark family in this exhibition by dividing the exhibit into three areas. The first area would include a selection of the gifted works by my parents to IMAS. The second area would feature many series of works that composed my retrospective exhibition, including an oil painting completed at the age of 10. The third section would include an array of artworks produced by my daughter, Anne, who had recently returned to the Valley from Denton, Texas, with her husband Aaron and my toddler grandson, Ryan.

I was asked to choose the title for the exhibition. I chose *Celebration of Spirit, The Clark Legacy*. This title reflects the celebrated way in which my family lived with art and the spirit for life, which we all share.

It was important to me that we dedicate the show to my deceased parents, Charles and Dorothy Clark, who were among the founders of the museum around fifty years ago. The museum accepted and later named the exhibition hall, *The Clark Gallery* in their honor.

As we moved forward with this project, we understood that the renovation of the gallery would cost twice as much as originally estimated. With little hesitation, I determined that opportunities like this don't present themselves very often. After weighing all the options, we decided to make the investment, along with area sponsors, and continue forward. After all, this would enhance the legacy of the museum.

The museum staff, Yvonamor, and DeAnna, worked tirelessly with the contractor and his team to transform the

gallery into a beautiful showcase. It reminded me of the transformation of Cinderella. The exhibition reveals the intimate relationship that each of us shares with art. The choice of art works, and the well studied design of the displays, capture the uniqueness and essence of each and every one of the art works displayed.

I have considered myself to be an emerging poet, but have not seen myself in the past as an author. That is changing, and I am enjoying the challenge very much. It was a huge task to coordinate the selection of the works, complete the gallery renovation and complete the book, including its extensive illustration. I am lucky to surround myself with people who are competent and who truly love what they do.

The exhibition at IMAS opened on March 9, 2006, to a large crowd of various visitors, including city officials from Mexico, sponsors, students, and friends, all on hand for this momentous occasion. I could not have been happier

with the result. The show was glorious. I was proud to have my dear family present at the opening of the exhibit. We received a wonderful postcard from my aunt, Lydia Van Gelder, from California, who really touched my heart when she shared her thoughts on the exhibit. She was sure my parents were smiling down on us from heaven.

It was a true credit to the efforts of those who helped make this exhibit happen when the museum asked if it could extend the exhibit's duration from June to August 2006.

We recognized that there was a story to be told about this unusual exhibit. I wished to recognize my parents' unique contributions to the arts as collectors and philanthropists, and in particular, to the International Museum of Art and Science. I also wanted to share with others how my wonderful parents had influenced me and my art career, as well as that of my daughter, Anne. The result of this effort is the book you are reading.

Kirk Clark • *Shockwave Series* • 2005 • Pen and ink on mylar • Varied dimensions

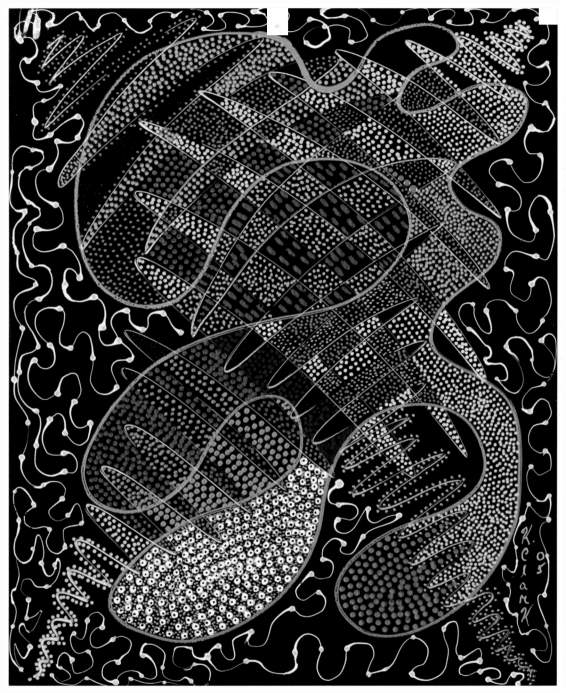

Kirk Clark • *Shockwave Series* • 2005 • Acrylic paint on mylar • 10 x 8 in.

Kirk Clark • *Angel's Path Series* • 2005
Scratch board • 7 x 5 in.

THEY ARE WITH US

I sense their sacred presence.
From time to time, angels'
wing tips brush my cheek.
The fragrant aroma of their
closeness wafts faintly amongst us.
Spirit guardians are God's overseers,
tirelessly tending to spiritual needs.

K.C.

Kirk Clark • *Angel's Path Series* • 2005
Scratch board • 5 x 7 in.

Introduction
by Yvonamor Palix

I had just started my sabbatical year in 2005, intending to withdraw from the international art world. After owning two galleries for over fourteen years – one in Paris and the other in Mexico City – and curating exhibitions for both the French and Mexican Cultural Ministries internationally non-stop, I had decided to take a break when my dear friend Kirk Clark, asked me to curate his retrospective exhibition in Texas.

I admit that had it not been for the innate curiosity that has always led me, like Ariadne's thread, to discover such unique universes as those created by artists of great folly and perseverance, I would not be writing these lines today.

My initial encounter with Kirk Clark was in 2003, when I began visiting with frequency the Rio Grande Valley after the birth of my niece, Odette. I had hoped to retreat there from art forums of any sort and dedicate myself to pure nothingness.

When I was introduced to Kirk, I was told that I would meet a very original and kind soul who was of a rare genre of businessman. Little did I imagine that I would meet a modern day character worthy of an Og Mandino story, the author of many acclaimed books such as *The Greatest Salesman in the World* and *The Greatest Secret in the World*.

His office (or his "Pandora's Box" to those who have seen it) reflects a personality vibrant with color, history and an almost childlike disorderliness. In time, I would discover the order in the disorder – an intricate pattern of display and archival form unique to Kirk. In his office, I was submerged in an atmosphere of memories and remembrances reflected in the many unique objects that surrounded him. There were rare insects under glass, paintings and drawings of diverse styles, totems, Indian artifacts, stone jewelry, masks, photographs, and books.

When I entered his office, Kirk sat behind a big table, an informal desk that felt as inviting as a supper table. His bright eyes, full of life, radiated knowledge, and his warm smile and hearty handshake made me feel like I was entering the home of Oz in the Emerald City. I never would have imagined this man to be a magnate of the automotive industry.

After only two minutes of conversation, we were enveloped in a charged atmosphere familiar to those who feed on conceptual energy and theory. The subjects of our exchange flew from the Cobra movement to the influence of primitive art in Cubism; from the Swiss Constructivists to Art Brut.

The words quickly wove into an endless and ever growing conversation. I felt energy quite similar to that experienced at the opening of an international art fair, or during private viewings of artworks before auction night in New York. It reminded me of the endless discussions I had with Achile Bonito Oliva, the most respected authority on contemporary Italian Art, who was the long time curator of the Venice Biennial and promoter of important art movements, such as the Transvanguardia and Fluxus, along with Pierre Restany.

How could it be that in a place far from the big cosmopolitan centers, I had stumbled upon a passionate art fiend, disguised as a serene businessman? The whole scene was quite surreal. It opened a window of reflection on so many levels for each of us. Our breakfast conversation that morning, which carried on to lunch, and was then followed by a series of art encounters that would last from fifteen minutes to endless hours at a time, flourished into a wonderful exchange of ideas and concepts related to art, humanity, religion and even politics.

I was delighted to have made a friend in McAllen that I could easily engage by e-mail or in person and whose experience and relentless imagination could transport me to the far reaches of the art universe.

Kirk effused spirit and knowledge in many areas other than art. His passion for all subjects is canopied by a humanistic preoccupation and a devotion to spirituality with uncanny freshness, always reflective of the pain or beauty in the creative process.

Kirk asked me to introduce him to some of the artists from other countries with whom I work. His perception of an artwork is always spontaneous, yet piercing. The moment is rare in which he is captivated by a work of art that does not contain a uniqueness in technique or in concept, and that is not a significant work for the artist himself.

A WAY OF LIFE

I came to learn of Kirk's unique relationship with art inherited from Dorothy and Charles, his loving parents. By listening to him speak of them as a couple of many passions, I soon understood that his inherent need to create, collect and promote art, not only his own, but any art that caught his discerning eye, was a genetic family trait.

As children, Kirk and his sister observed the comings and goings of their parents all over the world, whose passion for art was dictated by their colossal goal of achieving the unachievable: observing and absorbing the integral creative process of the artists they encountered and admired.

The time, energy and financial investment that they spent during their lives in pursuing this quest became a way of life for the entire family. Inevitably, Kirk was bound to inherit this energy and channel it by way of his own unique personality and soul. He would continue the legacy as an artist and discerning art collector.

The sense of responsibility and devotion with which Dorothy and Charles Clark thread the route of their collection is certainly rare for many reasons. In a time period when the scars of war were not yet healed, in an area where contemporary art was not one of the priorities, their ventures for bringing the most modern forms of art to this region of South Texas, were both audacious and enlightening.

The Clarks were similar to a modern De Medici family, something to them of great personal value. They carefully documented all their activities related to these endeavors. They amassed art works from many artists highly recognized today. At the time, however, little did one know in which direction the careers of Max Bill, Jorg Imendorf, Antoni Tápies, Sigmar Polk, Eduardo Chillida would go.

The Clarks had in them the souls of explorers. The unknown frontier for them was the future of contemporary art. What they accomplished was difficult and improbable, even if they had today's tools of prognostics and expert consultants. They relied on their instinct that served as a compass traversing the vast ocean of creation.

The post-war era brought with it great ventures for Americans in all fields, including the arts. Movements and styles made headway into the international scene by way of New York, and the mainstream art institutions. The works of many individual artists and art movements accented this period. However, the Clarks shied away from the conventional art values of the time. They had the courage to forge their own path and establish their own collection through their research, instinct and risk.

A TREASURE OF EXPERIENCES

Dorothy and Charles Clark lived their lives and collected their art with passion. Not all of the artists they encountered and whose works they collected became

famous or established in the art market. To the contrary, some artists were never heard of, but the moments that were shared with them in their studios or their travels to far away lands to meet with them, became a treasure of experiences and expressions unique to this formidable couple. Each work collected represents a story, an anecdote, or an unexpected surprise.

Their collection included thousands of the finest works by prominent artists of the time, as well as by artists who were later to be recognized. The Clarks' passion went beyond collecting. It involved much research, documentation, and ultimately the generous donation to institutions and museums all over the United States. Their main desire was to contribute continuously to the development of the arts in their community, and to spark the interest in other people for this magnificent and fulfilling passion.

The consummate research and professionalism with which Charles and Dorothy Clark amassed and preserved their print collection is worthy of a complete book covering the written documentation of each art piece.

Kirk has continued this adventure through his own work and through a demanding yet considerate eye for collecting the works of established artists, as well as younger emerging talents. Through his donations to charities and the gifting of art works to institutions, he continues the legacy of his parents.

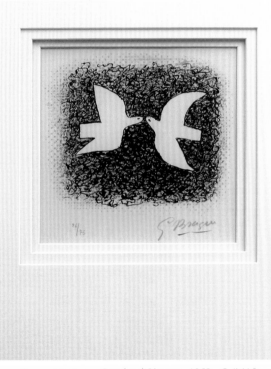

Georges Braque • *Couples d'Oiseaux* • 1963 • C. IMAS

Anne, Kirk's daughter, has undertaken her own artistic expression, experimenting with diverse mediums and concepts, thus developing her own style. She and Kirk share a common ideal, one of composition and structure that comes from an almost innate instinct. Neither of them shies away from unfamiliar art mediums. On the contrary, risk seems to be the common denominator in the works of father and daughter.

Perhaps one could say that the connective thread from one generation to the next of the Clark family is their willingness to take risks with their artwork and their aesthetic values. Whatever the case, it is certainly apparent that in all three generations, there is the audacity and tenacity for both collecting and creating, a drive that can be defined as a divine motion.

For whom do they collect? For whom do they create? All is given! Nothing remains at the end of the day except for the experience. In today's society, it is exceptional to find either collectors or artists of such sublime quests and such unselfish purposes, whose creation and collection of art derives its greatest fulfillment in the giving.

A SPIRIT ENGAGED

To enter Kirk Clark's universe is to enter a labyrinth of images and ideas uniquely interwoven. As you embrace one element of Kirk's work, there is suddenly another element such as style, subject or concept that overtakes the viewer by surprise and submerges him in the vastness of this artist's creative well.

The many aspects of Clark's works, taken from an aesthetic viewpoint, are all unique to his own experience, formation and philosophy. One element does not depend on another to make his work function. He has no set agenda as an artist other than the outward manifestation of his essence at any particular moment.

It would be quite fun and entertaining to note the diverse influences in his work, but such a gesture would be too limiting because Kirk erupts like a dormant volcano in an endless sea of creative processes. His uncanny attitude and unpredictable style distinguish his art.

Through personal contact with the artist, one understands his life's motive: to create. At a time when, according to Donald Kuspit, "scatological" art predominates, it is refreshing and unique to encounter an artist whose motives are to uplift the viewer spiritually. Kirk creates out of necessity. This is reflected through the passion, spirituality, perseverance and consistency with which his works are

created. Whether or not one can identify an element of Op Art, traces of Kinetic art, or vestiges of post-modernism in his works, such influences are but a trace of his own creative imagination.

The greatest influence upon Kirk came from his parents' passion as devoted art collectors, whose perseverance for the discovery of new artistic frontiers inspired Kirk and many others. He learned from them to value the illumination that comes from contact with other creative artists and the enlightenment, or "Satori moments," of the creative act itself.

REPETITION

In several of Clark's series, such as *Tidal Change, Satori,* and *Shock Wave*, one may perceive an almost obsessive quality in the works. These works raise the following questions: Are they a relentless search for form through the abstract? Or are they mere distractions to the

K. Clark • *Shockwave 44* • 2004
Pen and ink on paper • 11 x 14 in.

K. Clark • *In the Begining* • 2004
Pen and ink on paper • 14 x 11 in.

K. Clark • *Shockwave 47* • 2004
Pen and ink on paper • 11 x 14 in.

true essence of the work which cannot be materialized and is therefore incessantly worked over and over, perhaps a chef-d'oeuvre that must not be completed?

Does the repetitious style in these works indicate persistent frustration or a desire for liberation? Can these works reflect an inner self unknown even to the artist, such as the "other self" in a Jungian dialectic? Yet in all of Clark's work, the style and the accumulation of the never ending strokes become his redemptive quality.

As in Francis Bacon's paintings and illustrations, the repetitious substance of the artist's psyche may represent the fulfilling gesture of recreating one's self through the abstract whereby the gesture becomes an inventive act. In an almost subconscious manner, the artist's continuous repetition of a certain image through which he is represented brings substance and existence to himself, thus shedding the pain with which this act is provoked. In this respect, Goya comes to mind as well, although in his case, the subject matter of his paintings were both his pain and his solace, and the repetition in his case came mostly through the bloody subject matter, such as the carnage of battlefields or open decomposed carcasses of animals left to rot.

It would be an oversimplification to reduce these works to a psychoanalytical level since most art is an epiphany of sorts. It is unique not only to the artist's character, but also to the artist's sub-conscious state during the actual production séance.

A BALLET OF SYMBOLS

In other of Clark's series, one perceives a free flowing ballet of symbols. Much is left to the viewer's interpretation because the style and medium suffice in rendering the work acceptable. The artist is courageous and audacious enough to imply that beauty is not a taboo in his creative process, and goes to the extreme by ornately framing his works.

Kirk Clark • *Introspection* • 2003 • Pen and ink on paper • 11 x 14 in.

A few of the titles chosen for his series are associated with mystical realms known to humanity since the origin of human life. In *The Universe Below* and in *Incubus*, one discovers a colorful and playful biological wonderland rather than a Darwinian approach to nature – a universe of life and reproduction – as suggested by the titles.

The many colors that accompany this series of fictitious organic life are fascinating. Is this a manifestation of the beauty of life or simply a tribute to nature? Perhaps he dwells on the aesthetics of science and creates these forms as metaphors for a reality long lost. Can this be simply a muted reflection on the beginning of life? He swims in the

waters of science to feed his endless curiosity for the origin of mankind.

Kirk Clark • *Santo V* • 2004 • Pen and ink • 11 x 14 in.

THE SPIRITUAL IMAGE

In his *Santos* series, one is transported from the abstract to the figurative through fun and allegory. Why does he portray these characters in a more human-like form, and yet represents his *Atomic Jesus* in an exclusively organic or symbolic representation? The spiritual image is certainly present in most of Clark's works. He persistently maintains the resounding questions of faith through his portrayal of Jesus in the *Santos* series.

In Protestantism, the representation of figures is rare; however, in Kirk's representations, one is openly confronted with the constant questions raised in religion of reality versus history. These questions have been answered in the past by artists through their own artistic language from Michelangelo and Leonardo Da Vinci to Gérico and El Greco, all exclusively artists of faith whose works have been judged by time as divine inspirations with aesthetic originality. Thus, the iconic representations realized by Clark denote a certain baroque

quality that walks hand in hand with his own religious background.

Curiously, in his *Santos* series as well as in some of the *Angel's Path* series, one can observe a rare characteristic attributed to the Byzantine period, in which the Holy Family is portrayed without beauty. Clark's *Santos* goes from demons to angels in a unique and genuine visual interpretation. He strikes a balance by illustrating that the belief in angels is the only vehicle to truth, yet the images of such have an infinite number of interpretations.

LIFE EXPERICENCED

Kirk Clark's many styles are intricate and unique to his paintings, drawings, and sculptures. He once mentioned that the variation in the strokes depended on the fatigue of his hand! Like so many artists, he relies on both his inner self for inspiration and conceptual depth, as well as his own physical self and experience in technique for representation.

This brings us to the sculpture series, where technique and spontaneity play the main roles in his creative process. The *Shock Wave* sculptures are works of the artist's imagination married to the risk in the technique; the sand cast impressions in aluminum, copper and steel are ultimately determined by the print itself. Here, Clark uses the technique he has learned and applies his own instinctive inventiveness to complete the pieces.

Originally trained as a sculptor, Clark's sculptures reflect an ease and comfort. His freedom from visual constraint becomes a window of escape in this creative endeavor. The conceptual content of the work and the technical expertise are unique to the artist, yet the final outcome depends on the artist's playfulness, humility, and sense of the unexpected.

The many series realized by Clark represent chapters of his spiritual odyssey as well as the memoirs of a life experienced. He transposes many of his ideals to the world created by his imagination and combines reality with fantasy in a visual

choreography. He is both a humanistic and spiritual artist. He exists as a man, and therefore communicates his ideas and thoughts on life, love, God, and the ethereal through his own language, his art.

The work of Kirk Clark, with its many influences and styles, is a representation of humanity and our uniqueness in a universe inhabited by angels that guide the artist on a solitary and never ending road dictated by his art. In this exhibit, the viewer is taken by the hand of one of Kirk's angels and subtly led to the imagination of an artist whose spirit cannot be anything but completely engaged. Thus the celebration of spirit begins . . .

ABOUT THIS BOOK

The book that was inspired by Kirk's retrospective exhibition began as a simple idea that evolved into a rich product of research and analysis. The challenge of articulating the emotional path of the life of an artist is one which the artist himself seldom is confronted with in his or her lifetime. Usually, this is an event that takes place after the artist's death by critics and those who have lived close to him. In the case of *Celebration of Spirit*, Kirk has literally and physically dug into his past for his roots reflected here within the words and images of this book.

His personal process was cathartic at times; his perseverance was relentless; his dedication was devout; yet through all the obstacles and challenges of such an ambitious project, Kirk remained ever thankful, warm and considerate to all of us who embarked on this great adventure with him.

In his biography of St Francis of Assisi, G. K. Chesterton comments, "It is in a cynical sense that men have said, 'Blessed is he that expecteth nothing, for he shall not be disappointed.'" It was in the wholly happy and enthusiastic sense that St. Francis said, "Blessed is he who expecteth nothing, for he shall enjoy everything."

Kirk Clark shares the optimistic temperament of St. Francis and puts into practice his rare philosophy, reaping the joys of life through art only to share them with the world.

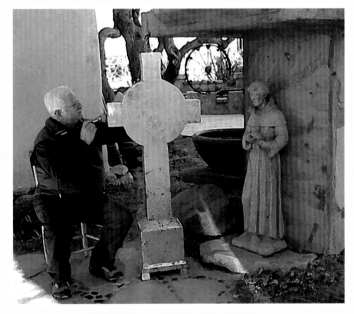

Kirk Clark at work in Taos, New Mexico.
Photo taken by Thom Wheeler • 2005

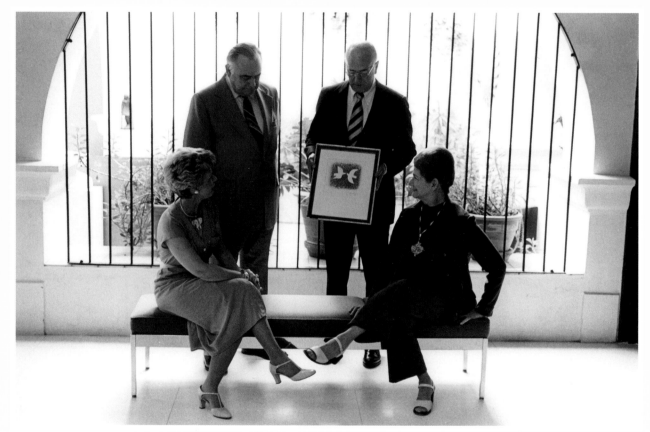

Charles & Dorothy Clark gifting *Couple d'Oiseaux* by Georges Braque to IMAS. Accepting the art piece are Marge Bentsen and Charles McLaughin.
Photo courtesy of IMAS • 1979

The Artistic Legacy of Charles and Dorothy Clark
by Kirk Clark

I am blessed. I was born on May 2, 1946, to Charles and Dorothy Clark, two of the most loving, caring, and interesting parents any child could have. Their love of life and each other, plus a fascination with the arts and artists, would greatly influence my life over the years and bring much joy to us all.

Mom was born in Lodi, California, Dad in Peoria, Illinois. Both of my parents were talented artists in their own right. Dad was a very capable young artist trained in the representational tradition. He studied art for two years at the Kansas City Art Institute. He achieved artistic recognition in Kansas City when he won a city-wide competition to design a Christmas card to be used by the city. The Christmas card became the official Christmas card of Kansas City, Missouri.

Unfortunately, his parents divorced and Dad was sent to live in Peoria, Illinois, with his father, and his grandmother. His father was often out of town on business. Although he did not get support of his artistic talents in Peoria, Dad never lost his interest in art, nor his masterful eye for art.

Mom was also trained in the representational tradition of art and theatre at The University of the Pacific in Stockton, California, where she got her degree in English and Literature, with a minor in Art. She was Dutch and a fourth generation Californian. Her family brought nursery stock around the Horn on a windjammer, settling in California and becoming nurserymen. I can still remember walking through the grass, barefooted on my grandparent's lawn in Lodi as a young boy. The texture of the grass was so different from the grass in McAllen, no sticker burrs either.

TWO ARTISTS MEET

My parents met in California where Dad was stationed in primary flying school in training to become a B-17 pilot. Mom and Dad met at a social event at the Air Force base where Dad was stationed. The Air Force would invite local young ladies in from the surrounding communities and sponsor a dance for the cadets and their guests. That's where Dad spotted Mom. It was love at first sight. He knew she was the one for him.

There was a whirlwind romance, and they were married by the local Justice of the Peace on a snowy night in Coeur d'Alene, Idaho. Dad's father flew in from Peoria for the wedding. Mom and Dad were snowbound for three days before he could return to base. He was worried about being AWOL, but his base commander heard the weather reports and Dad avoided retribution with a timely phone call. He shipped out shortly thereafter, completing primary flying school and bomber school before entering the war. He was based out of England as a B-17 pilot with the rank of Captain.

THE WAR YEARS

Dad's plane was shot down by anti-aircraft ground fire over Kiel, Germany, on May 19, 1943, on his twenty-fourth bombing raid. When his B-17, The Bloody Tangiers, was struck in the tail section, Dad got his crew members out of the plane before parachuting out himself. He free-fell for close to thirty thousand feet before he opened his parachute at the very last minute, and swung twice under the opened chute before hitting the ground hard. He was in excruciating pain, and later found out that he had cracked two vertebrae and crushed a disc in his back.

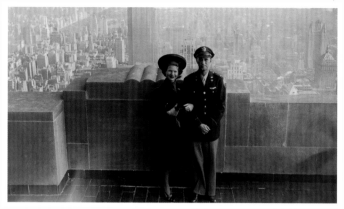

Charles & Dorothy Clark • New York, New York • 1941

It took Dad several years to regain his health and vigor following his imprisonment as a POW. By the late 1940's, Mom and Dad had relocated from California to McAllen, Texas. Following Dad's physical recovery from nineteen months of depravation as a POW, he joined his step-father, J. V. Carpenter, in the automobile business in McAllen.

A SHARED PASSION FOR LIFE AND ART

Mom and Dad shared a passion for life, art, artists, each other and their family. After settling in McAllen, they began to pursue their art interests again, shifting their studio art interests to collecting art, particularly limited edition prints, in the late 1940's.

He was captured by the Germans and taken to Stalag Luf III. During his imprisonment, he was moved on separate occasions from Stalag Luf III to Stalag Luf VII and then to Stalag Luf XIII. He survived both of those death marches, which cost the lives of a large number of American and British POWs.

In the early 1950's, my parents were not wealthy. Each work of art they collected required careful consideration. They seemed to relish the process leading up to a new purchase. The first thing I remember about art was not the visual impression of the art work itself, but the enthusiasm they shared about the work. Secondly, I remember the images that began to surround me.

My father was repatriated from the German prison camp at the end of WWII by General Patton and his American troops. He received the Distinguished Flying Cross with two oak leaf clusters, a Silver Star and a Bronze Star with three oak leaf clusters. His final rank was Major.

The art was fascinating to me when I was a young boy. I did not understand the techniques that Dad described relative to the imagery, but it didn't matter. I was fascinated by it. Later in my teens, I would gain an appreciation for the technical aspects of the prints. Art brought joy into the Clark house.

He was lucky to have survived the war. He actually crash-landed in B-17's six times before being shot out of the sky. He was tough, thanks be to God. When he wore a suit, he wore a metal caterpillar with a ruby eye, signifying that he had parachuted out of a military plane which was on fire.

We took a road trip to Lodi, California, every other year to visit my mom's parents, the Van Gelders. I remember the amazing peach pie Grandmother used to make from peaches grown in the garden just outside her kitchen window. Grandmother had a green thumb and was the favorite to win the annual table grape competition at the fair each year. Her garden was a wonder of fragrances, colors and textures. The garden was very much like a work of art, in its own way, the Van Gelder way. I loved our summer visits to Lodi.

His war experience affected his life afterwards in many ways that we did not know about until after his death in 1990. We discovered that dad, like so many veterans of that era, suffered from post-traumatic stress syndrome. That discovery explained a lot. He had his own way of working through his problems. I deeply regret that his condition was not identified during his lifetime, so that he might have found some relief. His family knew there was a problem and tried to accommodate him wherever possible.

It was on those trips that Mom and Dad began to explore the California art scene.

They began acquiring modest art works, watercolors by Joshua Meador, and various prints from artists in California. These early acquisitions began to feed their passion for art with serious collecting, research, and travel to meet the artists. Their love of art was a gift they shared with each other, with my sister, Robin, and me.

Later, they would count thousands of artists, gallery operators, museum curators, students, and the viewing public among those who came to admire them for their enthusiasm, academic excellence and their keen eye for art, not to mention their generosity. I think Dad found art and his research to be very therapeutic through his post-war life. His research was characterized by an extensive review of results from Christie's and Sotheby's art auctions and monitoring the sales results of several hundred galleries in America and Europe.

THE WORLD OF BUSINESS

When Mom and Dad moved back to McAllen, Dad's step-father, J.V. Carpenter, put Dad to work in the body shop sanding cars. Dad had to pay his dues before being transferred to the new car and truck sales department. His back injury during wartime, however, made sanding arduous. Fortunately, he graduated to a job that utilized his head, not just his hands. Dad was an economics and foreign trade graduate from The University of Michigan, in Ann Arbor, Michigan, with a minor in Spanish language.

It was not long after my parents' return to McAllen that J.V. had a severe stroke. I believe it occurred in 1952. The stroke left J.V. paralyzed from the neck down, unable to speak. J.V. survived for approximately a year before his death. Things were more than a little tense and challenging at the car dealership for some time to follow. Dad met his challengers head-on and prevailed to acquire a controlling interest in the Chevrolet dealership, for which I am eternally grateful.

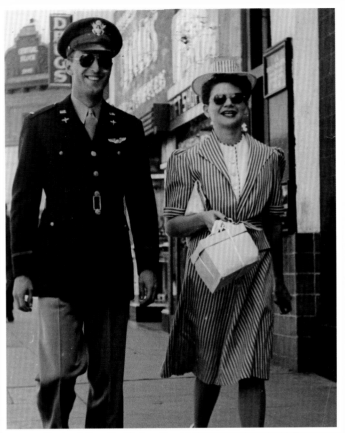

Charles & Dorothy Clark • Tucson, Arizona • March, 1942

BEGINNING OF ART COLLECTION

Soon Mom and Dad were able to visit Lodi again. While in California, they began to buy the work of a few California artists. One of the first artists that attracted their eye was a water colorist by the name of Joshua Meador. Meador became one of California's most renowned landscape watercolorists. Mom and Dad were delighted to add one of his works to their early collection.

This was the beginning of forty years of art collecting, writing about contemporary art, and lecturing by my parents. I have seldom heard of amateur collectors who did the level of research my parents did.

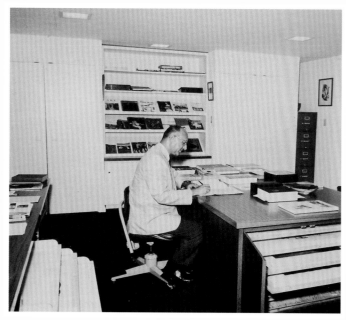

Charles Clark in the art room • McAllen, Texas • 1975

Often, Mom and Dad chose to collect limited edition works on paper. Dad truly felt that some artists did their best work print making. Both had a wonderful eye for great composition, space and color. Through his research and wisdom, Dad developed a feel for a contemporary art movement, was able to identify the dominant artists in the movement, and also the artists with the most potential.

Dad was always trying to catch the great artists as early in their careers as possible. I remember that on every art related trip we took, he would ask the established artists we visited who the young guns were going to be and when. Dad, with Mom's assistance, would begin to track their auction history, gallery sales histories, and monitor the opinions of other artists. They took meticulous notes about the artists and their work.

Jakob Bill, son of Max Bill, a major founding father of the Swiss Constructivist movement, was an example of an outstanding young artist who gained national recognition

in Switzerland over the years. Often, Dad would identify the young artist's work which had that special quality about it.

Mom and Dad's friendships with gallery owners, curators and museum directors developed through extensive correspondence and visits to galleries and museums in the United States and around the world. They would ask for the names of artists who impressed the professionals in the art world, including successful artists themselves.

THE ART ROOM

My parents had Dorothy Norris, a dear friend of my mother's, design an addition to our house. Mrs. Norris designed the home originally for them. The addition was to serve the purpose of providing proper storage for unframed prints and stack storage for paintings, as well as a research library.

Every nook and cranny in the addition had a purpose and it functioned beautifully. It had a long built-in desk that went nearly the length of the room with two cutouts, one each for Mom and Dad, providing them their own work area with a book case just in front of them that also ran the length of the room. The art room was a serious place for study. When my sister or I entered the art room, we knew to do so quietly. There was to be no horse-play permitted in the art room.

I really admired my father for working hard all day at the office, coming home for a quick meal, and then into the art room with Mom for two to three hours of research and study. When artists came to our home, they were led to the art room/art library and the ice was broken. Artists loved Mom and Dad because they were both genuinely interested in the artist and his or her work. Their enthusiasm was contagious. I know that I caught it.

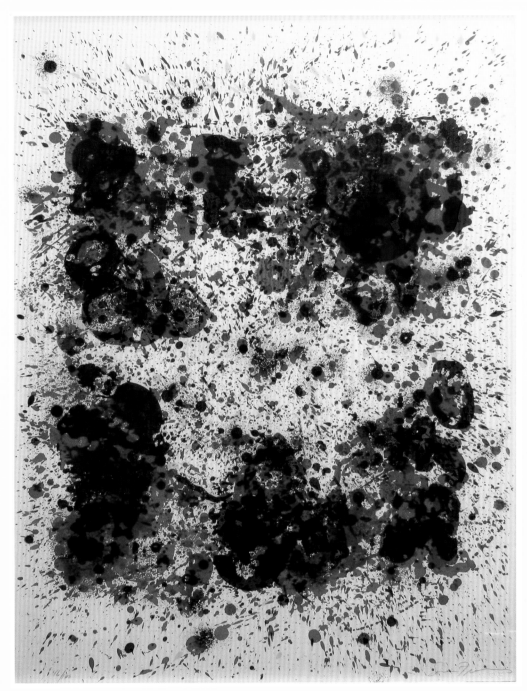

Sam Francis • *Spun for James Kirsch* • 1972 • Courtesy of IMAS

Ernst Mether-Borgstrom • *Untitled* • 1977 • C. IMAS

Lars-Gunnar Nordstrom • *Untitled* • 1977 • C. IMAS

Sam Vanni • *Untitled* • 1977 • C. IMAS

Exploring European Art Movements

GERMAN ABSTRACT EXPRESSIONISM

One of Dad's early art interests was German Abstract Expressionism. He did not speak German, but taught himself German from an English/German dictionary, so that he could do research in German language documents. He was remarkably determined. He found the post-war German art movement to be very interesting and powerful.

Somehow, he was able to relate to the German art movement in a very personal, visceral way. He found that German Abstract Expressionism was a powerful visual response to the dynamics of World War II. He could relate to those images and was passionate about the artwork.

At the time, I could not figure out why a man, who had gone on twenty-four bombing missions over Germany and was a prisoner of war for almost two years, would be attracted at all to the art produced by the culture that kept him captive and barely alive.

I still do not have all the answers to that question. It might have been that Dad found the study of German contemporary art to be cathartic in some fashion, putting a human face on an otherwise inhumane experience. It might have been the insights Dad discovered about the German culture through his study of their art. I am not sure. At this point in time, I may never know for sure. I do know that dad was determined to understand all he could about German Abstract Expressionism.

AUSTRIAN SCHOOL OF THE FANTASTIC

Sometime during the latter stages of Dad's intense study of the German art movement, he began to explore an art movement in Austria called the Austrian School of the Fantastic. Professor Ernst Fuchs was the founder of the movement that captivated his attention. This Austrian art movement was surrealistic in nature, fanciful, and magical, all at the same time. Fuchs was a master sculptor, painter and print maker. In my view, Fuchs was to the Austrian School of the Fantastic as was Salvador Dali to Surrealism. Fuchs' work explored the erotic, as well as the holy, with a mastery of composition, color, superb technique, and a passion for art rarely seen.

My parents went to Paris, France, for the opening of a one-man show for Ernst Fuchs in 1962. They had a ball. Dad, who always did his homework before going to an art opening, wowed Professor Fuchs with his knowledge of his work, show history and notoriety.

Many years later in 1999, my wife Jeri, and two of my sons, Alex, 12, and Daniel, 8, were on a European tour with me, including a stopover in Vienna. All four of us were getting over a mild case of the flu at the time and were a bit weary. The boys asked, "What do you have lined up for us in Vienna, Dad?" I said, "I have great news, sons. We have an eight hour walking tour of museums and galleries with a guide."

The moans still resonate in my ears. Jeri suggested that I return to the hotel about one p.m. to pick them all up for the afternoon portion of the tour. I was determined to get an early start and joined the art guide, Rudi Evers, in the lobby of our hotel in Vienna that morning. He was a gentleman in his early thirties. He was from Holland, and spoke perfect English with only the slightest hint of an accent.

He asked me which artists I was most interested in. I quickly responded, "Professor Ernst Fuchs". His voice lifted and with a broad smile he said, "Do you know the work of Ernst Fuchs?" I told him that I loved his work, wanted to know much more about it, and hoped that I could visit as many museums and galleries as possible in pursuit of Fuchs' artistic creations. The guide asked, "Did you know you will be passing by Professor

Fuchs' home and museum on your way to Salzburg tomorrow?" I did not know that.

The guide pulled out his cell phone and asked if I would like for him to contact Professor Fuchs to see if it would be convenient for us to stop by the next day. I was delighted. Rudi called straight away and was able to ring up the museum/gallery. He spoke to Professor Fuchs' daughter-in-law, who was Fuchs' manager. She agreed to a thirty minute visit mid-morning the next day. I could not believe that we were going to get to meet Ernst Fuchs.

Rudi and I went on about the art tour and got in as many visits to galleries and museums as we could before returning to the hotel for Jeri and the kids. After a light lunch, we set out to finish the tour. Jeri and the kids were all very excited to know that we were going to get to meet Ernst Fuchs the next day. It added additional interest for all of us as we studied the fantastic work of Professor Fuchs and his contemporaries throughout the afternoon art walk.

ERNST FUCHS' MUSEUM IN THE BLACK FOREST

The next morning we checked out of our hotel and our driver picked us up in a VW van and drove us directly to Professor Fuchs' museum in the Black Forest. We rang the door bell and the door was opened by a lovely young lady who welcomed us. She was striking and well spoken. She was Fuchs' manager and daughter-in-law. She did admonish us that the professor was on a tight schedule and she would be particularly grateful if we did not exceed our thirty minute visit. I assured her that we would not.

As we walked into the museum, we were overwhelmed with the beauty and the intensity of Fuchs' works. His work was marked by the beauty of human form that brought Michelangelo to mind. He had a whimsy and curiosity in his work that was full of fantasy, eroticism and imagination, having drawn on the great masters of the past for body posture and composition. I knew that we were in the presence of a genius.

We looked to the far end of the Museum, where we spotted a tall man dressed in an ochre robe and ochre turban, closely followed by an entourage, spellbound by his every word. Fuchs had gravitas. We all turned as his daughter-in-law intercepted him, pointed to us and stepped between Fuchs and the entourage as the professor strode in our direction.

He was an impressive looking man. He reminded me a bit of the magician, Merlin. He smiled our way as he approached us, extended his large, firm hand, looked directly into my eyes and smiled. I shook his hand and introduced him to my family. I told him how wonderful it was for us to have the opportunity to visit with him.

"OF COURSE I REMEMBER"

I asked, "Would you happen to remember my parents, Charles and Dorothy Clark from McAllen, Texas?" I went on to say that they told me they had met him in Paris, during the opening of his show there in 1962. Fuchs smiled and said, "But, of course I remember Charles and Dorothy Clark. I have never met anyone before or since who knew more about me, than me." We all had a good laugh over that one.

Fuchs was gracious enough to take us on a tour of the museum that had been built by Austria's foremost architect, Otto Wagoner, who had built the massive structure as his home, until such time as Professor Fuchs talked Wagoner into selling it to him. Years later, Fuchs had Wagoner design and build a wonderful Art Nouveau home in the Black Forest, only a hundred yards from the Museum. Wagoner introduced Art Nouveau to Austrian Architecture. We picked out several works from the gallery; three framed prints as I recall, and a series of posters which Fuchs autographed for us.

We ended up spending three hours with Fuchs and had the time of our lives. It did appear that the daughter-in-law managed the waiting crowd quite nicely, who had been waiting to see the Professor as soon as we left. We were not very popular with the entourage, but we were most grateful to have made this wonderful connection.

Several years later, my elder son, Charlie, visited Professor Fuchs. Charlie, an expert negotiator, talked Fuchs into some deep discounts on several works, one of which he gifted to me. It was a beautiful, hand colored, illustrated Bible colored by Fuchs. That was one of the nicest gifts that I have ever received.

SWITZERLAND – ART MELTING POT

In the early to mid 1960's, Mom and Dad's art interest gravitated to the Swiss Constructivist (Concreta) art movement, a movement greatly influenced by the Bauhaus and the melting pot for artists that was created by Swiss neutrality during WWII. Professor Max Bill was a significant player in this exciting art movement that focused on the mathematical relationships between line, space and color. Professor Bill was Switzerland's foremost architect and renowned artist. His son, Jakob, was greatly influenced by his father's work and was a huge success as an artist as well.

Camile Graeser defined Swiss Concrete Art in 1944, "Concrete means to renounce the presentation of an optical figurative world in art – Concrete means to create a new, clear picture world – Concrete means to erect, build and develop rhythms on a geometrical basis – Concrete is strictly logical formation and creation of works of art which have their own law – Concrete is the play with measure and value of color, form, and line – Concrete means elimination of the unconscious – Concrete is the visibly constructed pictorial timbre, similar to music – Concrete means purity, law and order."

Jakob Bill • *1967 #40* • 1967 • C. IMAS

Suzanne Bollag translated from German into English. This definition is used in her introduction for the Swiss Constructivist show that Mom and Dad put together for The University of Texas, Austin, in the early 1970's.

My parents met Suzanne Bollag from Zurich, Switzerland. She was owner of the Bollag Gallery in Zurich and became a dear friend of the family. Suzanne was very knowledgeable about the Swiss movement and was an invaluable resource for Mom and Dad. In their travels to Switzerland, Suzanne would take them to meet the artists in and around Zurich.

Many artists from surrounding countries fled their homelands to seek refuge and artistic freedom in Switzerland during WWII. Mom and Dad were quite taken with the stable of artists that Suzanne represented. Her gallery was filled with the best and brightest contemporary Swiss artists' work. They thought Suzanne's gallery was a candy store.

When Mom and Dad traveled to Switzerland, they always went to see Suzanne, whose cat, Mush Mush, became a source of mutual interest and great entertainment. She lived alone with the cat. When Mush Mush died at an advanced age, Suzanne almost died as well. Mom and Dad entertained the idea of going to Switzerland to console Suzanne, but did not in the end.

Jakob Bill • *1973 #5* • 1973 • C. IMAS

Jurg Janet and Franz Loressa, who owned and operated the Im Merker Presse in St. Gallen, Switzerland, became fast friends with my parents, who met them, I feel certain, through Suzanne Bollag. The Im Merker

Presse had Europe's finest contemporary artists print limited editions for sale and distribution throughout the world.

Mom and Dad became members of a select group of collectors who agreed to buy one print from each of the artists doing work throughout the year. This gave them great satisfaction. They could hardly wait to receive their monthly print. Each Christmas, the Presse would have a guest artist design an original, limited edition Christmas card which would be sent to each of the print subscribers. Even the Christmas cards became collectibles. My parents framed them all. I got to visit Jurg and Franz with my parents on several occasions. It was always an adventure. It was hard for Mom and me to keep up with Dad, whose energies were boundless.

"MAD AS A HATTER"

During my visits to Switzerland with my parents in the late 1960's and early 1970's, I was always amazed at the cleanliness of the Im Merker printing operation. It also had a pungent aroma. I will never forget that the expression, "mad as a hatter" derived from the awful effects of working in a hat factory which used mercury in the hat making process. It likely applies to early print operations where chemicals were used freely in poorly ventilated print shops, creating an unknown hazard for master printers, as well as the artists working at their sides.

I continue to be aware of the need to work with non-lethal materials and use proper disposal techniques for materials common to contemporary art making. I believe it is not only an artist's responsibility, but an act of self-preservation.

VISITS TO GALLERIES IN EUROPE

My parents departed in October, 1969, for Europe to visit galleries in Amsterdam, Munich, Zurich, and, in particular, a visit to Gallery Hartman, to study works done by artists in the Swiss Fantastic school. Then on to Milan, where they had an appointment to visit with the famous sculptor, Arnaldo

Pomodoro. They also planned a side trip to the Im Merker Presse in St. Gallen, Switzerland, and to catch the artist, Santimaso, in a creative session there during their visit.

It was not long before they ventured back to Europe. On December 21, 1969, they headed to Cologne, Germany, for the annual Kunstmarkt. They loved the Kunstmarkt experience, because of the large quantity of work as well as the quantity and quality of the artists' creations.

Just as the captain of a sailing vessel sets its sails to catch the best wind, Mom and Dad seemed to catch the changes going on in the art world, particularly in the world of print making. Through their research, travels, acquaintances, correspondence and friendships, they set out to explore the larger world, the world of art and artists, a world influenced by advancements of technology every day, everywhere. What a journey! I would be a deck hand on their art voyage any day! Amen and Amen!

Mom and Dad returned to Europe in October of 1970. They visited with Anton Lemlen, a remarkable artist who had lost three of his fingers on his drawing hand in WWII. He only had his thumb and pinkie remaining on that hand. That did not slow him down as an artist. Anton's work displayed a remarkable line, control and expression. I wished that I could have gone with them to meet Anton, whose work I admire greatly, but, I could not. Following a sensational meeting with Anton, Mom and Dad journeyed on to St. Gallen, to visit Jerg and Franz, at the Im Merker Presse, always a visit they looked forward to.

MORE ART TRAVELS IN EUROPE

In the late sixties we started spending most of our vacation periods in Europe. We traveled to Zurich, where our dear friend, Suzanne Bollag, made possible for us visits to the artists of her gallery, and also to St. Gallen, where our friends, Jurg Janett and Franz Larese, brought artists to create prints in their workshops, and we had an opportunity to meet and visit with them. In these workshops we could see

Victor Vassarely • *Rui-Kui* • 1964 • Courtesy of IMAS

Meetings followed with Professor Fritz Wotruba at the Vienna Akademie.

I also remember our visit during this trip to Becky Schuster Jones at the Viena Akademie of Art. Becky was the only American art student to ever receive full undergraduate and graduate scholarships for all of her years as a student there. Becky is currently an instructor of art at South Texas College, a wonderful photographer and artist, as well as being the wife to Foss Jones and mother of a lovely daughter.

Additional meetings followed at Im Merker Presse with Asger Jorn, Denmark's foremost artist at that time. Mom and Dad had an eight-hour visit with him in St. Gallen. Jorn's work was collected by my parents early on. This visit was part of their 1970 European art trip. They liked his work and found him to be of great interest personally.

Mom and Dad went to Munich during the 1970 trip to visit with Professor Toni Stadler and his wife, Priska von Martin. Both of the Stadlers were primarily sculptors. I was lucky enough to attend a visit with Verena Loewensberg at her apartment in Zurich. She was a lovely and talented lady whose work was marvelous.

Other artists that my parents met during that period were: Par Gunnar Thelander, head of a group of artists called "The Nine", Philip von Shantz, the director of the Moderna Museet in Stockholm during that period, and Giuseppe Santomaso, of Venice, yet another Im Merker artist of great talent and charm. Otto Dix, the great German artist, was most impressive to my parents, personally and as a talented and highly regarded artist. Their meeting took place three years before his death. Dix's personal dedication print to Mom and Dad was a true highpoint in the years they collected.

It was an honor and an education to have made this particular trip with my parents. I was very proud of the manner in which we were always received by the artists. Dad was genuinely interested in every artist he visited. He

the interplay between the artists and master printers in addition to the final results produced on the presses.

The first time we met Professor Max Bill, famed architect and a leader of the Constructivist movement, was in 1970, in Zumikon, Switzerland, outside of Zurich in the beautiful home he had designed for himself. From 1927 to 1929, he studied under Albers, Kandinsky, Klee and others at the Bauhaus in Dessau. His personal collection of early Constructivist and Concrete artists' works will fill a small museum. Professor Bill took us into his studio and showed us completed works and works in progress. He first develops his ideas on graph sketches and then enlarges them, sometimes into huge paintings.

Three years later we returned to Zurich, to Max Bill's home, this time with Professor Bill's son, Jakob and daughter-in-law, Chantal. Jakob's work shows his father's influence, but is distinctive and stands on its own merits.

and Mom would return to their hotel room and compare notes on each meeting with the artists. They were great fun to be with, and I got experience that would be most difficult, if not impossible to replicate in the classroom. I was proud to be their son and could hardly wait for the next trip, which did not come often enough for me.

On October 25, 1971, my parents traveled to Dublin, Ireland, to attend the ROSC art festival, a world famous gathering of art and artists. If my memory serves me well, my sister, Robin, traveled to Dublin to attend a creative art workshop for about three weeks. My parents were delighted to see Robin's artistic interests bloom.

Garo Antreasian • *73-5-1* • 1973 • Courtesy of IMAS

Shows and Gifting of Artworks

LIMITED EDITION PRINTS

By the mid 1960's, Mom and Dad's art collection, primarily limited edition prints, numbered around a thousand. They gifted many of these artworks during the mid to late 1960's to over thirty museums and universities. Their space at home was limited at that time and they were obsessed with the proper storage and care of their collection.

On November 10, 1966, my parents had a show of their emerging collection at McAllen State Bank, where Dad was on the board of directors. Dad was asked by the bank to make art acquisitions to display in the bank. It was great fun for Dad and very lucrative for the bank.

On July 30, 1967, Mom and Dad made gifts of art to several museums, which included the San Francisco Museum of Art, The University of California at Berkeley, The University of New Mexico in Albuquerque, NM, and the Andrew Dickson White Museum, Cornell University, Ithaca, New York. Their gifts represented a wide cross-section of artwork, primarily limited edition prints.

The names of the artists whose works were gifted by my parents are: Italian: Enrico Baj and Lucio Fontana; German: Max Ernest, Ger Lataster, Herst Antes, Alexander Archipenko, Hans Hartung, and Sonia DeLaunay; Russian: Boris Margo; Nordic: Asger Jorn; Austrian: Ernst Fuchs; American: Sam Francis and Richard Diebenkorn; Japanese / American: George Miasaki; Englishman: Victor Passmore; Dutch: Dorneille, Japanese: Hideo Hagiwara and Francois Nakayama. Also, Darrell Forney, Joost Huizinga, Maria Baromi, Jan Voss, Dorothy Boman. The gifts were very well received by each of the museums.

My parents shared their wisdom about the arts and artists as well as sharing their passion for discovery. Their desire to share their discoveries with others, as many others as would look and listen, was a true miracle to me. Their compulsion was to research, reveal connections and influences between artists, develop knowledge about a school of art, collect art representative of the movement, and then gift it to a museum or university that they knew would enjoy the art.

THE CRITICAL ROLE OF MUSEUMS

My parents recognized the critical role of museums, in particular, and supported them with gifts of art and cash. They hoped the museums would share the discoveries with the widest audience possible. They recognized that museums have the potential to be living institutions that offer their communities a unique vista into the past, capture the present, and teach about the possibilities for humanity in the future.

Museums are more than repositories of history and culture; they are living organizations that with proper leadership and community involvement, can become the heart of any community and a destination for young and old to experience a wide range of the best of humanity. Museums can breathe sensitivity, a vitality of excitement, and enhance our understanding of the fabric of our communities. Museums can be more than a reflection of our communities; they can help to focus awareness on the quality of our lives. Our museums deserve our support and deserve the best we can give them in time, talent and treasure.

SPECIAL GIFTS

On September 24, 1967, my parents gifted forty-two oil paintings, water colors and limited edition prints to Texas A&I University in Kingsville, Texas, including a portfolio of graphic arts, with many limited edition prints from New York. The works were exploratory and experimental in nature. The

artists' work that they gifted included: Arman, Mary Baumiester, Oyvind Fahlstrom, John Goodyear, Charles Hinman, Allen Jones, Robert Motherwell, Ad Reinhardt, James Rosenquist and Saul Stienberg.

The first thing my parents looked for in graphic art was its visual impact and secondarily, the technique. From time to time, Dad would find an artist whose work particularly interested him. Occasionally, he would commission the artist to create a work that he would then gift to a particular institution. On October 11, 1968, Dad commissioned a sculptor, Sid Garrett, who was on the art faculty of LSU, to do a sculpture for the McAllen Library on Main Street in McAllen.

That sculpture is still there today, and I continue to enjoy it as do many other library goers. The Sid Garrett sculpture is fashioned in wood and canvas. The slightest breeze would move the canvas panels, similar to a sailboat catching the breeze and filling the sails.

In March, 1969, The University of the Pacific received three prints and a painting, donated by Mom and Dad. Mom enjoyed many fond memories from her college years at The University of the Pacific in Stockton, California, where she had graduated with honors. Mom was the daughter of an English teacher, and was always a terrific speller.

Often, my parents would recognize the need or opportunity to share art with others, and they almost always acted on that impulse. Gifting was a compulsion to them. I asked my father one time, "Dad, is there anything in your collection that you love so much that you wouldn't give it away?" Dad said, "Son, I do not have anything that I own that I would not be willing to give away. I don't believe that I own anything. I am only a steward of my possessions.

"God has given me the opportunity, through the love of my life, Dorothy, to study, travel and collect art from all over the world. Our job, as I see it, is to enlighten others through our research, our discussions with artists, museum directors, curators, and gallery owners as well as fellow collectors. I want the institutions to which we make the gifts to teach, display and share these wonderful artistic creations with a wider audience than your mother and I could ever reach on our own."

A SHOW AT UT AUSTIN IN 1968

Mom and Dad worked hard in January of 1968, to prepare a show of contemporary graphic arts at The Art Museum of The University of Texas at Austin. Included in the show were the following artists: Mario Avati, Eduardo Chillida, Ben Nicholson, Jean Krasno, Pierre Alechinsky, Horst Antes, Garo Antresian, Karen Appel, Enrico Baj, Jakob Bill, Max Bill, Roger Bissiere, Karl Bohrmann, Peter Bruning, Camille Bryen, and Eugenio Carmi.

Also, Minna Citron, Bernd Damke, Alan Davie, Otto Dix, Jean DuBuffet, Jan Forsberg, Christian Fossier, Wolfgang Gafgen, Peter Gee, Jan Gelb, Terry Hass, Haku-Maki, Joost Huzinga, Masuo Ikeda, Asger Jorn, Jan Montijin and Karl Kasten.

My father curated this show. I know what great pleasure and excitement it brought both Mom and Dad to be involved in putting a show together, particularly at The University of Texas, Austin.

COLLECTORS CHOICE AT THE UNIVERSITY OF MICHIGAN

In April of 1971, my parents curated a show called Collectors Choice, that ran through June 27, 1971, at The University of Michigan. This show included the following artists: Horst Antes, Garo Antresian, Jakob Bill, Max Bill, Lee Bontecou, James Boynton, Kirt Bundell, Eugenio Carmi, Eduardo Chillida, Karl Dahmen, Allan D'Arcangelo, Piero Dorazio, Angel Duarte, Wojciech Fangor, David Folkman, Sam Francis, Ernst Fuchs, and Fritz Genkiger.

Also, Terry Gravett, Howard Hack, Asger Jorn, Karl Kasten, Konrad Klapheck, Rainer Kuchenmeister, Arnold Leissler,

Thomas Lenk, Richard Lindner, Joan Miro, Peter Nagel, Werner Nofer, Wolfgang Opperman, Joshua Reichert, Giuseppe Santomaso, Toni Stadler, Antonio Tapies, Mark Tobey, Fritz Wotruba, and Paul Wunderlich.

The vast majority of these prints were gifted to The University of Michigan at the time of the show. Dad was a graduate of the university, with an economics and foreign trade major and a minor in Spanish. He was delighted to be on The University of Michigan Fine Arts Council. It brought him great joy to be able to stay connected to his alma mater.

CONTEMPORARY ART SHOW IN HOUSTON

While I am unsure of the exact date that my father invited me to Houston to meet with Pierre de Montebello, who was the director of the Houston Museum of Contemporary Art, I do however, remember the trip.

A young man who had worked in Edinburg, Texas, at Pan American University in the Art Department left for Houston and joined the staff at the Houston Contemporary Museum of Art.

He was very familiar with the contributions of art that my parents made to Pan American University over the years. He was also aware of the tremendous amount of research that Mom and Dad did before gifting art to museums and universities around the country. He promoted the idea with Pierre de Montebello that it would be wonderful for the Museum to have an exhibit of contemporary print making at the museum. He arranged a meeting between Dad and de Montebello at the museum in Houston. Dad asked me if I wanted to go along, and I was delighted to accompany him to Houston for the meeting.

We arrived at the museum and were taken aback by the wonderful Polmodoro sculptures on each side of the entrance to the museum. It was a great way to start. Dad and I found the director's office and announced ourselves to his secretary, who then called de Montebello, informing him

Aimo Taleva • *Untitled* • 1977 • Courtesy of IMAS

of our arrival. We waited for fifteen minutes and were then led into his office. I recall the richness of the furniture and the wonderful art around the sumptuous office.

Pierre rose from behind the expansive desk to shake our hands. I noticed the look exchanged between Dad and the director. It was like two pit bulls sizing each other up. We all sat down. Pierre was the first to speak. When he did, I almost fell out of my chair. He said, "Mr. Clark, what makes you think that you have anything in your collection of prints that this museum might have the slightest interest in?" I could not believe my ears.

Dad did not say a word to Mr. de Montebello, but turned to me as he slowly rose out of his chair and said, "Son, it appears that we have made a terrible mistake. I had understood that Pierre de Montebello was a fine, well-mannered gentleman. It appears that gentleman is not in this room today. We are leaving."

"I WAS JUST TESTING YOU"

Dad turned and headed to the door with me in hot pursuit. The director stood, leaning forward with his knuckles on the desk and said, "Please, forgive me. I was just testing you." He asked us to return to his desk. After a moment's hesitation, a nervous one for me, Dad turned around, looked de Montebello straight in the eye for what felt like a very long time without saying a word and began to walk back to his desk. I was right behind him.

I could not believe the tension in the room the whole time this melodrama was unfolding. We all sat down. It was our four eyes to his two. The director apologized and went on to say, "We have so many people who attempt to use the museum for their own purposes. I try to separate the pretenders from those who are authentic."

The director asked my father to talk with him about the proposal for a show of contemporary graphic art at the museum. Dad had carefully prepared a comprehensive proposal with complete descriptions of each art work, their dimensions and a biography of each of the artists. It was quite extensive.

When the director took a close look at the photographs and carefully documented notes, he began to smile for the first time. Pierre said, "It appears that I have underestimated you, Sir; my apologies. I would be delighted to bring your proposal before the board and make a strong recommendation that we set a date for the show at your earliest convenience, our show schedule allowing." Dad smiled for the first time and said, "Thank you, you will not be disappointed."

Several months later the show opened at the Houston Museum of Contemporary Art. The show was well received and well attended. Mr. de Montebello was a gracious host that evening and Mom and Dad were very happy with the final result. Shortly afterwards, de Montebello was hired by one of New York City's finest museums. I don't believe that Dad ever talked to him again.

I will never forget that initial meeting. It did make me particularly proud of Dad. There was never any pretense with him. He made a point never to over promise and under deliver. I think that he learned this in the automobile business. It taught me several of life's most important lessons, including: to be totally prepared, to always be a gentleman,

Seppo Karkkainen • *Untitled* • 1977 • C. IMAS

Paul Osipow • *Untitled* • 1977 • C. IMAS

Outi Ikkala • *Untitled* • 1977 • C. IMAS

Jorma Hautala • *Untitled* • 1977 • Courtesy of IMAS

particularly when dealing with difficult people, and to always know what you are doing, always. Never walk into a meeting unprepared and never suffer a bore.

GERMAN GRAPHICS OF THE SIXTIES AT UT AUSTIN

My parents continued to do their research and continued their art collecting. On February 17, 1974, they opened their show, *German Graphics of the Sixties*, at the Archer M. Huntington Gallery, University Art Museum at The University of Texas at Austin. This exhibit was designed to document the resurgence of graphic art activity in central Europe, including the whole of Germany, following the end of WWII.

Germany became a stopping point for printmakers after the war. In fact, American graphic artists made the pilgrimage to Germany to work with master printers and attend printmaking workshops. Mom and Dad took a look back into the decade of the sixties to see what was produced in the German graphic arts. Dad was the guest curator of the show. Donald Goodall was the Director of the museum and Marian Davis was the Chief Curator.

I believe that the work my parents did on this exhibit was remarkably fine. The show was warmly received and professionally acclaimed. Works from about a hundred artists were included in the exhibit: Gerhard Altenbourg, Horst Antes, Hans Baschang, Joseph Beuys, Karl Bohrman, Karl Fred Dahmen, Hanne Darboven, Rolf-Gunter Dienst, Hans Friedrich, Dieter Asmus, Michael Badura, Ulrich Baehr, Thomas Bayrle, and Erwin Bechtold.

Also, Bernd Berner, Clarus Bohmler, Victor Bonato, Peter Bruning, Wolff Buchholz, Axel Dick, Hans-Jurgen Diehl, Simon Dittrich, Gerd Van Dulmen, Hans Martin Erhardt, Gunter Fruhtrunk, Winfred Gaul, Johannes Geccelli, Rupprecht Geiger, Fritz Genkinger, Gerhard Von Graevenitz, Fredrich Grasel, Gotthard Graubner, and Hannes Grosse.

Others were Dieter Haack, Heijo Hangen, Erich Hauser, Erqwin Heerich, Klaus Heider, Gerhard Home, Alfonzo Huppi, Horst Janssen, Reimer Jochims, Horst Egon Kalinowski, Herbert Kaufman, Konrad Klapheck, Peter Klasen, Kleinhammes, Karl-Heinz Kliemann, Werner Knapp, Imere Kocsis, Reinhold Koehler, Heinz Kreutz, Dieter Krieg, Ferdinand Kriwet, Rainer Kuchenmiester, Jens Lausen, Uwe Lausen, Rolf Laute, Arnold Leissler, and Thomas Lenk.

Also, Heinz Mack, Almir Mavignier, Fredrich Meckseper, Jobst Meyer, Lienhard von Monkiewitsch, Piet Morell, Peter Nagel, Siegfried Neuenhausen, Werner Nofer, Herbert Oehm, Wolfgang Oppermann, Diethelm Pasler, Joachim Palm, Peter Paul, Wolfgang Petrick, Karl Pfahler, Otto Piene, Uli Pohl, Lothar Quinte, Josua Reichart, Jurgen Reipka, Gerhard Richter, Christian Rickert, and Dieter Rot.

Additional artists were Fritz Ruoff, Eberhard Schlotter, Herbert Schnieder, Rudolf Schoofs, Johannes Schrieter, Bernard Schultze, Konrad Schulz, Peter Sorge, Nikolaus Stortenbecker, Helmut Sundhaussen, Heinz Trokes, Peter Tuma, Gunther Uecker, Dietmar Ullrich, Jan Voss, Wolf Vostell, Hans-Jorg Voth, Marie-Luise Weil-Heller, Stefan Wewerka, Ludwig Wilding, E.G. Willikens, Lambert Maria Wintersberger, Rainer Wittenborn, Paul Wunderlich and Hans-Peter Zimmer.

This is an impressive collection of German Graphic Art of the 1960's. Mom and Dad gave a brief biographic sketch of each artist, and a complete list of all the galleries in Germany handling *German Graphics of the Sixties*, as well as a listing of the German workshops printing for German artists in the 1960's. Also included in the catalogue was a listing of the artists and the schools of art that they followed.

The research, the catalogue and the show were huge undertakings, and I am most proud of my parents for the wonderful job they did on all three. They gifted the show and all the research to The University of Texas as a complete teaching unit.

LOUISIANA STATE UNIVERSITY

After The University of Michigan show and the *German Graphics of the Sixties* show, Mom and Dad sponsored a show, *Contemporary Graphic Prints from the Collection of Charles and Dorothy Clark* at the LSU Union Gallery at The Louisiana State University November 7-26, 1974. My parents were delighted to have a member of The University of Michigan art faculty, Sidney Garrett, take a position at LSU. My parents had met Sid when Dad served on The University of Michigan Fine Arts Council, and they became good friends. Mom and Dad recognized Garrett's talent early on and were delighted when he became the Director of the Art Museum at LSU.

Dad prepared a proposal for a Contemporary Graphic Print show at LSU, which my parents gifted to the university in honor of Garrett. Their gifts included the following artists:

Robert Gordy, Peter Plagens, Walter Gabrielson, Herbert Bayer, Bob Bonies, James Boyton, Ernst Fuchs, Friedreich Hunterwasser, Karl Korab, Anton Lehmden, John Maggio, Wander Bertoni, Erich Brauer, Georg Eisler, Albert Paris Gutersloh, Rudolf Hoflehner, Alfred Hrdlicka, Peter Pongratz, Arnulf Rainer, Erwin Reiter, Rudolf Schonwald and Robert Raushenberg.

SWISS CONCRETE ART SHOW AT UT AUSTIN

The next exhibit that my parents put together was *Swiss Concrete Art in Graphics*. The show took place in the mid - 1970's at The Archer M. Huntington Gallery at The University of Texas at Austin.

This exhibit may have been their very best. Only history will tell. Artists whose work was chosen for this extensive show included the following: Felix Wasser, Willi Muller-Brittnau, Elsa Burkhardt-Blum, Fritz Glarner, Sophie Taeuber-Arp, Jean Baier, Jakob Bill, Richard Lohse, Sergei Candolfi, Andres Christen, Angel Duarte, Jenny Ferri-Losinger, Hans Fishli, Annemie Fontana, Willi Fust, Karl Gerstner, and Hansjorg Glattfelder.

Also, Camille Graeser, Pierre Haubensak, Christian Herdeg, Hans Hinterreiter, Gottrieed Honegger, Max Huber, Johannes Itten, Arthur Jobin, Leo Leuppi, Verena Loewensberg, Christian Megert, Hansruedi Minder, Werner Von Mutzenbecher, Nelly Rudin, Natale Sapone, Manfred Schoch, Josef Staub, Carlo Vivarelli, Felix Wasser, Gido Wiendkeher, and Marcel Wyss.

Swiss Concrete Art brought my parents a particularly intense joy. Mom and Dad's previous research on German Abstract Expressionism, with its many movements and complexities, raised many challenges and took considerable intellectual energy from them both. Swiss Concrete, on the other hand, appeared to be a fairly straight line of development from Eastern European constructivists.

They did find the key to and the purpose of the Swiss Concrete movement to be rather difficult to comprehend and engaged in extensive discussions with Suzanne Bollag, Max Bill,

Mrs. Anne Rotzler at the Gimpel and Hanover Galerie, and with Miss Margit Staber, art critic and lecturer, all of Zurich, Switzerland.

"If I were to try to define Concrete Art," Dad said, "I could not do better than to borrow the headline which Peter Schjeldahl used in his article on Josef Albers in *The New York Times* on November 28, 1971: 'Art that owes nothing to nature, but everything to man himself.'"

Willi Muller-Brittnau • *Untitled* • 1972 • Courtesy of IMAS

Suzanne arranged for countless meetings between Mom, Dad and Swiss Concrete artists. My parents were particularly uplifted by this particular school of art because of its non-representational nature, its underlying mathematical basis, and its formulas for social order inherent in the formulas. It is also interesting that the show represented art from three generations of Swiss artists, while maintaining a remarkable consistency throughout the work.

"We have seen that some of the first generation of Swiss concrete artists came from the Bauhaus (architectural school of Walter Gropius, founded in Germany, 1919) and had, like their contemporaries in Switzerland, contacts with the De Stijl and Abstraction-Creation movements. Many of the younger artists in the movement had a link with either architecture or graphic design, which was highly developed in Switzerland. These links might explain the evolution of Concrete Art in Switzerland."

Suzanne Bollag wrote a wonderful essay in the catalogue for the Swiss Show at The University of Texas, Austin. I found Ms. Bollag to be remarkably well educated in the contemporary arts, insightful, in the Swiss art scene, as well as a great friend to the Clark family. She was a gem.

"As one looks at the products of these thirty-eight artists," Donald Goodall, the museum director said, "one can understand why the titles of their exhibitions not only contain words like 'concrete' and 'kinetic,' but also words like structure, color, light and movement. With discipline, formality, and control ever apparent, the works stir, writhe, vibrate, or gleam like living entities. They also at times seem crystalline-sharp, clean, and clear, reminding one of dazzling sunshine on new snow on the stark mountain peaks of the land that gave rise to them."

Mom and Dad admired Donald Goodall greatly, as well as his wife Gladys. They were all good friends and shared a passion for contemporary art. Their friendship lasted for decades. The fruits of their passion for contemporary art live on.

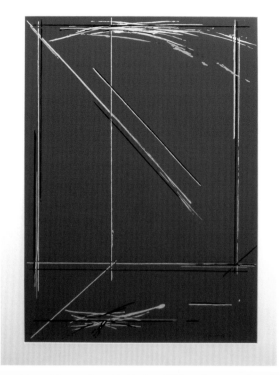

Juhana Blomstedt • *Untitled* • 1979 • Courtesy of IMAS

PERSONAL DEDICATION PRINTS AT UT AUSTIN IN 1976

From December 5, 1975, to February 13, 1976, a very interesting show was exhibited at The University of Texas at Austin. The show was titled, *Personal Dedication Prints, from the Collection of Charles and Dorothy Clark*. I was touched by the kind words written in the foreword by museum director Donald Goodall about Mom and Dad and their personal connection with the artists whose work they so greatly admired and enjoyed. I would like to share Donald's foreword from the catalogue.

"Within the last fifty years the art world has undergone a change. The acquisition and display of works of art has become fashionable; there has been an outburst of the art production by professionals and amateurs in all media; the inclusion of art works in an investment portfolio is regarded as not only sound, but almost a necessity. Even before this change, and certainly since, one hears the accusation that some collectors have depended largely on dealers or critics to guide them in the selection of objects to which they are in no way attached except by the fact of possession.

"In the years that The University Art Museum has been in existence it has been our good fortune to meet, almost without exception, with collectors who have not played such a passive role in forming their collections. On the contrary, they have become scholars and connoisseurs in the areas in which they have specialized. And they also have become deeply attached to their possessions by bonds similar to the most enduring ties of friendship. They are committed and involved, not detached and indifferent.

"Charles D. Clark is one of the collectors who has been personally responsible for his choice of works, even though he would be the first to acknowledge his debt to critics, dealers and artists for a great deal of his knowledge about printmakers, processes, movements in art, and quality in prints. He has attempted to meet artists, visit their studios, learn of their aims and concerns.

"He has visited workshops to learn about printing processes and the problems confronting the printer. Through acquaintance with many dealers and visits to major print markets and exhibitions, he has become further informed. His enthusiasm for the prints he has acquired has little to do with mere monetary value and much to do with the individuality and quality of the objects.

"Mr. Clark's regular and generous gifts of prints to The University of Texas, Austin, Art Museum, would seem to imply a wearying of them, an eagerness to weed out their collection, but such is not the case. After completing the gifts, he visits exhibitions of the prints and talks as enthusiastically about them as he did when he first acquired them. He merely displays, by his gifts, his responsibility to the works and to the artists who created them.

"THE PRINTS DESERVE TO BE SEEN"

"He knows that the prints deserve to be seen by many people, serious people, students and faculty members, those who may not have had the opportunity to see what he has seen, to learn what he has learned. He wants to share, and this desire he has in common with most informed and excited collectors, public or private. Loan exhibition programs depend on the willingness of owners and curators to share their works. The rash of bicentennial exhibitions is testimony to the attitude of American collectors and museums, and also to the willingness to share of foreign governments, museums, and collectors.

"The sharing always involves risk and that fact merely underlines the strength of conviction on the part of lenders, that works of art, in a sense really belong to no one person or group but to all mankind. Museums, in forming their holdings, have in large part depended on the generosity of donors who wish their works to be seen and appreciated by many. Certainly, this is true of The University Art Museum with its gifts from Mr. and Mrs. James Michener, from Mr. and Mrs. John C. Duncan, from Mr. and Mrs. Charles D. Clark, Mr. and Mrs. Robert Straus, and many others.

"The exhibition for Charles and Dorothy Clark is composed of modern prints (and one drawing) by many different artists, from many different countries, of many different styles and many different subjects, of many different processes. What holds them together are their dedicatory inscriptions to Mr. Clark and often Mrs. Clark as well. Mrs. Clark has accompanied Mr. Clark, a complete and equal partner on print-searching journeys, has become informed as he has, and has been a complete and equal partner in the formation of the collection.

"In this introduction, and in the dedications, her name is implied, if not included, beside that of her husband. Mr. and Mrs. Clark's foreword describes to some extent the nature and closeness of their acquaintance with artists. Only a study of the correspondence between Mr. and Mrs. Clark on the one hand, and the artists on the other, can reveal the real warmth of the friendship in many instances. There is often revealed in the letters, a baring of the soul or humorous by-play of reference to conversations about art theory. Some dedications themselves show the depth of attachment of the artist to those collectors.

"Perhaps the bringing together of this group of prints on the basis of the dedications alone seems artificial, inconsequential. On the other hand, the prints indicate the artists' estimate of the prints as worthy gifts, and of the collectors as worthy recipients. The group also reveals much about the collectors, the breadth of their interests, the sincerity of their regard for prints as a form of art. There is a personal tie that binds them together and helps to offset the lack of personality and warmth of which public museums are often accused.

Timo Aalto • *Untitled* • 1979 • Courtesy of IMAS

"The University Art Museum is proud to present this exhibition and honored by the generosity of Mr. and Mrs. Clark, not because it is generosity, but because it comes from them."

Mom and Dad collaborated on the foreword to the catalogue. I will include highlights from it here which I find revealing:

"In the sixties we concentrated our print collecting activities in the New York area and in the San Francisco-Berkeley and Los Angeles area of California. During our visit to the Berkeley campus in 1967, we met Professor Karl Kasten and viewed his collograph plates, which introduced us to a new technique.

"Professor Kasten has since continued to experiment with thermal plastics to form plates for printing. In March of 1972, Karl invited me to come to California to chair the jury for the California Society of Printmakers at the Richmond Art Center and to serve with professor-printmaker, Walter Askin, of the California State College at Los Angeles, and Mr. Stefan Munsing, the distinguished Director of the Art in the Embassies Program for the U. S. Department of State."

Artists exhibited in the *Personal Dedication Print Show* at The University of Texas at Austin, in December of 1976, included the following: Jakob Bill, Max Bill, Bob Bonies, Serge Brignoni, Camille Bryen, Guiseppe Capogrossi, Lynn Chadwick, Andraes Christen, Otto Dix, Piero Dorazio, Walter Gabrielson, Bernard Heliger, Alfred Hofkunst, Asger Jorn, Karl Kasten, Wilfredo Lam, Verena Loewensberg, Priska von Martin, Willy Muller-Brittnau, Jean Raine, Giuseppe Santomaso, Natale Sapone, Slbert Siegenthaler, Toni Stadler, Antonio Tapies, Par Gunnar Thelander, Earnest Trova, Gunther Uecker, Milos Urbasek, and Fritz Wotruba.

THE SMITHSONIAN INSTITUTION ARCHIVES

I recall that shortly after the conclusion of this wonderful show, the Smithsonian Institution in Washington, D.C., sent a large van to McAllen, Texas, loaded up Dad's personal correspondence files, which were extensive, and filled with copies of letters written by dad to individual artists, gallery operators, museum curators, print makers and fellow collectors, as well as their letters of response. They took the files back to Washington, D.C., and transferred them to microfiche to become part of the national archives. The files were returned several months later, perfectly intact and perfectly in order.

This effort confirmed the value the Smithsonian placed on this unique connection my mother and father had with the contemporary art world and the artists who occupied it.

CONCRETE ARTISTS SHOW
AT PAN AMERICAN UNIVERSITY IN 1977

Shortly after the closing of the *Personal Dedication Print Show* at The University of Texas at Austin, in 1977, Pan American University (now The University of Texas Pan American) held a *Selected Print Show of Concrete Artists* in the Learning Resource Center foyer.

Ed E. Nichols, a highly respected instructor of art at Pan American University, organized the show. In the preface to the catalogue he wrote:

"If to collect art is to show an active concern for life, it is self-evident that Charles and Dorothy Clark love sharing the fruits of their art-concerned lifestyle in international collecting. As collaborative collectors, they demonstrate an atmosphere of thought complementary to those values fostered by the university.

"That their tasteful scholarship is complete, comprehensive and respected is recently evidenced by three major survey exhibitions taken from their collections and gifted to The University of Texas at Austin. Those surveys included *German Graphics of the Sixties*, 1974, *Swiss Concrete Art in Graphics*, 1975, and *For Charles and Dorothy Clark (personal dedication prints)*, 1977. Yet, above and beyond the academic, their art

collecting is warmed by personal friendships and creative relationships between artist and collectors and by helping artists and being helped by them in the best humanistic tradition."

AT TEXAS A&I IN 1977

Two more shows took place in 1977 at Texas A&I University, Kingsville, Texas. Both shows included works that had been gifted to the university and were used as a study collection, dedicated to education.

AN IRS CHANGE

My parents continued their tradition of collecting and gifting to museums and universities around the country, often lecturing students and staff with personal stories about the artists, their work, and their approach to their art work. They continued their studies through the end of the 1970's and into the 1980's, until 1985 when the tax law changed relative to gifting.

Dad was the only individual in the Southern United States at that time who had attained investor status, a tightly defined status issued by the Internal Revenue Service. Achieving "investor status," an IRS designation for a special category of art collectors, was reserved for serious collectors. The collectors were then allowed to deduct all their reasonable collecting expenses. They could add those expenses to the cost of collected artwork and the total of the appreciated, retail value of the donated artwork,

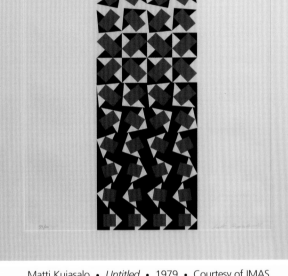

Matti Kujasalo • *Untitled* • 1979 • Courtesy of IMAS

expenses, could be deducted from gross income.

This was critical because the graduated tax rate, up until 1985, went up to over ninety percent. It gave Dad a clear path from the IRS relative to his collecting and gifting. However, in 1985, when the tax law changed, and a collector could no longer write off a gift of art at retail, fair market value. The tax change only allowed a collector to gift artwork at cost, thus minimizing the benefit of gifting, post 1985.

ANOTHER INTERESTING JOURNEY

When the tax law changed dramatically in 1985, Mom and Dad ceased to collect art and began an interesting journey into the world of wine collecting. I was a bit amused by that transition, because I knew that Dad suffered from gout and could not drink wine. He could however, taste it, breathe in its essence, and spit it out, quickly noting its properties.

Dad connected with several prominent wine authorities and writers and traveled on many occasions in their behalf to test California, Oregon, and Washington wines. They would report their discoveries and share their research with the writers. Many of these writers used their research to write articles about wines in prominent wine magazines, with and sometimes without attribution. Mom and Dad enthusiasticly enjoyed the journey and were particularly adept at sniffing out, literally, the best wines in all three regions.

"BIGGER THAN LIFE"

Dad had a stroke in 1987, and he never fully recovered his stamina, which frustrated him greatly. Up until his stroke, I always saw him bigger than life. It was hard to see him with a diminished physical capacity. Other than a short term memory loss, his mind stayed sharp as a tack until his untimely death by massive heart attack on February 21, 1990.

Mom tended to his every need up until that moment, at a complete sacrifice of her own personal life. She was a true angel. She and I grieved together at the loss of Dad. They had been my best friends my entire life. After Dad's funeral at Trinity Episcopal Church, Pharr, Texas, where our family had attended for thirty-three years, Mom began to come down to the office daily for about half a day and helped me with the business mail. She checked the service waiting rooms to be sure that every customer was content. If they were not for some reason, she would remedy the matter without fail. It kept us all on our toes.

A STAR IN HER OWN RIGHT

Mom was called on to lecture about the years of collecting when Dad was at her side. She had a keen memory and a sharp sense of humor. She was grateful for every moment she shared with my dad, her soul mate, over the years. I was too. Now it was incumbent on me to do all that I could for Mom. We began to do automobile ads together, beginning in early 1990's. She was a great actress and we had many laughs on the TV production set. We sold a few cars, too.

Over a period of time, Mom became a local celebrity and was a wonderful spokesperson for our Chevrolet business in McAllen, Texas. I was the pitchman and she was the affirmer. We were always on screen together. Mom wore a different hat in every ad. I would pitch the deal of the month, turn to her and say," Right Mom?", and she would look up at me and say, "Right Son!" She became a star and we sold a lot of Chevys. It was a sad day for all of our family when she joined Dad in 1997.

Bertil Sjoberg • *Night Conference* • 1979 • Courtesy of IMAS

CHARLES CLARK IN MEMORIAM AT UT AUSTIN IN 1991

The University of Texas at Austin produced a fantastic art exhibition in January of 1991. The show was titled, *Charles Clark In Memoriam, European and American Prints Since 1960.* Jonathan Bober was the Curator of prints and drawings at UT Austin. My parents were very fond of Jonathan. We were most appreciative of the effort made by him, Becky Duval Reese, interim director, and Mark Petr, a graduate student who wrote brilliantly in the catalogue of his impressions on the history of my parents' collecting, their scholarship, and their love of art, particularly printmaking.

Dr. Marian Davis, who had formerly played a pivotal role as director of the university museum before her retirement, wrote a wonderful essay for the catalogue in remembrance of Dad. At the time of the *In Memoriam* show, the university announced that its print room would be renamed the Charles and Dorothy Clark Print Room. We were delighted with that kind gesture. It was made even more rewarding because we knew that Jonathan Bober would be the curator of the collection. Mom and Dad admired Jonathan's dedication, his curatorial skills, and his enthusiasm for his work.

Jonathan Bober's essay, *Interpreting the Collection*, made careful note of the passion for prints that my parents shared with the world. He also observed the diversity of interest without adhering to any single master artist or school of art.

ARTISTS INCLUDED IN UT AUSTIN MEMORIAM SHOW

As I look through the *In Memoriam* catalogue, I am awash with emotion. Each illustration of the artists' work brings back memories of their art journey together. In the area of late Modernism, prints from the following artists were shown: Mario Aviti, Alexander Calder, Lynn Chadwick, Sonia Delaunay, Otto Dix, Johnny Friedlaender, Hans Hartung, Stanley William Hatter, Barbara Hepworth, Alfred Hrdlicka, Horst Janseen, Henry Moore, Louise Nevelson, and Stanley William Hayter.

Artists whose works were categorized as Concrete Art and Geometric Abstraction selected for this outstanding exhibit were: Josef Albers, Richard Joseph Anuszkeiwicz, Jakob Bill, Max Bill, Bob Bonies, Gene Davis, Hans Fischli, Fritz Glarner, Hansjorg Glatfelder, Camille Graeser, Gottfried Honegger, Max Huber, Johannes Itten, Verena Loewensberg, Richard Paul Lohse, Ernst Mether-Borgstrom, Paul Osipow, and Frank Stella. In the Cobra and Expressionistic Abstaction schools: Asger Jorn, Pierre Alechinsky, Karel Appel, Peter Bruning, Sam Francis, Carl-Heinz Klehmann, Robert Motherwell, and Bram Van Velde.

The following Pop Art was also exhibited from the collection: Shusaku Arakawa, Robert Indiana, Jasper Johns, Ronald Kitaj, Roy Lichtenstein, James Rosenquist, Wayne Thiebaud, Andy Warhol, and Peter Wunderlich. Representing the field of new German Art were the works of the following artists: Joseph Beuys, Cornelis Guillaume Beverloo, called Cornelle, Karl Fred Dahmen, and Ernst Fuchs.

Also, Johannes Grutzke, Jorg Immendorf, Donald Judd, Gary Kuehn, Sol Lewitt, Joachim Palm, A.R. Penck, Sigmar Polke, Gerhard Richter, Dieter Roth, and Wolf Vostell. Artists represented from Workshop Presses, Im Merker were:

Guiseppe Capogrossi, Piero Dorazio, Hans Hartung, Guiseppe Santomaso, Antoni Tapies, and Gunther, Ueker. From the Workshop Presses, II: Tamarind, Clinton Adams, Garo Antresian, Nathan Olveira, Philip Pearlstein, Fritz Scholder and Steven Sorman.

This was a memorable show, a show of love and appreciation for my parents. I attended the opening with Mom, and we were amazed at the beauty of the show in Dad's memory. We were overwhelmed as a family and most appreciative to Jonathan Bober in particular for curating such a superb show. There was not a dry eye in the gallery. However, they were tears of joy for the memories of a most remarkable, wise, generous, and loving man. We all sensed his presence at the opening. We felt his smile. Thank you UT Austin.

THE ART OF PRINTMAKING

As Mark Petr, graduate student and Curatorial Assistant at The University of Texas, Austin, wrote in 1991 in the preface of the *Charles and Dorothy Clark in Memoriam, European and American Prints since 1960*:

"Modern printmaking had captured the interest of Charles and Dorothy Clark in a wonderful way. Technological advancements were driving the public's interest all around the world. New printing technologies, in particular, advanced the printed image in new and interesting ways. There was literally an explosion of artistic expression going on in the 60's and 70's. This wonderful period of technological advancement put a man on the moon and advanced knowledge throughout society in remarkable ways."

Petr asks, "What message about the concerns of the 1960's does printmaking give us? The process of making a print is a collaborative one, involving the artist and the printers. Depending upon the technique used to make the print, there is the potential of involving a small crew. People must work together, make compromises, and suggest novel

Kees Okx • *Fleur de Nuit* • 1987 • Courtesy of IMAS

university through his collection of prints. The variety of works displayed simultaneously show the unity of human spirit. Art as a cultural process suggests the underpinnings of human thought. In turn, this creates an alternating circuit: we can understand the art through the intellectual stances of the period and the art makes manifest thoughts from which we are distanced by time. Clark's collection offers a cross section of the sensibility of the 1960's and 1970's to those of us who seek to understand the ideas and conflicts that shaped the world immediately preceding our time, and still affect the human environment."

MEMORIAL EXHIBITION AT UTPA IN 1992

The remarkable Austin *In Memoriam* show was followed in 1992 by another outstanding exhibition at The University of Texas, Pan American, in Edinburg, Texas. A great catalogue of the works exhibited in the show was named *The Charles and Dorothy Clark Collection Catalogue.*

The exhibition drew from art gifted by Mom and Dad over the years. It was noted in the catalogue that major gifts of art had been made to thirty-four institutions, along with significant research concerning the artists individually and the schools of art with which they were associated. As Dad said, "When choosing a work of art to purchase, it is always best to select something you like and about which you are knowledgeable."

I certainly share that perspective. Dad had previously stated, "We feel that our involvement with art has added a new dimension to our lives. It has also influenced the lives of our children, Kirk Clark and Robin Clark von Rosenberg, who have joined their parents in collecting and gifting works of art."

Quoting from Sandra Swenson, Editor and Assistant Curator, University of Texas-Pan American, at that time, "It has certainly enriched the lives of many others, not only through the works themselves, but also through the Clarks' example of dedication, hard work, and personal growth."

methods of drawing, inking, printing, and often even papermaking to get the final artistic product.

"Many of the artists in this show participated in such collectives, part of an international revival of the art of printmaking. It does not seem a leap to see such concerns aligned with the quest for unity and collective endeavor that philosophers like McLuhan espouse in order to solve the problems of humanity.

"The encouragement to look and see for ourselves is perhaps the most valuable legacy that Charles Clark left the

STEWARD OF ART WORKS

My parents were facilitators of art knowledge and artists. They spread the word like art missionaries from continent to continent. Their generosity has led me along the same path of stewardship. Dad saw himself as a steward of the works.

He and Mom added value to their collection through their research and insights. Dad took great joy in gifting blocks of prints, along with their research, so that the gifts would become teaching units at the universities and museums who received the gifts. This research and hands-on collecting experience added a special quality to their collecting and gifting.

My parents were such remarkable examples of what can be accomplished on a modest budget. They were inspired by a passionate desire to learn and teach about art and artists, and give something to the community that was of great value. They engaged in a lifetime of work and study that opened doors, created new friends and added quality both intellectually and spiritually to their lives together, to their family and to the larger community, both here and abroad.

Dad was often asked to speak about their collection. I stumbled upon a speech he gave to the Lion's Club of Weslaco, Texas, in 1968, that embraces Dad's feeling on collecting.

"Let me say that my own art collecting activity started quite innocently in 1950 with the purchase of a $25.00 painting. Many dollars and many mistakes later, I seem to have accumulated a rather significant collection of contemporary art. I say mistakes because there have been some wrong choices, and then, my tastes have changed as the years passed by. There have been some successes such as the little known artist who suddenly gains recognition.

"But most importantly, two things have evolved. First, the genuine pleasure I experience in meeting artists, gallery directors and museum people. Secondly, observing the visual arts more completely and understanding better what I'm seeing."

In the closing of his speech, he states:

"Let me finish this talk by telling the story of an encounter with a business friend some months ago. He was visiting in my home one evening and subjected to viewing some pretty far out art, or so it seemed to him. I didn't bring the subject of art up, he did! That gave me an opportunity to get in my licks. A month or so later, I saw him in another city. He said to me, 'Clark, you rascal, you've got me looking at paintings wherever I go and darned if I'm not getting involved!' I sincerely hope I've involved all of you somewhat and you'll start looking too!"

Dad would have made a great curator or museum director, but McAllen was not the place for that during his years of dedication to the arts. He had a fulltime job as dealer/operator of Charles Clark Chevrolet Co., the number one Chevrolet dealership in South Texas. I got to work side by side with him for twenty-one of those years and enjoyed every minute of it. Our coffee breaks were more often spent talking about art than the car business. I truly think it made us both better as businessmen because it added a passion, a different dimension to our work together.

A LASTING LEGACY

Mom and Dad were always learning about art and artists. Art was a fabric that held their attention and fed their passion for new adventures. I am still amazed at the way they grew together over the years, as they made new discoveries and new friends through art.

Through the discovery process, they learned more about each other. I know that I learned much more about them and I think they discovered much about me as well.

I noticed that Mom and Dad related to their art journey slightly differently. Mom particularly enjoyed the interaction

with the artists, in addition to the visual and intellectual stimulation of excellent art. Dad enjoyed the interaction with the artists as well, but he really seemed to enjoy the acquisition phase in particular. He had excellent curatorial instincts as well and took great pleasure in caring for his art treasures.

They both seemed to be able to shift from the art world back to the commercial world with ease. Dad was always aware of the connection between being successful in business and his avocation, art. One could not help but see the car dealer in him during the negotiation phase. He had researched most of the artists in advance, and generally knew more about the artist than the gallery operators he was dealing with. He also was fascinated with the technical details of various printing techniques.

Many gifts of art to over thirty-four museums and universities around the country were made in the late 1970's and up through the 1980's. Our family is most grateful to those dedicated souls who have done so much in those institutions which received gifts of art from the Clark family. Their dedication, thoughtfulness and professional handling of the collections in their care are greatly appreciated.

The Clark family is most appreciative and delighted that students in many universities and museum goers are able to share the story of my parents, and live the joy of the artwork they have gifted enthusiastically. I could not have enjoyed being their son more.

Thomas Luthi • *Licht* • 1987 • Courtesy of IMAS

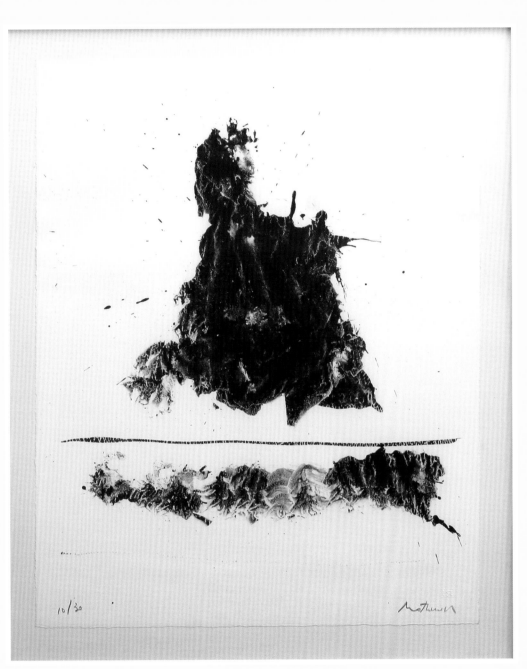

10/30

Robert Motherwell • *Untitled* • 1966 • Courtesy of IMAS

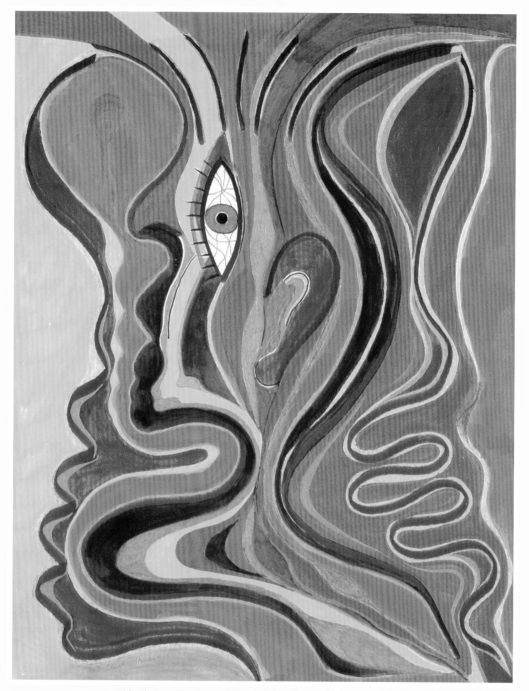

Kirk Clark • *Shockwave 73* • 2004 • Pen and ink • 16 x 12 in.

An Artist's Way
THE SELF PORTRAIT

LEARNING ABOUT LIFE AND ART

I was very challenged by my parent's passion for art, challenged in an inspired way. Frankly, I realized that in the Clark house, you better get with the program, or you might be left behind.

Growing up, I was always amazed at the combination of scholarly investigation Mom and Dad demonstrated along with a remarkable eye for composition, color and line. It was a mutual gift and was a way they shared their love of art with each other, and for each other. Their enthusiasm for the arts and artists set a great example for me and my sister, Robin. It led to many art adventures here and abroad.

I became really interested in drawing around the age of nine. I spent a lot more time drawing than most nine-year-olds. It must have been in my DNA. I can still conjure up the distinctive aroma of linseed oil, which I learned to mix sparingly with oil paint to create a silky quality. It allowed the oil paint to flow smoothly. By the age of ten, I was painting my first oil paintings on canvas board, three of which are in my retrospective show. I mainly attempted landscapes, one of which was a bit on the surrealist side.

My first painting was titled *Lone Cypress*. The painting depicts a solitary cypress tree located on a rock point overlooking the Pacific Ocean on Seventeen Mile Drive between Monterrey, California, and Carmel, two of my favorite places on the planet. The second painting is titled *Fire Fall*. It depicts the ceremonial cascade of glowing embers at Yosemite National Park in California. Somehow, I was able to retain my first two paintings for this retrospective show at IMAS.

These paintings were a beginning point for me as a young artist. I was hooked on art. My life would be touched over and over again by the wonderful legacy of art and artists that coursed through my parent's veins. I recall that I took a few art lessons in my mid-teens and remember that it was a wonderful experience. I loved to draw and paint as a teenager. At this early age, my love for art was in the embryonic stage. I was fortunate that this passion for art ripened in my teens, and flourished in my college years, giving momentum to the development of my artistic talents.

I entered high school in McAllen in 1960. I must admit that I was not a particularly disciplined student. I seemed to do well in the courses I found interesting and did miserably in those that I did not have an interest in. I did do well in my art classes, history, communications, and high school debate.

FIRST ART SALE

I began to feel in earnest in my high school years that there might be an artist inside me. In fact, I remember painting a self portrait, my first, as a junior in high school and entered it in an art competition during the Citrus Fiesta in Mission, Texas, in 1962. My painting, which I named *Armageddon*, took first place in the open painting division.

A lady from a local art league came to me and asked, "How much do you want for that painting, son?" I told her that I appreciated her interest, but the painting was not for sale. She was persistent and asked, "If the painting was for sale, how much would you ask for it?" I said, "I don't know." She was determined and said, "Would you

take $300 for it?" I almost fainted, but gathered myself up and said, "You have a deal."

She walked off with my painting and I stuffed three one-hundred dollar bills in my blue jeans. I was on cloud nine. That was more money in my pocket than I had ever had in my life. Things began to change when I got home and began to think about selling my prize-winning painting. I guess that was about the time I recognized that I had a car guy in me too. That car guy has been showing up every day as well for the last thirty-six years.

That first painting I sold is still memorable to me. It was done in a cubist style, surrealistic in nature, and was characterized by haunting eyes. The painting even haunted me. That is part of the fun of art. You never know how much a work of art that you created is going to mean to you, until you have sold it or given it away.

A STUDY TOUR OF EUROPE

Mom and Dad gave me the opportunity to take a three-week-long study tour to Europe when I was 16. The trip was

sponsored by the National Automobile Dealers Association. I had a wonderful time in England, Holland, Germany, Austria, Italy, Switzerland, France and Spain. Before I left on the tour, Dad gave me $150 and one of his business cards. He said, "I have written the names of galleries that I want you to visit in Paris."

The writing was so small, I had to use a magnifying glass. There were over 100 galleries listed on the back of the business card. Dad told me that he wanted me to visit every gallery he had listed before I spent a dollar on any artwork. I promised him that I would. I had no idea what a task it would be to visit all the galleries. Frankly, I window shopped and put at least one toe inside many of the galleries so I could say to Dad that I had been in all of them.

I remember that the first gallery I visited carried limited print editions by Joan Miró. I carried the image of my favorite Miró through the rest of my gallery visits. I did return to the gallery and purchased the Miró print for sixty dollars.

I also found the work of DuBuffet, a French contemporary artist, to be intriguing and bought one of his prints for thirty

K. Clark • *Kirk* • 1963 • Acrylic on canvas
10 x 8 in.

K. Clark • *Untitled* • 1965 • Acrylic on canvas
18 x 23 in.

K. Clark • *Fire Fall* • 1956 • Acrylic on canvas
24 x 18 in.

dollars. My final selection was a Lynn Chadwick, an English artist, whose print I bought for twenty dollars. When I returned to McAllen at the end of the tour, I carried the works back from Europe in a shipping tube. I could hardly wait to show my parents what I had purchased.

When we got home from the airport in McAllen, I handed Dad his thirty dollars in change, then showed my parents the newly acquired prints. We were all very excited. They were delighted with the prints I had purchased. I breathed a sigh of relief. Today, each of those prints is worth thousands of dollars. The experience my parents gave me in acquiring artworks has proved to be invaluable.

A STAND AGAINST ART CENSORSHIP

My personal works of art at the time were not without controversy. I recall an art teacher my senior year in high school who insisted that artists were never to leave white space on their canvas. She insisted in covering the total canvas area with pigment. As I think back on that rule, I was already doing that, but decided to challenge the rule based on principle, not practice. I created a monster with my arguments, which were logical and non-argumentative.

Her theory applied to painting and printmaking, in particular. I held the view that not all the surface area of a painting or print needed to be covered. I felt that areas could be left neutral, without pigment, creating special areas of interest and curiosity. The teacher became so annoyed by my debate strategy, which was always respectful, that she ended up giving me an F in the art class for the semester even though I carried an A+ average in the art class. She refused to let me take the final exam. I was determined that this injustice would not go unchallenged. I asked for a review by the principal of the high school and he gave me a hearing.

I showed the principal my portfolio that had extensive work in it, four times the required amount of completed art work. I had a few art competitions under my belt by then, in which my work was selected best of show. The principal

agreed that I had certainly exceeded the class requirements. The teacher, who was not going to let me take the final exam, finally relented. I made an A+ on the final exam and an A for the course.

That was my first experience with a form of art censorship. I was very uncomfortable with the censorship, and I am glad I stood my ground while at the same time remaining polite and respectful. It is the first time in memory that I took a stand against an adult other than my parents. I was glad to have my parents' support. The challenge made me think hard about art and what worked and why.

EARLY INTRODUCTION TO THE CAR BUSINESS

During high school, I worked summers at the family's car dealership. I sold my first car when I was sixteen. I had been on the job for two weeks before that sale took place. I doubted whether I would ever sell a car.

My Dad paged me to his office. He told me, "Son, I appreciate the effort you are making to be a successful car person. I know that you are mighty frustrated, inasmuch as you have not made your first sale. I would like to share some ideas with you. First, God gave you two ears and one mouth. Learn to ask probing questions and then shut up until you get an answer.

"Find out what the customer expects to accomplish. Be a servant, and deliver what the customer wants with enthusiasm and gratitude. Relax. Enjoy meeting people. Son, sales people typically respond to customers in one of three ways, with sympathy, apathy, or empathy. Only empathy works in sales. You have to be able to put yourself in the customer's shoes, and then provide a plan of action to satisfy their transportation wants and needs. Good luck, son!"

Dad was right. I practiced listening and asking probing questions. The second day after I visited my father in his office, I sold my first car. I sold fifty-two cars in the next fifty-two calendar days, including that first sale. Thank heaven for

dads. I was the first person to arrive in the morning that summer and the last to leave. I was salesman of the month my first month on the job.

I liked the feeling I got selling cars. I was hooked on the car business. I still feel the same degree of enthusiasm about the car business today, though I have seen our business change dramatically as new challenges have arisen, as well as new challengers.

DAD'S PASSION FOR RESEARCH

During my early to mid-teens I became aware of my father's passion to do research. Dad first began to research German Abstract Expressionism in the 1950's. He taught himself German from an English/German dictionary so that he could research that art movement documented in the German language, which at that time had not been translated into English.

As I look back over the years, and think of those special occasions when I joined my parents in their travels, I never met an artist, gallery operator, museum director, or curator who had anything but favorable things to say about my parents. Once again, I was proud to be my parents' son.

I must admit, however, that I was torn between the great discoveries my parents made in their research and travels, and my desire to create artwork out of my own imagination and experience. As long as I can remember, I have had a desire to create art, art that discovers and reveals knowledge and wisdom of the ages, images that fly through the heavens and under the sea, uninhibited and unconstrained by convention.

When I find myself attempting to take too scholarly an approach, I am compelled to throw in a bit of whimsy and humor as a reminder not to take myself too seriously. We all look at life through the filters of our own experiences, and surely my art-related travels with Mom and Dad had a great impact on me and my art work.

LEARNING FROM THE MASTERS

Mom and Dad taught me many things. One of the most important things was to study the masters in art. As a consequence, I have loved art history and continue to enjoy the study of the masters to this day. They also taught me one of their collecting secrets, to look for the rising artists whose work showed a maturity and understanding of the media, the subject matter, and technique.

They concentrated on the composition of each work, the tone and the statement the work made to the viewer. They quickly recognized the potential in exceptional young artists as discerned by the educated eye.

From my early years as an artist, I had a keen awareness of Michelangelo's work, Leonardo da Vinci, Pablo Picasso, Joan Miró, and many more highly regarded artists. Only occasionally would I attempt to copy their work, but when I did, I came away with a great sense of respect for the masters. It encouraged me to practice, practice, practice. It also made me a prolific artist, always itching to see my completed work, creating a desire to get to the next work as soon as possible.

Kirk Clark • *Untitled* • 1973 • Pen and ink on paper • 19.5 x 19.5 in

Kirk Clark • *I Have Always Loved You* • 2005 • Monoprint • 30 x 22.5 in.

I HAVE ALWAYS LOVED YOU!

I have always loved you.
God loves all his creations.
Mother's love for her son,
father's love for his wife,
brother's love for his siblings,
my love for our family,
our love for symphony music.
Love's greatest reward, love returned.

K.C.

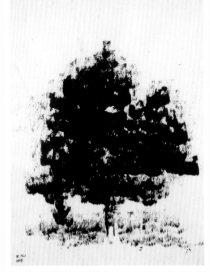

K. Clark • *Secret* • 1962 • Ink on paper
11 x 8 in.

K. Clark • *Untitled* • 1965 • Ink on paper
23 x 18 in.

K. Clark • *Untitled* • 1965 • Ink on paper
23 x 18 in.

The University of New Mexico

As I approached my high school graduation, I became strongly disposed to pursuing at least one degree in the studio arts. I loved New Mexico. I entertained the idea of attending The University of New Mexico because of its excellent reputation as a fine art school. When I found out I was accepted by the university, I was very excited. I had a wide range of academic interests, which included business communications, my second area of major study, and I also pursued minors in English, anthropology and political science.

I entered The University of New Mexico in 1965. As a freshman, I was anxious to get started on my painting career. However, I soon discovered that the university required that I take prerequisite courses in drawing and two and three dimensional design courses before I could take painting classes. I was truly disappointed. I did retain some drawings from that period that are included in the retrospective exhibit.

The University of New Mexico Art Department was most impressive. It had an interesting combination of West Coast art professors as well as the East Coast contingent, not to mention a smattering of New Mexico and Arizona artists.

Even though I never took a painting course at the university. I was very excited about the work I saw being created by my fellow art students as well as the instructors. I knew that I had made the right decision in picking UNM.

THE WONDERS OF SCULPTURE

The Chairman of the Art Department at that time was Charles Maddox, a renowned sculptor from Venice, California. He was a master of Kinetic Art. Kinetic Art is art that moves or has the potential for motion. Often, Maddox would involve the viewer, who would be instructed to stand in a particular place in the gallery. The weight of the viewer activated an electrical circuit, which activated the artwork, which then began to move.

Maddox told me, "Son, I know that you came here to paint. I am a sculptor, not a painter, so you are going to learn how to draw well and sculpt well. When you have proven that you can do those things well, we may let you paint again. In the meantime I am going to teach you about the wonders of sculpture and you may never want to return to the two dimensional plane once you have felt the power of the third dimension." Maddox was inspirational, tough, and energetic.

Maddox influenced me to become a sculptor, as did Steve Dubov, as well as William Goodman, sculptors that I was lucky enough to have studied under and been inspired by during my years at The University of New Mexico.

My transformation from painter to sculptor was not an easy one. My total experience in art up to that point was dealing with the two dimensional plane that a painter utilizes. Dealing in the third dimension had me flustered in the beginning. The volume of objects, and the backside of things challenged me.

Sculpture offered a special challenge for me. At first, the whole idea was more than a bit intimidating. I had been used to working in a confined space on canvas as a painter, controlling the two-dimensional surface with each brush stroke. Sculpture was a different challenge altogether.

Once I got over the initial fear of being a lousy sculptor and focused on exploring my options and developing a style that gave me some hope of success, I got into the flow and could not get enough of sculpture. The sculpture

department was open until all hours, and I was there most of them. My academic studies too often reflected my over-emphasis on sculpture.

MASTER WELDER

While at The University of New Mexico, I had the good fortune of studying under William Goodman, who taught me how to weld. He was a master welder, having worked as a professional welder in the British Navy. He was like Michelangelo with a torch; his creations were beautiful and often massive. He was a wonderful teacher. He was also a printmaker, but his true talent was in sculpture. He was an inspiration to me.

Once I became a competent gas welder, I was on a roll. I loved to weld and felt comfortable taking on more challenging assignments.

I finally decided that working in automobile bumpers was a natural. I found their shapes to be beautiful; their shiny chrome surfaces were an attraction as well. However, when I tried to weld one, I learned how difficult it was. Immediately, as the flame touched the surface of the bumper, I found that the flame burned the chrome off the metal, leaving a nasty black mark.

A LIFELONG FRIENDSHIP BEGINS

It was during this time that I met my dear friend Dick Hyslin, who was working on his master's degree in clay arts at UNM under the guidance of Carl Pak, a world-class potter and clay artist. Dick had been working on his

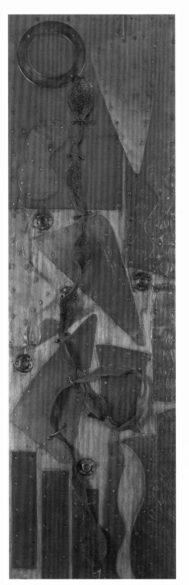

K. Clark • *Temptation in Check* • 2002
Mixed media on metal • Private c.

doctorate in chemistry when he decided that he had to be a clay artist. It was a great decision. No one I ever met had a better knowledge of the chemistry of glazes and clays. The clay art department was next to the sculpture department.

One late night in the sculpture studio, Dick saw me struggling with bumpers, my sculpting material of choice that I was trying to turn into sculpture. He had been there and done that, having studied under Chamberlain, the world renowned sculptor who utilized vehicle bumpers as his sculpture material.

Dick introduced himself and offered to help me get over the technical obstacles I was facing. He showed me how to bend the bumpers without using heat. Once the bumpers had been shaped, mainly with muscle power and leverage, then a minimum of heat could be applied in such a way as to utilize the black lines as part of the sculpture.

I was most grateful for Dick's help. I just wish that the bumper sculptures I created at UNM lasted as well and as long as my friendship with Dick. Unfortunately, the bumper sculptures rusted into oblivion. My respect for Dick as a friend and a mentor has continued to grow over the years.

A fun part of the history of our friendship includes a connection Dad and I made between Dick Hyslin and Rudy Pharis, who was Dean of Fine Arts at Pan American University back in 1969. Rudy was trying to recruit a clay artist, with the knowledge of kiln construction, who could head a clay arts department. Dick came to McAllen with his friend Joe Bova. Joe was a

wonderfully talented clay artist, who went on to become the Chairman of the Art Department at Ohio State University.

They stayed at our house in McAllen while Dick interviewed for the job. Rudy hired him on the spot. I have admired Dick as a friend, artist and successful administrator. I am quite sure that he will continue to sculpt until he can't rise out of a wheel chair. Hopefully, that will be many years from now.

My friendship with Dick has spanned approximately four decades and, I hope, for many years to come. In fact, we were both included in an exhibit at the International Museum of Art and Science in McAllen, in July, 2005. It is the third exhibit in which we both have had sculptures. It is always an honor to show with Dick. I mentioned to him the other day that I thought the work he was doing right now was the best I had ever seen him do. Dick served as the Chairman of the Art Department at The University of Texas Pan American, in Edinburg, Texas, for many years.

BUMPER SCULPTURES AT UNM

I was asked to show the bumper sculptures in various university student shows. One of my sculptures was selected by the university for their permanent collection. That recognition was most pleasing to me. I didn't seem to miss painting as much any more. I enjoyed sculpture, particularly that I could go to the studio any time, night or day, schedule allowing, and work in the University sculpture studio. I was, and continue to be a night owl.

I got to know the local crane operators at the junkyard I frequented. I had an eagle eye, always looking for that one piece of metal on the scrap pile. When I found the piece of metal I was looking for, I would flag down the crane operator, ask him to hold it up a minute. I then would scramble up the pile of metal he was working, and snag the metal object I could not live without. Then the crane operator went on about his business.

There were actually five crane operators who worked at different times, and I got to flag them all down over time. One day, a curious crane operator stopped his crane, crawled out of his machine and walked over in my direction. At first, I thought he was going to take exception to my frequent delays, but quite to the contrary, he was curious as to what I could possibly be doing with these precious scraps of metal. I introduced myself to this hulk of a man, and thanked him profusely for holding up his work while I picked the pile. I told him that I was a metal sculptor, and that I was going to have a show in a few weeks at UNM.

CRANE OPERATORS BECOME SCULPTORS

I invited him and all the other crane operators to the exhibit. Much to my delight, all five came to my art show at the UNM campus. They dropped their jaws when they saw my work.

There were a few ohs and wows. I was delighted. All five of the crane operators showed an interest in becoming metal sculptors. From then on, the efficiency of the crane operators must have dropped off. When they would spot a particularly interesting piece of metal in the pile, they would stop their cranes and scramble for the special find. They set those pieces aside and always let me have my choice before they got theirs.

Three of the five crane operators actually took up sculpture seriously, one becoming a self-supporting sculptor and two others enjoying their new found hobby in their spare time. All five came to my senior show and we had a wonderful time. My fellow art students said, "Where did you get these guys?" I took great pleasure in telling them that these gentlemen were five of my favorite collectors, and supporters of my art. A few of the crane operators purchased several of my sculptures created from metal scrap. The crane operators became fascinated with turning metal scrap into sculpture.

I recall that I did a bumper sculpture for the owner of the junkyard, and he greatly appreciated it. It did occur to me how fine the line is between a successful sculpture and a stack of random junk.

TAMARIND INSTITUTE AT UNM

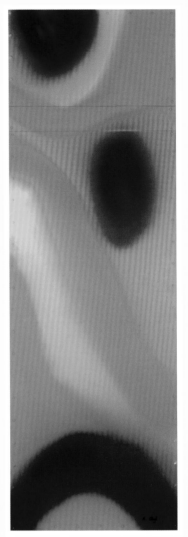

Kirk Clark • *Northern Lights* • 2002
Mixed media on metal

The Tamarind Institute was established to produce the finest prints, lithographs, etchings, serigraphs, and other printing techniques. June West was in charge of Tamarind's West Coast division, and Garo Antresian ran the Tamarind Institute's printmaking operations in Albuquerque at The University of New Mexico, where he was an art professor.

Tamarind had an excellent reputation for technical expertise and many of America's finest artists and printmakers utilized its excellent facilities. The Institute made a huge contribution to the Art Department. Until this day, I have no recollection of why I never took printmaking in college. In retrospect, this was an opportunity lost.

as well as some pencil drawings that appear in the 2006 retrospective exhibit at IMAS.

I could not find one of my best works, a self-portrait, drawn in pencil, using the cross-hatch method. I used a mirror to draw my face. It was the first time that I had done that, and it was more than a bit weird. When it was completed, however, I knew that I had captured that moment and could relate to the drawing in a very personal way.

AN INVITATION TO STUDY IN JAPAN

Three weeks before my graduation, David Kung, one of the owners of the Kiko Gallery in the River Oaks section of Houston, called me and made me an enticing offer. Mr. Kung had visited my parents at our home in McAllen. It was on one of his first visits that David spotted several sculptures of mine that were displayed in our home.

He proposed that he would sponsor me at the graduate level, studying under some of Japan's finest sculptors for a period of five years in Japan. He would pay my tuition, and a small stipend as well as providing room and board. The catch was that I would have to give him fifty percent of the profits from the sale of my work for ten years. I found out that was the deal he worked with some of Japan's outstanding young sculpture students. He always had three or four Japanese students living above his gallery in Houston, studying sculpture at Rice University and The University of Houston.

I didn't take the deal. It finally came down to simple economics. I couldn't make it work financially. I also was not sure that I could learn the Japanese language quickly enough. I was afraid too, that I would be miserable if I could not adapt to the Japanese way of life.

I did not make my final decision, however, until two days before my graduation from UNM. I have always wondered what my life might have been like if I had I made the decision to take

I have very few regrets about my course of study in the arts, other than my failure to avail myself of the training offered at the UNM print department, directed by Garo Antresian. I do, however, think that I made some remarkable strides in sculpture and art history studies. It was something I needed to do. I am delighted that I retained a few of the pen and ink studies from that time,

David Kung's offer. It certainly would have provided a different slant to my sculpture. I continue to wonder what my life would have looked like if I had studied sculpture in Japan.

I have never lost my curiosity about the Orient. I have been drawn to the wonderful artwork from China, in particular. I am also fond of writing poetry in the ancient Chinese style called bagua, which utilizes eight lines with five words per line. I often write baguas about my art and place the poetry amongst the art works at my shows. Many of my art themes have a scientific bent, and I find that the poems provide a valuable context for my art work.

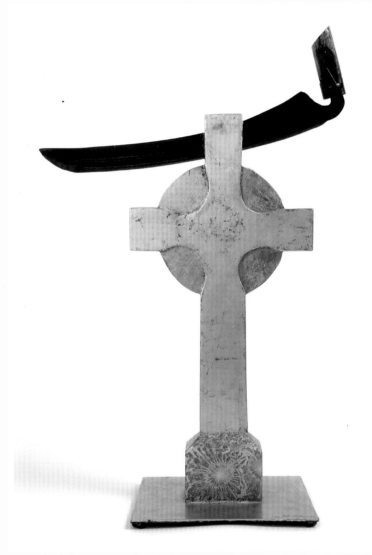

Kirk Clark • *Harvest of Souls* • 2004 • Sculpture, wood and steel • 43 x 26.5 in.

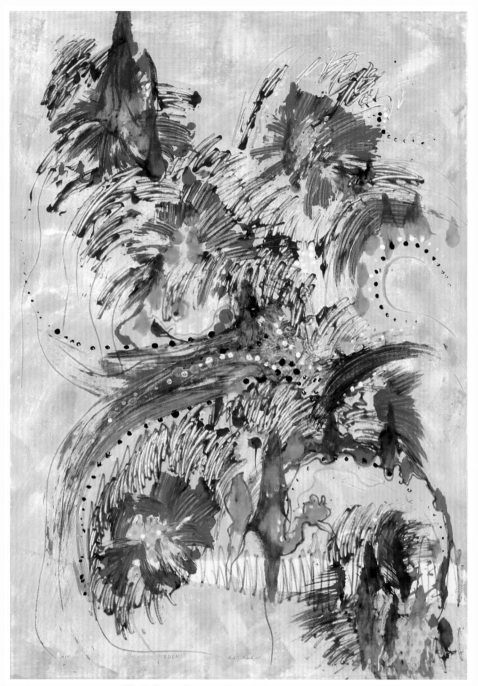

Kirk Clark • *Eden* • 2004 • Monoprint • 44 x 30 in.
Private collection, McAllen, Texas

Business and Art – A Good Combination

STARVING ARTIST

I enjoyed The University of New Mexico very much, but I could never figure out how an artist could make a living creating art, unless the artist was very gifted and knew how to market the work or was represented by someone who could. I do know artists who are eminently successful monetarily, but they are few and far between. They are the exception and not the rule.

After working with Charles Maddox and William Goodman, in particular, I gave some thought to becoming a full-time artist. I never could get over the fear of being a starving artist, however, and never regretted the path I took as a businessman/artist. If the truth be known, most artists fear rejection of their work. I must admit to being one of them, although I have toughened up a bit in recent years.

In time, I came to appreciate how my father was able to put in a full day's work at the car dealership and still come home at night and spend hours studying art and artists. I finally decided that there was no reason that I could not do both. I decided that I really wanted to work at Charles Clark Chevrolet Company in McAllen, Texas, with my father and continue to create art in my spare time. I got to enjoy the best of both worlds and work with my father, a man that I adored and admired greatly. I also enjoyed Mom greatly. She was my angel and still is today.

After my college graduation, I went to work for Dad in January of 1969, which continued up until his untimely death in early 1990. I had graduated on a Friday, mid-year, 1969. The following Monday, Dad gave me the opportunity and challenge of becoming the Used Car Manager.

Little direction was provided to me. The college boy was supposed to show his dad and his associates what he had learned in college. It is not very often that used car managers are mistaken for artists. I guess one could say that I may have broken the mold. The first six months on the job were very stressful. I finally got my confidence up and avoided getting the dealership into too much financial trouble. The department did operate in the black, thankfully.

A NEW USED CAR MANAGER

Sometime between 1971 and 1972, Dad needed a new car manager and said to me, "Son, you are now the new and the used car manager, until such time as you select a replacement for yourself as used car manager." It just so happened that I contacted my dear friend, Trev Sparks, who was teaching business at Texas A&I University in Kingsville, and asked him if he wanted to become our used car manager. He had grown up in the used car business. His father, R.T. Sparks, had helped me learn about the used car business in the critical months following my graduation from college. I was most grateful to R.T. and felt sure his son, Trev, would prove to be invaluable.

Trev was invaluable as the used car manager at Clark Chevrolet. We very much enjoyed working together for a number of years until such time as he joined his father, R.T., at Moxie Motors, a successful, independent used car and truck sales operation, just down the street from Clark Chevrolet, which he continues to operate successfully today. We both learned a lot from our fathers. Trev continues to be a wonderful musician, writer, and successful independent used car dealer. He is one of the most talented individuals that I know, artist, photographer, musician and poet. I value his friendship and support.

THE PERFECT LOGO

In 1974, I became fascinated by the front cover of the LSU art catalogue. It was essentially rectangular in dimension, with

the upper right hand corner and the lower left corner in black, and the rest of the front cover in white. In the lower right hand corner was the Clark name printed four times into the shape of a square, in black letters on a white field. I thought it was beautiful.

The more I worked with the name Clark, the more it seemed to naturally evolve into the logo I had been looking for. I took my sketches to a local artist, who specialized in logos, and asked him to align the name Clark, repeated four times in a square, so as to make the L's line up in such a way as to make a Swiss cross on the inside of the logo.

He did a wonderful job, and I truly believe that there is not an automobile dealer today that has a better logo. It occurred to me that Louis Chevrolet, the founder of Chevrolet Motor Division, was Swiss. It seemed to me that the Swiss cross that formed inside the logo was remarkably powerful. I had the logo designer put a Chevrolet bow tie in the middle of the Swiss cross and there we had it.

The four-sided Clark name, with the Swiss cross and the Chevy bow tie in the middle, was symbolic of the total commitment the Clark family had made to Chevrolet. That simple logo has worn well with me over the years. It has served as a lesson that there is no substitute for excellent design.

I LIKE MY DAY JOB

Working with Dad was a blessing, both from the business standpoint and the artistic standpoint. I remember that every day we would make a mail run to the post office after we went to have coffee at the Fairway Motel, on the South side of McAllen across from La Plaza Mall. We did talk about business from time to time, but mainly, we talked about art and artists. We shared our passion for the automobile business and for art.

Only one time in twenty-one years of working together did Dad and I have an angry argument. We argued about my recommendation to increase our used car inventory. I did not

clearly understand at the time that you needed cash to expand used-car inventories. I stormed out of his office because I was not getting my way. I got about thirty feet from Dad's office, turned around to go back to apologize to him for my insolence, and as I turned around, there was Dad coming after me to apologize. We gave each other a big hug, and agreed to never let that happen again. It never did. It was such a blessing to learn from and share life's interests with my parents. My good fortune in both areas was the luck of birth. I'll take it. Thank you Lord!

As I look back on my choices for a career I am content. I chose to be a businessman and an artist. I like my day job. I also like my night job as an artist. I have only been in the automobile business for thirty-seven years. I have been an artist for fifty years. I have much to be grateful for.

When my fellow artists finally stop saying, "Don't give up your day job," I may begin to believe there is a second career for me as a full-time artist, some day, but not as yet. I have all the respect in the world for artists who are so good at what they do, that they can make a comfortable or even an outrageously grand living through their art work, exclusively. Hopefully, some day I will have the opportunity to experience that artistic independence.

FUN TO WORK WITH

As a youngster, I was fully aware that Dad took the automobile business very seriously. He took his passion for art seriously as well. He had served as guest curator in 1975 at The University of Texas Art Museum, and he would have made a fabulous museum curator or gallery operator had he been in a larger market. As it was, he made the best of his business expertise in the automobile business and distinguished himself in every aspect of the business.

He was able to utilize much of his business knowledge in the art world as well. He was fun to work with and also fun to watch in the art world. I know that Mom also flourished in both worlds. Dad's remarkable attention to detail and his

disciplined record keeping held him in good stead. He kept meticulous records.

LED BY GOD'S SPIRIT

A sense of anticipation pulls me forward daily in my quest for the best art work I can create. Each work is approached with both anticipation and wonder. This desire to create keeps me advancing in my work and in my art.

My college years were particularly formative in that regard. Instruction at the hands of Charles Maddox, William Goodman, Stephan Dubov, and Dick Hyslin, all sculptors, was

a blessing beyond belief. I am grateful to them and many others. I still think it is rather ironic that I was in an art department headed by Garo Antresian, one of the movers and shakers in the Tamirand Art Institute, and I never took a printmaking course while I was attending The University of New Mexico in the mid to late 1960's. What a missed opportunity!

I am most grateful to my Maker for reconnecting me with my art in 1999 after a long hiatus. I do feel as if my creative spirit is being led by God's spirit. I hardly ever sit down to draw something I already have in my mind. Usually, I get a feeling, a compulsion to draw, paint, print or sculpt in metal or stone.

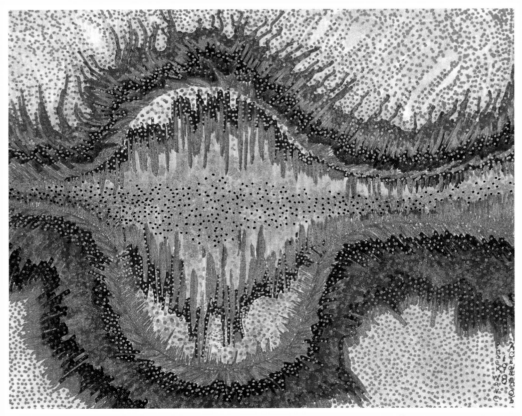

Kirk Clark • *Shockwave Series* • 2005 • Pen & ink on paper • 8 x 10 in. • Private collection, Houston, Texas

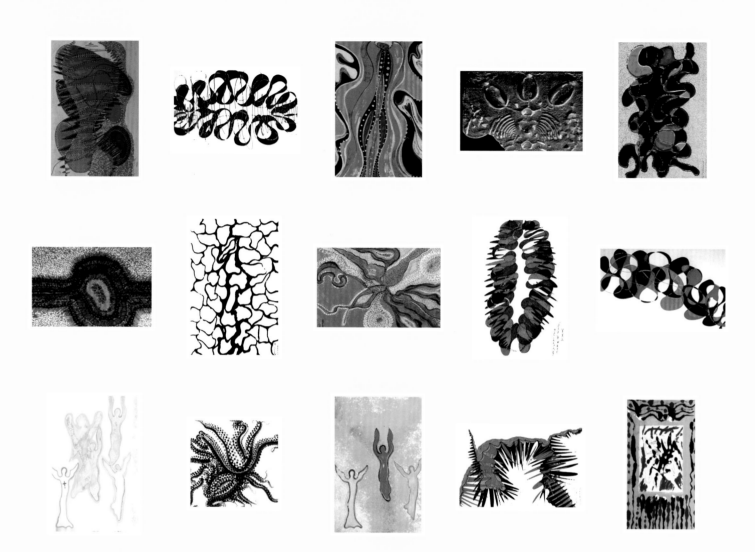

Kirk Clark • Various works and media • 1964 - 2005

Varied Approaches to Art

EXPLORING ANCIENT CHINESE POETRY

In the mid-1990's, I wanted to push myself out of my comfort zone by learning to do something that was difficult for me. I decided to take a fiction writing course at the Taos Art Institute given by Professor William Melvin Kelly. Bill was a literature professor at Sarah Lawrence University in New York. We were a real match, Bill and I. I thought to myself, Kirk, it will be a miracle if you can find a way of relating to this guy. By the end of the week, we were best friends. He is the author of *A Distant Drum*, a fictional portrayal of life in Harlem.

Professor Kelly taught me to write in the ancient Chinese bagua poetry style. Bagua is also a form of martial arts whose movements are based on the mathematical principles that guide the poetry. The utilization of eight lines, with five words per line, equals thirteen elements. The number thirteen in Chinese means "enlightenment."

The Japanese study of Fung Shui seems to be based on the mathematical principles of bagua. An eight-sided mandala is used in the practice of Fung Shui. The primary reference point is due north. On the inside of the eight sided mandala are Chinese symbols representing the five revered elements: water, earth, metal, wood, and fire.

The relationship of the revered elements to the eight directional sides of the mandala, determine whether or not there is harmony or disharmony. I find that there is real magic in the formula relative to poetry writing.

Our first assignment in Professor Kelly's class was to keep a daily diary. Each night we were assigned the task of reducing the daily journal into nine lines, with no more than twenty words per line. We then had to reduce the 9 x 20 down to a bagua, 8 x 5. We then had to further reduce the bagua down to a 3 x 3, three lines with three words per line to summarize our daily diary entry. We did that exercise every night we were in class, which lasted a week.

It took me three days before I wrote my first bagua. I had been writing ad copy for many years prior to taking the class. I used iambic pentameter to time my commercials. I tried to write baguas to the same rhythm that I was used to. It did not work for baguas. I had a blast in the class, and I love to write in the bagua style today. I have written at least a thousand baguas about a myriad of subjects since that course.

AN IDEA COMES – POEM OR ART?

Sometimes when I sit down, an idea comes to my mind and I feel compelled to flesh it out. Sometimes it wants to be a poem and sometimes it wants to be an artwork. I don't fight it. If it wants to be expressed as a poem, I write a poem. If it wants to be a work of art, I make it a work of art. When I am in Taos, New Mexico, for concentrated creative sessions, I will normally write a poem a day or complete a drawing, sometimes more, but rarely less. I seem to find my center and my comfort there.

I pray each day for guidance and forgiveness for my sins in thought, work and deed. When I complete that prayer, I am often compelled to write or to start an art work. If the idea chooses to be an art work, I imagine sitting in a comfortable couch at one end of a dimly lit, cool room with a white sheet stretched from wall to wall and ceiling to floor. I breathe deeply and slowly and clear my mind.

Moments later, I will sense that someone or something is pressing on the taut sheet from the other side. I also get a sense of the direction of the impression. My pen goes immediately to the spot on my drawing pad that replicates what I saw on the sheet. I start moving the pen in the direction

indicated by the pressure on the sheet. Then I let the pen fly, allowing it to take me where it wants me to go, much like automatic writing.

When the abstract sketch is complete, I take a few minutes to study the result. I begin to feel the nuances of the drawing and try to be receptive to the colors that seem to want to be in different portions of the drawing. The less I try to force myself to figure it out, the better my intuition is about what it wants to become. I have the last three drawings that I have done over this weekend in front of me on my desk. As I look at them I am surprised by what I see. They have several things in common. They are pointillist, curvilinear, organic, and galactic all at the same time.

TO TAOS WITH DAUGHTER ANNE

I must give my talented daughter, Anne, then a student at North Texas State University in Denton, Texas, a hearty thanks for suggesting a few years ago that I join her in an advanced sculpture course. It was conducted in Taos Canyon by the vice-chairman of the Fine Arts Department, Don Shoal, a wonderful wood sculptor.

This was the first of two courses I took with Don in separate summers. We stayed at a place called Shady Brooke Retreat, almost half way between Taos and Angel Fire, New Mexico. Shady Brooke was owned by a couple who knew Don. It was a hippy hideout in the 1960's and 1970's and was full of character. There were a few geezers like myself taking the course, but most were art students from North Texas State. It was interesting and a lot of fun.

Anne and I were a bit like the tortoise and the hare. I got up early; she got up late. I started my project early and finished late. She started late and finished early. She seemed to adhere to the adage, measure twice, cut once. I found it hard to believe what a fabulous outcome she created. She is full of talent and I enjoyed watching her work. She is quick and precise. I remember that one of our projects was to create something out of a habitat that we selected. We were to use as many natural materials from that area as we could. Naturally, I had to make a Wal-Mart run to pick up a bunch of yarn.

A PAIR OF ASPEN TREES

I had spotted two very large aspen trees, which stood about fifteen feet apart. They were located about twenty feet from a stream that ran in the bottom of the canyon across the road from Shady Brooke. The thought came to me that these two trees had grown up beside each other for over thirty years, side by side. I wondered if they were aware of each other's presence. As I sat between them, I wondered what these two aspens would say to each other if they could speak.

That's when I came up with the idea to weave a large fifteen foot by ten foot spider web, tying the web to the branches of the two trees and creating totems to hang in the web. The totems would represent the stories that the two aspens would have shared if they could have spoken. It was great fun, and I felt that the two aspens were delighted to connect to each other for the first time in thirty years. I haven't told that story to many people over the years, for obvious reasons, particularly my automobile dealer friends who already find me to be a bit on the eccentric side.

Anne asked if she could borrow some of my yarn for her project, and I gave her what she needed. An hour later, she came looking for me and she took me to her project site. She had found a site at the stream's side about ten feet by fifteen feet, with a stand of six foot tall trees, with thin trunks growing inches apart from each other. She had gathered the young trees together at the five foot mark and gently tied them together, creating live cone shapes. She had modified the environment beautifully and changed a beautiful spot in nature into a wonderful sculpture garden in a very short period of time. I think you can tell that I am very proud of her personally and of her art work. She has a great deal of talent and I always look forward to sharing art projects with her. She is the real art talent in our family.

I am very grateful to Anne for insisting that we take the sculpture courses together in New Mexico. It not only reconnected us as daughter and father, but also artist to artist. From the time Anne was two and a half, I knew that she was an artist. At that early age, she was putting colors together that were remarkable. She still does. I guess she has it in her DNA, too.

THOM WHEELER AND SAND-CASTING

While in New Mexico for one of the summer sculpture classes, I drove by an interesting gallery/studio owned by Thom Wheeler. I stopped in to look around and was taken aback by

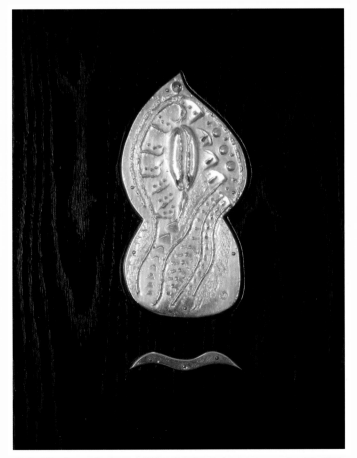

K. Clark • *Shockwave Sculpture* • 2004 • Sand-cast aluminum on oak • 18 x 13 in.

the beautiful home, a two story adobe castle, designed and constructed by Thom Wheeler himself, with a lot of help from his fellow artists.

Over a period of time, Thom and I became good friends. He invited me to come back and work in his studio and foundry. I began to do sand-casting for the first time in years and loved the process. I began to progress very quickly, working with Jim, a foundry worker with twenty-five years of casting experience, and Thom. His mentorship has been most generous and is greatly appreciated by me.

Our casting sessions are fun beyond belief. I really do not think much about what I am going to do in the sand-casting process as far as creating an image. I just lay out all the tools and found objects I think I might use. When I start, I start in the moment and move very quickly through the process. I always feel like an expectant father before Jim pours the molten metal into the sand mold. After the pouring, the casting needs to cool for a bit. Then, the sand is gouged away from the casting, and there is the first look at something that has never existed before and will never exist again in exactly the same way. Casting is great fun from the artist's perspective. I love making impressions in the sand.

PRINTMAKING

Thom suggested that I meet Michael Vigil, artist and master printer. I did so and arranged to begin to learn printmaking at his print shop, Graphic Impressions in Taos, New Mexico.

I am coming to believe that printmaking may be my best media. Time will tell. I find printmaking, particularly monoprints, to be very rewarding and fun. I certainly don't know enough yet to know what I can't do.

I am deeply involved in printmaking today, working with Michael in Taos as frequently as I can. Sometimes, I look at Michael, who is standing patiently by while I am creating, and I see him wince. I guess I started the process from the perspective of a sculptor, bold, unafraid and filled with great

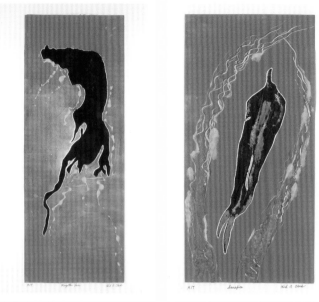

K. Clark • *Forgotten Love* • 2003
Monoprint • 40 x 20 in

K. Clark • *Sacrifice* • 2004
Monoprint • 22 x 12 in

anticipation, but lacking a background in printmaking. I always look forward to my next printmaking session with him. I just wish that I had started earlier.

Recently I received an e-mail from the owner of a graphics studio in New Mexico, where I was having my first Geclees printed from original monoprints. Jack, the owner, told me that he had never encountered the phenomena he was dealing with in my prints. He described the quality of the colors that I used in my prints as luminescent, and he wasn't sure he could begin to capture it, or do it justice, even though he had the most sophisticated scanners and printers. I told him I thought it might be due to Angel dust. Could be! That is where the spirit-led nature of my work is leading me.

Time allowing, I am hopeful of working with Leonard Brown, a master printmaker who is a print instructor currently at The University of Texas Pan American, in Edinburg, Texas.

PAINTING ON TILES IN MCALLEN

One evening, I was driving North on 10th Street in McAllen, and I noticed a familiar car coming my way. DeAnna Garza and her husband Roy, were driving past me. They waved to me to follow and I did. They were meeting Michele and Cody Sparks for an evening of painting and wine and asked if I would like to join them. I never turn down painting or wine, so I accepted their invitation enthusiasticly.

They led me to Colors and Clay, a delightful store where you could paint ceramic tiles and molded objects of various shapes and prices. The employees at Colors and Clay would fire the work in a kiln after the painting was completed on the ceramics. I loved it and started on my first tile. I painted an underwater creature or two, and found it much to my liking. Needless to say, I became a regular customer.

One day I was painting on a six inch tile and a small voice in my head said, "Put that tile aside and put a new tile in front of you." I did. I dipped the tip of the handle in a small puddle of black glaze and placed a dot slightly above dead center of the tile. My next dot went slightly higher at a thirty degree angle to the right of the first dot. The third dot was to the left of the first dot at a thirty degree angle. This formed a V of sorts and I returned to the upper, right dot and continued to make a curved line that looked much like a seagull's wing. I did the same thing on the left.

Now I had created a shape that looked like a seagull flying straight toward me. One of the wings seemed to have a bit more of an arch to it, so from the first dot at the bottom of the V, I made a series of dots that curved downward to the left and then back to the right. Then it hit me, this is beginning to look a bit like a crucifix. I then made a circle of dots at the top, representing a head. From the head I made lines of dots upward, as if to portray an aura. Bingo. I had just painted my first *Atomic Jesus*. I thought to myself, wow, how did I do that?

A BURST OF LIGHT

The answer was clear, but I felt a bit uneasy about where this was headed. I began to re-read about Christ's crucifixion, and began to contemplate the compression of time between the micro-seconds before Christ's death on the cross, the exact death moment, and the exact moment following death. Ever since I was a little boy, I had imagined that at the death moment of Christ, there was a burst of light as the soul left the body and returned to the Father in heaven.

Then it hit me. I had created with considerable heavenly assistance a symbol of that compression of time between life, death and after life. As I contemplated the atomic nature of all of God's creations, I asked myself, "What separates mankind from all the rest of God's creations?" The only answer that came to me was "Spirit." I referred to the Bible to see how it described spirit.

Most of the time, I found that spirit was described in the Bible as "Light." As stated in John 8:12, Jesus spoke again, saying, "I am the light of the world. Whoever follows me will not walk in darkness, but will have the light of life." I began to read about and study the dual nature of light, both its particle and wave-like nature. I read about the Heisenberg Uncertainty Principle and a very curious discovery.

If a scientist were determined to prove light's particulate nature, light seemed to sense that and would reveal itself more often than not as a particle. Conversely, the scientist that tried to prove light's wave-like nature was also rewarded. Light would disclose itself, more often than not, as a wave.

I pondered, "Is this how the power of prayer works in a Quantum Physical Universe?" I do believe that it is. As stated in Proverbs 23:7, "For as he thinketh in his heart, so is he," I believe may be one of the most powerful revelations given to us in the Bible. I was discussing this theory with Thom Wheeler on one of my visits to his studio. He told me, "It sounds to me as if you have discovered the *Atomic Jesus*." I thought, "Wow, that really fits."

PAINTING IN THE POINTILLIST STYLE

I did most of my painting in the pointillist style, carefully making dots with the bristle portion of the brush, no easy task. One Saturday morning, a school teacher walked by and she saw me struggling to make round dots. She said, "You know there is a lot easier way to make those dots." I said, "Oh, please tell me." She said, "Turn the brush around and use the rounded tip of the handle of the paint brush."

It worked like a charm, and I have been flying with that technique ever since. It started a series of painted tiles called *The Universe Below*. I don't know why I began that series, but I am glad I did. It led me to other series that compelled me to explore God's creation of the universe, and engage the Big Bang Theory.

SATORI MOMENTS

Satori, is a Japanese word that stands for "instantaneous enlightenment." Those satori moments are ones that seem to come out of the ether. I often ask myself why I didn't think of that before. More often than not, the answer is that I was not ready for that enlightenment before I received it. I would have to say that all of my art series thus far have started out as satori moments, moments that are spirit-filled. It has been great fun to grasp at these concepts and develop them in line, space and color.

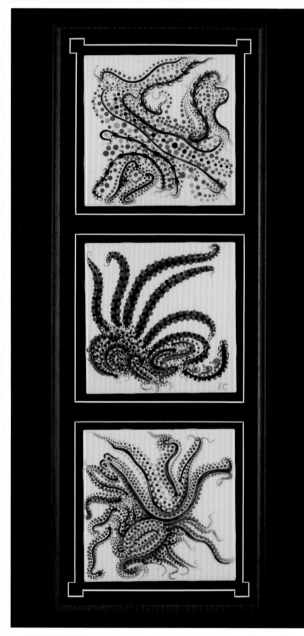

Kirk Clark • *Tidal Pool* • 2001 • Acrylic paint on ceramic tile • 20 x 10 in.

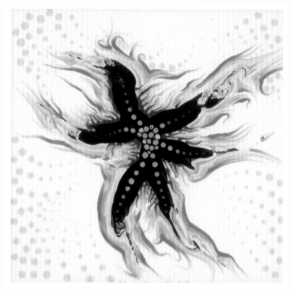

Kirk Clark • *Untitled* • 2001 • Acrylic paint on ceramic tile • 6 x 6 in.

FILL THE SPACES

Look through the telescope or microscope.
Study universe and algae bloom.
Feel the similarity of creation.
Patterns of chaos divinely given,
emerging and declining, life changing.
Colors, shapes ebb and flow.
Fill the spaces between atoms
With your consciousness, spirit filled.

K.C.

Shows and Exhibits

ATOMIC JESUS IN TAOS

After I had created a significant body of work in Taos, Thom Wheeler offered me a one-man show at the Zane-Wheeler Gallery on the plaza in Taos, in February, 2002. The show was titled, *The Atomic Jesus*, which I knew would be more than a bit controversial. It was a huge success, with hundreds of guests. I am most indebted to Thom, who continues to be my mentor and friend.

THE UNIVERSE BELOW IN MCALLEN

My second major one-man show was on September 16, 2002, at the South Texas Community College (now South Texas College) art gallery, in McAllen. When I was shown the gallery for the first time, I was very aware that the gallery had served as a classroom, and its concrete block walls were stark as a jail cell. Jeri and I were delighted to fund the creation of a beautiful gallery transformation before my show.

That show was called *The Universe Below*. I attempted to capture a view of outer space through the Hubble telescope and compress it with a view of snorkeling over a coral reef. The concept behind this is that images that we see in outer space are also seen in and around a coral reef. The underlying theory is that wherever creation is observed, God is present. I am fascinated by the fractal nature of the universe and its beauty.

I wanted to create an interesting ambiance in the gallery to achieve a total environmental sensation. I added the sounds of creatures under the water in the Antarctic. I also aspirated essential oils into the gallery to provide the presence of an unusual fragrance which I thought would add an element of surprise that would not be expected by the viewers. Richard Smith, an artist and instructor at STCC, was instrumental in renovating the gallery and

hanging my show. Richard is an accomplished artist in his own right.

The Universe Below show was very well received. I was most appreciative of the excellent catalogue that Cody Sparks created for this show. I also wrote a series of bagua poems for the show to explain the concepts and add a dimension that made the show unique. The turnout and acceptance of the artwork were rewarding.

AT UTPA DURING ITS 75TH ANNIVERSARY

Not long after *The Universe Below* show came down, I was invited to have a show at The University of Texas Pan American, in Edinburg, Texas. This show was going to be part of the 75th anniversary of the university, which was celebrated in 2002. We decided that it would be an excellent opportunity to show selected works that my deceased parents had gifted to the university over the years, work done by my daughter, Anne, paintings, drawings and aluminum sculpture, along with a variety of my work.

The show was held at the Charles and Dorothy Clark Gallery. It was a gratifying experience getting to see so much of the artwork my parents had collected and gifted to Pan Am, alongside the work Anne and I did. There was definitely a connection between the works. It was a great evening.

STC WITH AMADO PEÑA

I have been invited on two different occasions to exhibit my work with Amado Peña at South Texas College in McAllen. Peña graduated from The University of Texas, Austin, and has established himself as a successful artist. Amado is also one of the most generous people I have ever known. I have been most fortunate to be invited by him to Albuquerque twice (2004 and 2005) for his *Legacy Art Extravaganza*, which raises

money through the sale of donated art for scholarships for native American young people so that they can attend St. Pius Catholic School in Albuquerque.

ART AND POEMS SIDE BY SIDE AT UTPA

In June of 2004, I participated in my first Poetry Art show at the University Gallery at the University of Texas Pan American. Dr. Steven Schneider, Chairman of the Department of English, invited me to participate in the show with his lovely wife Reefka. The show consisted entirely of works of art and poems side by side, in the tradition of "Ekphrasis" that I learned about from Professor Schneider. His wife, Reefka, does marvelous figurative drawings as well as paintings, and he has written a compelling series of poems about her artwork.

It was an unusual opportunity for me to hang my baguas beside my artwork, and the show proved to be both educational and fun. In the summer of 2004, the three of us participated in another exhibit at the South Texas Literary Festival held at the International Museum of Art and Science in McAllen. I was delighted to partner with the Schneiders for both of those shows.

THE ANCIENT ONES

On December 11, 2004, I had an exhibit titled *The Ancient Ones*, at the Michael McCormick Gallery, in Taos, New Mexico. A highlight of this show was a performance by Michael Vigil's wife, Tanya, a world-renowned native dancer, and her fellow dancers, who dance in an ancient Aztec style that is out of this world. Tanya surprised me further by inviting a Navajo Shaman, Blackfeather, to bless the show. He lit a ceremonial punk of chamisa. With a sacred cluster of eagle feathers, he fanned the smoke around me, my wife Jeri, and our guests. The smoke rose among the works of art and provided a wonderful ambiance. It was a very special show for me. Thom co-sponsored the show with Michael McCormick.

THOMAS MASTERS GALLERY IN CHICAGO

The highlight of 2005 was a show at the Thomas Masters Gallery in Chicago, on December 9, 2005. It was an international invitation to artists, with twenty-seven artists from various countries participating. The show was titled, *Blue*. Artists were asked to submit a total of four 6x6 masonite boards using specifically the color blue. The show was very well received by the Chicago art community and critics.

Peter Dabrowski, PhD, a music professor at UTPA and symphony conductor for the Rio Grande Valley Symphony in South Texas, was instrumental in my inclusion in the Chicago show. I am most grateful to Peter, whose work has inspired me greatly and whose friendship and support are treasured.

Kirk Clark • *Shockwave Sculptures* • 2003 • Sand-cast aluminum • Varied dimensions

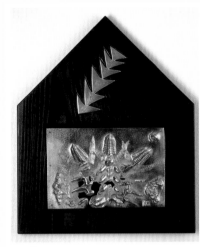

K. Clark • *Shockwave Sculpture* • 2004
Sand-cast aluminum on wood • 22 x 18 in.

Kirk Clark • *Womb of Madonna & Sacrifice* • 2003
Sterling silver jewelry • Varied dimensions

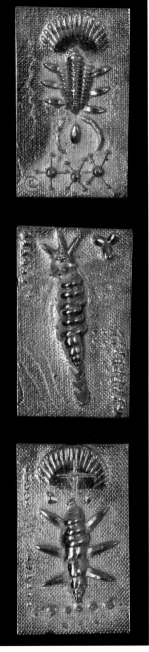

K. Clark • *Shockwave* • 2003
Sand-cast aluminum • 7 x 4.5 in. ea.

SHOCKWAVE

The big bang initiated creation,
resonating throughout the heavenly void.
Searing heat created optimal alchemy
for atomic creation, heaven made.
Shock waves radiate from source
setting the stage for formation
of elements, transforming into matter,
revealing God's creative atomic origins.

K.C.

Kirk Clark • *Shockwave Series* • 2003-2005 • Pen and ink on paper • Varied dimensions

Shows in Mexico

MATAMOROS, TAMAULIPAS

I was invited to show my sculptures with an international group of artists, including Dick Hyslin, at the Contemporary Museum of Art of Tamaulipas, Mexico, across the border from Brownsville in Matamoros. Maria Elena Macias Urzua, a talented painter who is on the staff of the Art Department at UTPA in Edinburg, was the curator for the show. She and I have shown our work together on several occasions. She is a most talented and delightful person. I was honored to show my work with such a fine group of artists.

While the show was up, an accomplished artist from Saltillo, Mexico, Inés De León, visited the exhibit in Matamoros and saw my work. She was apparently very taken with it. She sought me out, came to my office and said, "Mr. Clark, you must show your work in the Saltillo and Ramos Arizpe area of Mexico, in the state of Coahuila."

I did not know what to think. I was flattered and stunned. Her enthusiasm for the idea was contagious, and I agreed to pursue it in earnest. Several weeks passed before she returned to McAllen to announce that she had arranged a show through the Technological University of Coahuila.

RAMOS ARIZPE, COAHUILA

My host for the show was Governor Martinez y Martinez and his charming wife, Lupita, both strong supporters of the arts and the university. I found out that the governor was a Chrysler dealer in Ramos Arizpe. That news made me feel good, too. He and his wife were very gracious. I decided that I would donate all the art sale proceeds from my show to the university.

All of the people at the university were delightful to work with. I titled the exhibit, *Otros Mundos/Other Worlds*. The exhibition consisted of over seventy sculptures, drawings and prints, with a special spiritual section for the *Atomic Jesus* and the *Santos* series, which was a series of ethereal drawings that depicted my interpretation of departed saints in the other realm.

The Cultural Arts Center in Ramos Arizpe was a beautiful facility. It was in a one hundred fifty year-old hacienda-styled schoolhouse that had been converted to a Cultural Arts Center. There were four individual galleries at each corner of the interior.

QUANTUM PHYSICIST TAKES UNUSUAL PHOTOS

I was holding court in the print gallery, and I noticed that there was a gentleman in the gallery right across from me. He was studying my drawings very carefully. He had a satchel hanging from his shoulder. He would look at my drawings, fiddle around in the satchel, pull something out of his satchel, and put it alongside one of my drawings.

Curiosity was really getting to me. I walked over to the gallery to meet the gentleman. I introduced myself. He said that he was a quantum physicist and theoretical mathematician. He asked me where I got the inspiration for my drawings. The drawings he was looking at were from my *Universe Below* series and my *Shockwave* series. I told him that I was not a scientist, but I had a tremendous curiosity about the origins of the universe and the fractal nature of the universe.

He looked quite surprised and said, "I thought you might be into this. I am doing research on the origins of the universe myself." I asked him, "What are you pulling out of your satchel and holding up to my drawings?" He said, "Let me show you photographs that I have taken over the last several days through an electron microscope."

He held a photograph up to one of my drawings. My jaw dropped. The photograph was almost identical to my drawing, it had the same shapes and colors. He went to four more of my drawings and held up separate photographs he had taken through the electron microscope. Each one of them was an exact replica of my work. It was really strange, but very exciting.

A HUICHOL INDIAN SHAMAN

The governor's wife, Lupita, was most taken with my crosses. I had gifted her one of my *Shamanic Conversion Series* crosses. It was during this period that she had a big surprise for me. She arranged for an anthropologist to bring a Huichol Indian Shaman from Nayarit, Mexico, to meet me. This was a complete and total surprise, and one that I will treasure all my life.

We walked into the entrance of the Technological University, and there he stood in all his glory. Through an interpreter, the shaman asked if we would like a blessing. I responded immediately in the affirmative. The blessing was a remarkable experience. I truly felt that I was in the presence of a holy man. It was exhilarating. Later, we had a private lunch with the shaman and the anthropologist.

During lunch, the subject of the *Atomic Jesus* came up. The shaman was introduced to my concept by the anthropologist. The first question the shaman had was, "What is an atom?" The anthropologist described what an atom was and its various components. The shaman said to the anthropologist, "Give me a minute please to consider what you have told me."

The shaman said that he created an image of an atom in his mind. He made the image about the size of a grapefruit and positioned it about fourteen inches from his eyes, in front of him. He said that he allowed his consciousness to enter the atom. As his consciousness entered the atom, he said that much to his delight, he was greeted by God. I got goose bumps all over when he said that. I will never forget the wonder of the shaman's presence that day. I still feel transported by my four hour visit with him. I cannot wait to see him again. I cannot explain how it feels to have these enlightened moments, which have become more frequent over time. It is as if life is revealing itself, from time to time in very special ways through very interesting people.

We were very well taken care of while on this particular trip by Jaime Guevarra Villanueva, Director of the Technological University of Coahuila, by Veronica Murillo, who handles marketing and public relations for the university, as well as other major responsibilities, and by Lic. Emilio Grimaldo Torres, and "Architecto" Bill, who spots and hangs my shows in Mexico.

ANCIENT PETROGLYPHS NEAR PARRAS

Following the opening of the show in Parras, Nuevo León, they took me, my wife, Jeri, Trev and Donna Jo Sparks, and several others who had flown down to Mexico for the show, to a very special site in the high, mountain desert of Mexico, outside of Parras. There we saw a particularly interesting ancient, petroglyphic site, with two kilometers of petroglyphs. They were magnificent.

The visit led me to study abstract, shamanic, petroglyphic images from that site, as well as other sites in North America, Africa, China, Indonesia, New Zealand and Australia. My first showing of these new works was at the Michael McCormick Gallery in Taos, New Mexico, on December 11, 2004. I found a surprising number of similar images from around the world from which I drew inspiration for the show.

DESERT FESTIVAL OF THE ARTS

The Real de Catorce art exhibit was part of the *Desert Festival of the Arts* which included eight high desert cities that participated in the festival. That exhibit then traveled to Saltillo for a very special venue at the Desert Museum of Natural History, one of the most beautiful museums that I have ever seen.

Kirk Clark • *Shaman Conversion* • 2005
Acrylic paint, glazed, on ceramic • 17 x 12 in.

Kirk Clark • *Shaman Conversion* • 2005
Acrylic paint, glazed, on ceramic • 17 x 12 in.

To my great surprise and delight, Governor Martinez had established a foundation in support of the Technological University of Coahuila utilizing the sale proceeds from my two shows. There was a huge press conference and the swearing in of five trustees for the foundation. I was asked to give a presentation and a talk to a large crowd of dignitaries, press and museum goers. I was greatly honored by the governor's kind words. To my delight, all of the drawings, paintings and sculptures on exhibit for the show were sold.

I have a deep bond with the communities of Saltillo and Ramos Arizpe. The university administration has been very kind to me. I have made many wonderful friends there. I always look forward to seeing them again and showing them my latest work.

GREAT JOY FROM GIVING

I have been delighted to be included in numerous local shows and delight to see the remarkable growth of activity in the local art community. I continue to show my work and make gifts of my art to charitable organizations through silent auctions and donations.

I derive great joy from donating the proceeds of all sales of my art, and donating my art for fundraisers to feed the hungry, for churches, and other non-profit organizations in the community and around the country.

I am inspired by the generosity of my fellow artists, specifically: Thom Wheeler, Amado Peña, Dick Hyslin, Maria Elena Macias Urzua, Brian Wedgeworth, Jonathan Sobol, Jd Challenger, Ed Sandoval and his wife, Ann Huston, as well as Michael Vigil, his brother, Daniel, both sons of the master printer, Viloy Vigil, from the Taos School, and Inés De León, from Saltillo, Mexico, and many others who have demonstrated their generosity time and again.

In recent years, I have come to know many artists who have done so much by donating their work to raise money to feed the hungry, to provide scholarships, donations for the Humane Society, those in need of all sorts, and the community in general. I was truly unaware of the depth and breadth of caring my fellow artists display every day through their generosity. I am truly amazed and proud to know them.

In addition to indulging my passion for art, my stated occupation is Auto Dealer at Charles Clark Chevrolet and Clark Knapp Honda. People ask, "When are you going to give up your day job and do your art full time?" I am quick to remind them that I enjoy the automobile business as much as I enjoy being an artist.

After my hiatus from creating art in the 1970's and 80's and re-engaging my passion for the arts in early 2000, I decided that my art had a greater purpose and that I would donate its sales proceeds to charity. It is an important part of my stewardship in this life, and I was encouraged and inspired by my parents' legacy of giving.

I thank my wife, Jeri, my four children, and grandson Ryan, for their support and understanding. I thank the Lord for the blessing of my family, friends and associates, as well as for my dual careers as automobile dealer and artist. I am truly blessed!

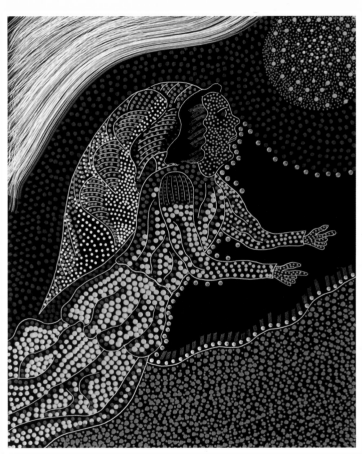

Kirk Clark • *Angel's Path Series* • 2005
Acrylic on scratch board • 10 x 8 in.

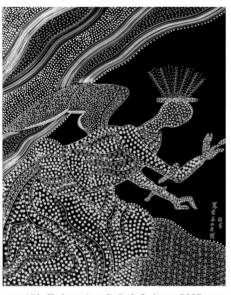

Kirk Clark • *Angel's Path Series* • 2005
Acrylic on scratch board • 10 x 8 in.

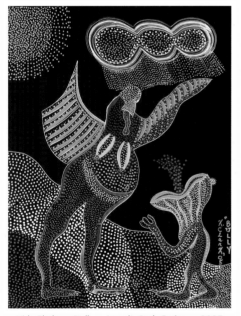

Kirk Clark • *Bully – Angel's Path Series* • 2005
Acrylic on scratch board • 10 x 8 in.

GOD'S WHISPERING

Mind, stop your constant chatter.
Life's deeper meaning surely awaits
the opportunity to be revealed,
but self-speak constantly is interrupting.
Find a quiet place now
to search your troubled heart,
with God's voice gently whispering,
"My grace is freely given."

K.C.

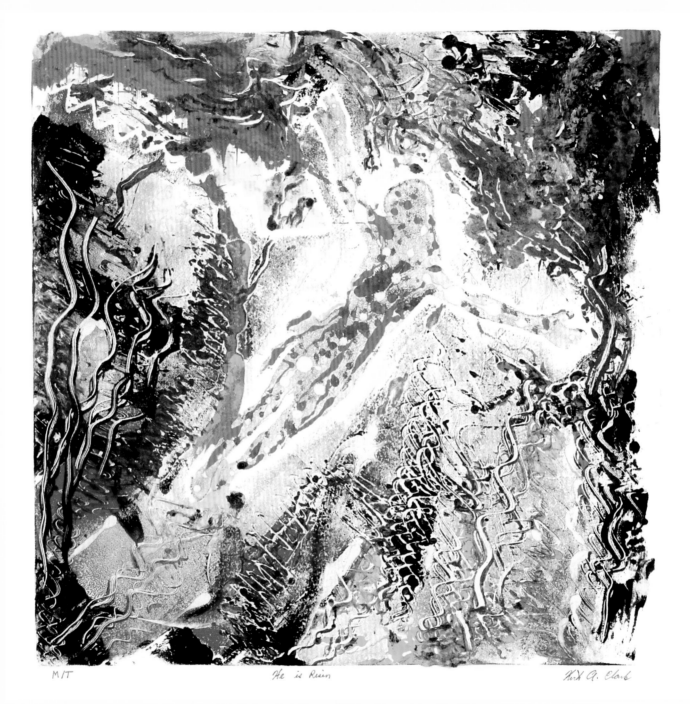

MIT *He is Risen* Kirk A. Clark

Kirk Clark • *He is Risen* • 2004 • Monoprint • 32 x 32 in.

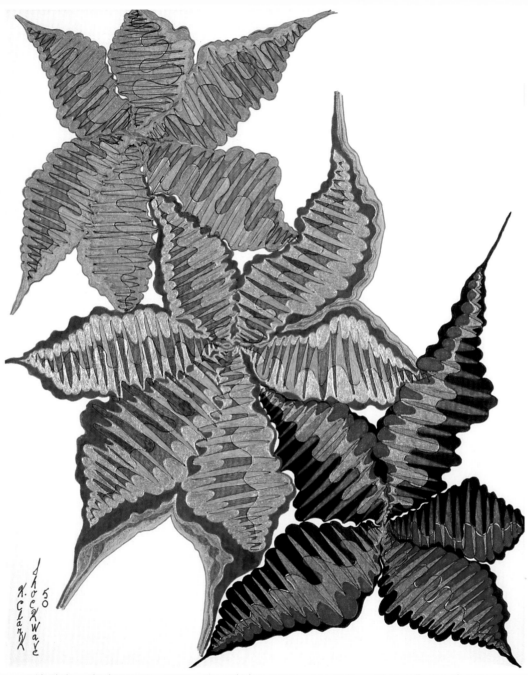

Kirk Clark • *Shockwave 50* • 2003 • Pen and ink on paper • 14 x 11 in. • Private collection, Pharr, Texas

A Dialogue

There are many other areas of interest regarding the Clark family and its artistic legacy that could be explored. I will content myself by continuing my ongoing conversation with Kirk as usual. What follows is a series of questions and answers that transpired between us by e-mail, which allowed us to get at the root of Kirk Clark's creative process in an informal and practical way — Yvonamor Palix

LET THE DIALOGUE BEGIN . . .

Yvonamor: Kirk, I am fascinated with the great research that your parents realized in order to grasp the wholeness of certain artistic movements. Do you think that their devotion to the Swiss constructivists was something that they developed through their trips to Switzerland, and their constant contact with knowledgeable Swiss art dealers? Was this influence therefore an acquired one that could have very well developed for any other contemporary art movement depending on the circumstances of the contact?

Kirk: Dad was a real academic in his own right. He kept meticulous records, personally and in business. I believe that Dad became aware of Swiss Concrete Art through his general research. He was very much taken by the power of the prints and their formula of line, space and color.

He was referred to the Bolag Gallery in Zurich, of which Suzanne Bollag was the owner. Mom and Dad became fast friends with her and traveled to Zurich to meet her. Suzanne took them to meet many of the artists, including one of the fathers of the movement, Max Bill.

Yvonamor: Of all the art pieces that your parents collected, which of them has been your favorite and why?

Kirk: I would be hard pressed to pick out a singular work that was my favorite from my parents' collection. There are favorites, however, including Hans Hartung, Victor Vasarely, Ernst Fuchs, and Max Bill, along with Verena Loewensberg, a Swiss artist.

Yvonamor: Many great art collectors have gone to the extreme of becoming artists themselves in order to understand the pain and joy of creation. Alvar Carrillo Gil from Mexico, did so before donating his great collection to the state, forming the now known Carrillo Gil Contemporary Art Museum. You had mentioned that both your parents had studied art in school; however, to what extent did they go to understand the artistic creative process?

Kirk: Yes, both of my parents started out as artists in their youth. Their experiences as studio artists gave them a unique appreciation of technique. They were drawn to the print world because of affordability issues, which grew into a deep appreciation for print techniques.

Dad felt that many fine printmakers excelled on paper rather than canvas or sculpture. They both became students with a passion. They spent approximately three hours a night, six days a week from the early sixties until 1985, when the tax law changed, which put a halt to dad's collecting and gifting vigor.

Yvonamor: When do you consider your own artistic idiom to have truly begun, when your parents were still alive, or after their departure?

Kirk: I was greatly influenced by the passion my parents shared for fine arts. Our home was a veritable gallery, with works going onto and off the walls for shows and donations. Like my parents, I could hardly wait for the next arrivals. It was a very stimulating environment for a young person.

Many visiting artists, collectors and professionals in the art world traveled to McAllen to see the collection. In response to

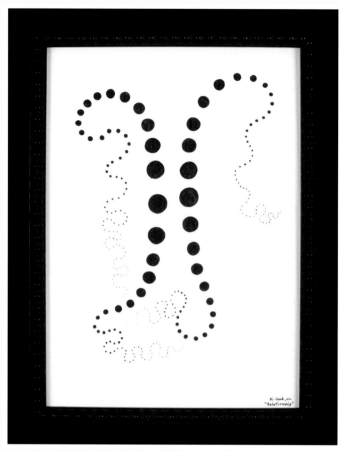

K. Clark • *Relationship* • 2002 • Pen and ink • 12 x 8 in.

the stimulation, I began to paint at the age of ten. I was more of a studio artist than my parents over time, and while I respected their research, discipline, and focus, I was much more interested in creating art myself.

Yvonamor: Do you think that your parents were the greatest influence in your choice to become an artist?

Kirk: I truly feel that my parents were my primary influence in pursuing a career in studio arts. Frankly, I was often quite intimidated by the discipline and regimen that they showed in pursuing their research. I found that making art had a great appeal and was in response to the tremendous intellectual stimulation I received daily from both of them.

I was very attracted to the joy I saw them share, both in their research of artists and in their collecting. I did not have a compulsion to join them in their research, but admired them for their dedication. The visual stimulation I received throughout my life in our home was a tremendous influence and spurred me on as an artist.

Yvonamor: No art form is completely unique, yet the process of personal interpretation and appropriation are often tools for artists. Which styles, forms, or movements do you consider strong influences on your work?

Kirk: Surrealism, Swiss Concreta and the great masters were my primary influences. Michelangelo is my favorite artist in the whole world. Leonardo da Vinci is my second favorite. I was greatly influenced by the great master painters and sculptors, particularly Michelangelo.

I was also fascinated by the Austrian School of the Fantastic and the work of Ernst Fuchs. The Swiss Constructivist movement headed by Max Bill, with its emphasis on line, space, and color, also influenced me. I am also a lover of Rembrandt's work, Salvador Dali, Miró and Picasso. However, my work is not derivative of a particular art movement or school per se.

Yvonamor: Does your incessant need to continually draw, dot, paint or sculpt reflect a pain, joy, or other form of emotional expression? Is this element important to your creation?

Kirk: At this stage of my life, my art is a compulsion, a passion, and a joy. I can't wait to see what is just around the corner, the next discovery, the next Satori moment. This is a Japanese expression I love, which means "instantaneous enlightenment." I move from revelation to revelation, and can't wait to uniquely express my discoveries.

Yvonamor: Do you feel that creating art is an escape from reality, or is your work an interpretation of reality?

Kirk: I would have to say that at times art is a great escape from reality for me. On other occasions, I find art to reveal the ultimate reality. It is a way for me to examine my soul.

Yvonamor: Do you create art in an improvisational, spontaneous way?

Kirk: A great deal of my art work is done spontaneously, in response to a compulsion to create. I seem to reveal my spirit in my creations. I have found out much about myself, as well as the universe, through my art and the art of others.

Yvonamor: Given the choice of one medium to work with exclusively, which would it be and why?

Kirk: I find this question to be a particularly tough one as I enjoy working in sculpture, painting and printmaking. If I had to choose only one, it would be metal sculpture, particularly cast aluminum and bronze. A close second would be sculpting in stone. I find that working with art that has volume and a 360 degree nature is the most fulfilling. I love to create in a foundry. I would say that printmaking is a close third because it has so many applications and is very spontaneous for me. Painting would be my next choice, but I find it to be the most constraining.

Yvonamor: Do you remember how your parents felt the first time they saw your own creations?

Kirk: My parents were delighted when I asked them to buy my first canvas board, a few brushes, linseed oil and oil paints at the age of ten. They were flabbergasted at my first painting, *The Lone Cypress*. They were excited for me and very encouraging.

Yvonamor: Much of your work is realized in Taos. Do you think that the environment in which you work influences your creative process or inspires you differently?

Kirk: My sculpture and my prints have been primarily created in Taos, New Mexico. I graduated from The University of New Mexico in 1969. Taos has had a powerful influence on my work. It inspires me. My dear friend and mentor, Thom Wheeler, an exceptional artist who lives in Taos, has been very gracious to teach me techniques, and challenges me to be all that I can be as an artist. I am grateful for his encouragement. The colors of the soil, trees, mountains and sky in Taos flip my switch. I can hardly wait for my next trip to Taos.

Yvonamor: Do you consider your work to be religious art or work that is inspired by your own spirituality? This is

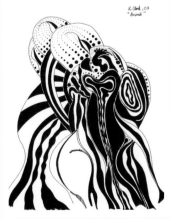

K.Clark • *Brandi - Satori Series* • 2003
Pen & ink on paper • 12 x 9.5 in

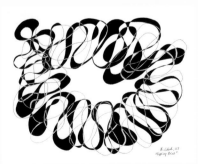

K.Clark • *Tipping Point* - Satori Series • 2003
Pen & ink on paper • 9 x 12 in.

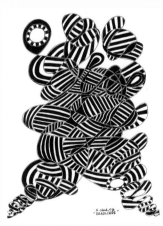

K.Clark • *Deadlines - Satori Series* • 2003
Pen & ink on paper • 12 x 9.5 in

considered quite courageous in the international art scene. What impact has this subject had on your career? Is there a message contained in your artwork?

Kirk: I would like my art work to be understood as spirit-filled art work. It is an expression of my faith in God. I see greater understanding and affirmation with my art works that reflect my life's journey to understand fully my purpose in this life. I would have to say that I have no reservations about declaring my spirituality, faith and love in my art work. I want it to be thought provoking, while avoiding being judgmental. It is my way of spreading my faith, my hope, and my dreams.

I declare my faith with each stroke of the brush and I am blessed by God's presence. Every breath I take is a blessing. The world we live in has become jaded and secular. My art is counter-secular, based on my own understanding of my creator and the mysteries of faith and surrender to God. I would characterize my art work as being spirit led. My art feeds my spirit and I hope the spirit of others as well.

I want my art work to be an expression of God's love in my life and his love for all of mankind. In a strange way, I believe that I am a messenger and my art is an attempt to convey the message, that God loves each of us. There is great joy and beauty in life for me that I wish to share with others in my faith-walk through my art creations. God is the hand, and I want to be his glove.

Yvonamor: If Charles and Dorothy Clark stepped into a gallery and saw your works today, not knowing they were yours, do you think they would collect them? Be honest now.

Kirk: I believe that if my parents could view my work today, they would be delighted and enthusiastic about the range of work and subject matter, even if they did not know that the work was that of their son. Yes, they would collect it, vigorously, which would delight me greatly. I know that they would select only my best work, but I also know that we would concur on which work met their criteria.

PURPOSE

A life led on purpose
produces results beyond one's imagination.
Energy follows focus through eternity
illuminating the pathway toward accomplishment
Individual achievement not so important
as a full life shared
giving others credit when possible.
Spirit led life most fulfilling

K.C.

Kirk Clark • Tidal Change Series • 2002
Pen and ink on paper • 12 x 9 in.

Kirk Clark • Tidal Change Series • 2002 • Pen and ink on paper
12 x 9 in. • Private collection, Pharr, Texas

Kirk Clark • Tidal Change Series • 2002
Pen and ink on paper • 12 x 9 in.

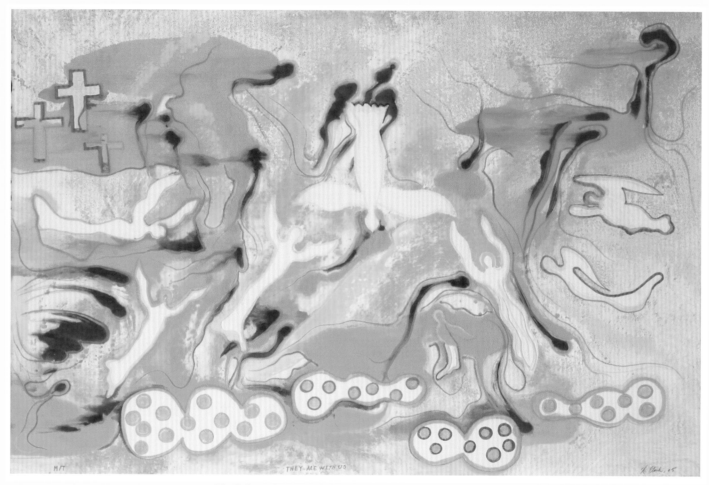

Kirk Clark • *They are with us* • 2005 • Monoprint • 30 x 44 in.

Kirk Clark, Artist and Friend
by Thom Wheeler

Everyone who knows Kirk has been impressed with the wonderful art he has produced. It is evident that he has the eye and touch to have developed into such an outstanding artist. His recent recognition in the art world only cheers him on to do more innovative work.

Just as important, is that he is a genuinely fine guy, a family man of deep faith. He is a generous man to his community, church, and fellow artists. A man who smiles when he works, and everyone smiles when in his company.

Through the years, we have shared ideas and I have enjoyed working side by side with him in my studio in Taos, New Mexico. I have grown to respect and regard Kirk as a fellow artist and a great friend.

Kirk has brought his own style and boundless energy into my casa and I am always delighted to see what projects he has dreamed up. The copper relief angel series show his tremendous amount of versatility. Then he has the ability to go into the print studio on the same day and produce the wonderfully colorful monoprints. That shows how he has mastered the flow of creativity.

Thom Wheeler at *The Ancient Ones* exhibit. Michael McCormick Gallery, Taos, New Mexico, 2004. Photo by Photoworks

Although we see how important Kirk Clark is becoming in the arts and as an artist, we must remember that most of all, we have had the privilege of knowing a true gentleman.

Kirk Clark • *Shockwave series* • Sand-cast aluminum • Varied dimendions

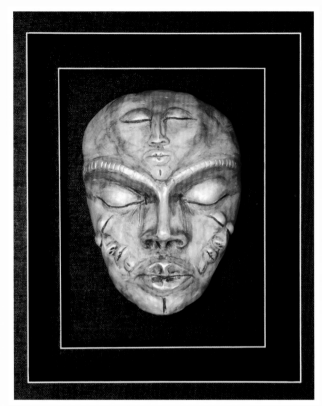

Anne Clark-Lawson • *Rebirth* • 2005
Acrylic paint on ceramic • 9 x 5 in.

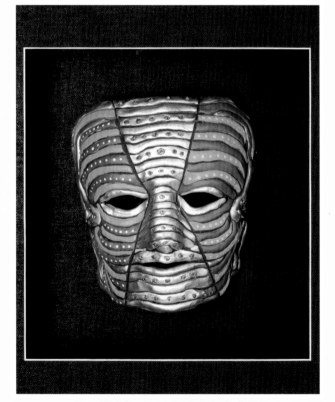

Anne Clark-Lawson • *Ancient Soul* • 2004
Acrylic paint on ceramic • 9 x 5 in.

My Father's Legacy
by Anne Clark-Lawson

My admiration of my dad's work began as a small child when I would watch him work in his studio. The intensity of his focus enthralled me even then and how he seemed to transport himself to another realm where anything was possible. His weird wax creations to the aluminum casts along the wall were always fascinating to me. I could watch him for hours. I knew that art would become a part of my life.

Not only was my dad's studio inspiring, our house was also a smorgasbord of interesting images. Some of the works of art that lived on the walls were from the likes of Hauser, Boterro, Vaserelli and Vill. My grandparents' house was just as alive with artwork, primarily prints which they had been collecting for years.

My dad and I have had few opportunities as adults to share in the creative process. I will always treasure these times together. They take me back to that same feeling I had as a little girl when I would be so excited just to see what he would come up with next. His artwork has a way of touching all planes of existence from the emotional and physical, to the spiritual and beyond. The colors invite and entice the imagination to wander. The rhythm in his work is hypnotic and fascinating.

He does it all with such pleasure and curiosity that it only draws you in more. I have never met a man like my father, and I doubt that I ever will. He continues to remind me to forge ahead in all aspects of my life. He inspires me to let my creative spirit guide and move me, just as he does.

Anne Clark-Lawson and Kirk Clark. 2006. Photo by Esperanza S. Chapa

ANNE
Talent fills her every cell.
Brilliant excecution she is seeking.
Her mind's eye is searching
for those special awe struck
elements that express her soul.
Intuitive heart swells with excitement
as life finds new expression.
Her spirit soars towards potential.
K.C.

Acknowledgements

I want to thank the following individuals who helped me immeasurably during this project:

• International Museum of Art and Science, McAllen: Director Serena Rosenkrantz for the invitation to exhibit at the museum; Yvonamor Palix, International Guest Curator for the show, and the inspiration for what this show could be and should be; Maria Elena Macias Urzua, Curator of IMAS and dear friend; and the professional museum staff at IMAS, who worked very hard to renovate the gallery in time for the show.

• *Celebration of Spirit* exhibit sponsors: I want to give my most sincere thanks to the following sponsors for their generous contributions to this exhibit. Trudie Abbott, Advertir, Inc., Artline America, Charles Clark Chevrolet Co., The Employees of Clark Chevrolet, The Employees of Clark-Knapp Honda, Enterprise Rent-a-car, Clark Insurance Agency, Clark-Knapp Honda, Peter Dabrowski, PhD, Jan's Fine Wines, Denny's, Dotcom Technologies, Frost Bank, GMAC, KRGV-TV Channel 5, Lucille Hendricks, The Monitor, Ann Moore, JS Media, Service Life and Casuality Insurance Group, and Texas State Bank.

• University of Texas-Pan American, Edinburg, Texas: Thanks to the administration and fellow artists for the care they have provided for the works gifted to the university by my parents, and to the generous support of my art through the invitation to show my work at the Charles and Dorothy Clark Gallery on campus. I also greatly appreciate the support over the last six years from the UTPA art community. Thanks also to Dr. Steven Schneider, editor, poet and inspiration.

• South Texas College: Richard Smith, talented painter and painting instructor at South Texas College in McAllen, Texas, who transformed a classroom into a beautiful gallery for my "Universe Below" art exhibit several years ago.

• UT Austin: I want to thank Jonathan Bober, Curator of prints and drawings at The Blanton Museum, and the staff of University of Texas, Austin, who has done so much to preserve the Charles and Dorothy Clark tradition and collection.

• From Mexico: Inés De León, artist and friend from Saltillo, who saw my art and almost single-handedly took my art work to Mexico. She introduced me to my wonderful friends, Jaime Guevarra, Director of the Technological University of Coahuila; Veronica Murillo, Public Relations and head of the Technological Department for the university, and the rest of the staff at the university in Ramos Arizpe, Mexico. I want to particularly thank the Governor of Coahuila, Enrique Martinez y Martinez, and his wonderful wife; Lupita, who have been such marvelous hosts for my art exhibits in Mexico.

• A special thanks to Dr. Peter Dabrowski, South Texas Symphony Conductor, whose music has inspired me beyond my wildest expectations. He showed me how to visualize the color and the shapes of a symphony.

• I want to thank Thom Wheeler, artist par excellence, and dear friend, whose art and mentorship have inspired me. To Michael Vigil and Tanya Vigil, owners of Graphic Impressions in Taos, New Mexico: Your patience with a sculptor aspiring to become a printmaker is greatly appreciated. Thanks to Edward Griego, videographer, for producing an excellent documentary for this exhibit.

• Thanks also to Esperanza Chapa, graphic designer, CopyZone; Ruth Hoyt, photographer and digital processor; Eduardo Luzuriaga, photographer, and David De Leon, photographer and web designer.

• Thanks to DeAnna Garza, my hardworking art assistant, who uses a shepherd's crook on me effectively;

to my administrative assistant, Nancy Dooley, and to Clark Chevrolet's marketing director, DeAnn Cohrs, for their invaluable assistance.

• I want to thank Jeri, my loving and supportive wife, and our sons, Alex and Daniel, who have been so patient with me and understanding of my need to create art work.

I would also like to thank my talented daughter, Anne Clark-Lawson, whose art and love inspire me deeply, Thank you all. May God bless you and keep you always! I am blessed by each of you and many more.

Spirit engaged,
Kirk Clark

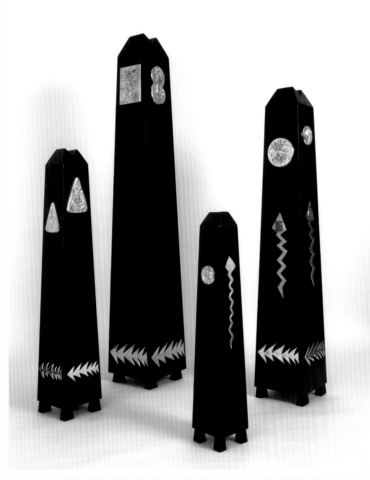

K. Clark • *Obelisk* • 2004 • Sand-cast aluminum on wood • Varied dimensions

Exhibition History

Taos Dreams
Ben P. Bailey Art Gallery
Texas A&M Kingsville
September 12 - October 6, 2006
Kingsville, Texas

Spirit Engaged
University Gallery
The University of Texas Pan American
August 7 - September 30, 2006
Edinburg, Texas

Time, Space and Motion
Museo del Desierto
July 7-31, 2006
Saltillo, Coahuila, México

Legacy Art
Sandia Indian Pueblo Resort
May 13, 2006
Albuquerque, New Mexico

Celebration of Spirit, The Clark Legacy
International Museum of Art and
Science
March 9 - August 27, 2006
McAllen, Texas

Young Masters
Su Casa Cultural Hinovations
December 17, 2005 - January 30, 2006
McAllen, Texas

Blue Period
Thomas Masters Gallery
December 9, 2005 - January 15, 2006
Chicago, Illinois

Art Walk
Art House
Nuevo Santander Gallery
November - December 2005
McAllen, Texas

The Ancient Ones / Los Antiguos
Museo del Desierto
May 3 – June 17, 2005
Saltillo, Coahuila

April Thunder Preview
STC Open House
W/ Amado Peña
April 22, 2005
McAllen, Texas

Angel's Path
Festival de Desierto
Galeria Vega m57
April 13, 2005
Real de Catorce, San Luis Potosi

Corrientes Alternas
Museo de Arte Contemporaneo
De Tamaulipas
March 17 - April 30, 2005
H. Matamoros, Tamaulipas, Mexico

Child-Rite, Inc.
The Michael McCormick Gallery
December 10, 2004
Taos, New Mexico

The Ancient Ones
The Michael McCormick Gallery
December 11, 2004 - January 31, 2005
Taos, New Mexico

Poetry Art Exhibition
University Gallery-CAS Building
May 31 - June 2, 2004
Edinburg, Texas

Otros Mundos / Other Worlds
Universidad Tecnologica de Coahuila
Centro Cultural Universitario
February 11, 2004
Ramos Arizpe, Coahuila, Mexico

Corazones Distintos
Sala Arte Gallery
February 14 - March 19, 2004
McAllen, Texas

Arabian Nights
Art Comes in Different Shapes
Casa Antigua
April 7, 2004
McAllen, Texas

Artist in Our Midst
McAllen Chamber of Commerce
April 6 - 8, 2004
McAllen, Texas

Frutos Del Valle
UTPA
Charles and Dorothy Clark Gallery
January 26 - February 20, 2004
Edinburg, Texas

Frutos del Valle
The Art House
December 6, 2003 - January 9, 2004
McAllen, Texas

Exhibition History (cont.)

STCC Valley Scholars
with Amado Peña
South Texas Community College
November 21 - 22, 2003
McAllen, Texas

The Day of the Dead
España Restaurant
November 1, 2003
McAllen, Texas

Los Siete Magnificos
Velvet
August 29, 2003
McAllen, Texas

Transformaciones
Museo De Arte Contemporaneo
April 10, 2003
H. Matamoros, Tamaulipas, Mexico

Traditions
Charles & Dorothy Clark Gallery
UTPA Fine Arts Building
May 1, 2003
Edinburg, TX

Universe Below
STCC Art Gallery
September 16 - October 10, 2002
McAllen, Texas

Atomic Jesus
Zane Wheeler Gallery
March 16 - 30, 2002
Taos, New Mexico

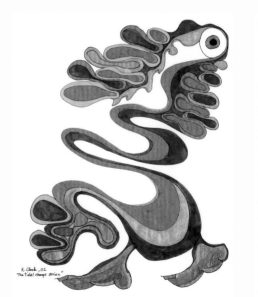

Kirk Clark • *Tidal Change Series* • 2002
Pen and ink • 8 x 10 in.

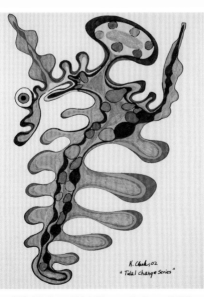

Kirk Clark • *Tidal Change Series* • 2002
Pen and ink • 8 x 10 in.

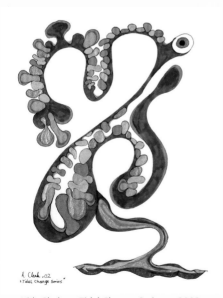

Kirk Clark • *Tidal Change Series* • 2002
Pen and ink • 8 x 10 in.

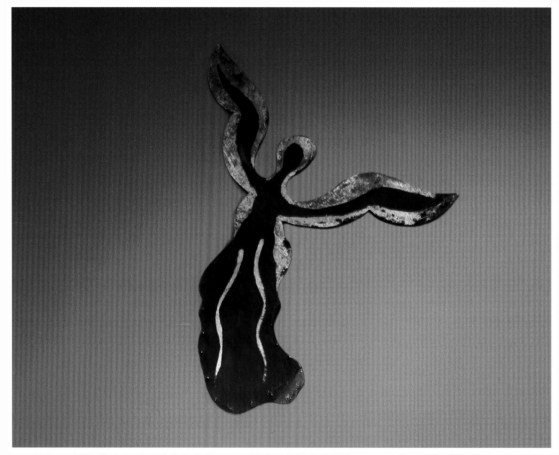

Kirk Clark • *Angel's Path Sculpture* • 2005 • Paint and copper on wood • 30.5 x 23.25 in

CELEBRATION OF *Spirit*
The Exhibit

CELEBRATION OF SPIRIT

KIRK CLARK

Charles & Dorothy Clark Collection
Anne Clark-Lawson

International Museum of Art and Science, McAllen, Texas
March 9, 2006

Curator and exhibit designer
Yvonamor Palix

Celebration of Spirit Documentary
Edward Griego, Coyote Productions

Music
Sarah West

IMAS technical support
Ron Caceres, Alex Garza, Jose Gutierrez, Maria Elena Macias, Alex Oyoque, Billy Ritter, Tina Virkus

Art Assistance and Research
DeAnna Garza

View of various series exhibited at IMAS.

Works from the permanent collection of the International Museum of Art and Science gifted by Charles and Dorothy Clark.

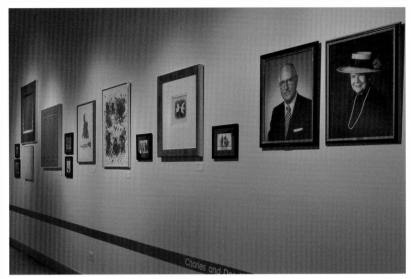

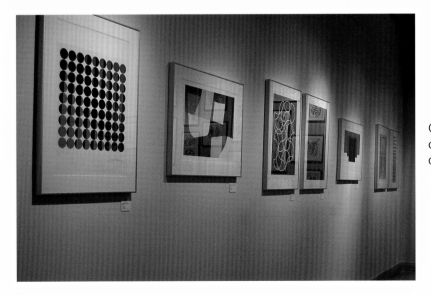

Continuation of works from the permanent collection of the International Museum of Art and Science.

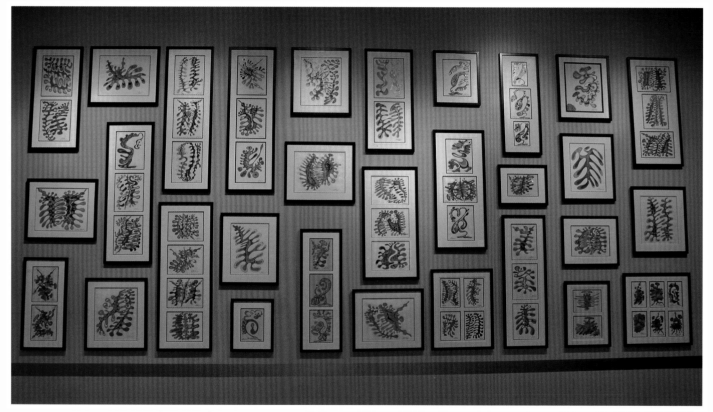

The view from outer space through the Hubble telescope combined with
experiences of snorkeling over a coral reef are interpretated
by the artist in the *Universe Below* and *Tidal Change* series.

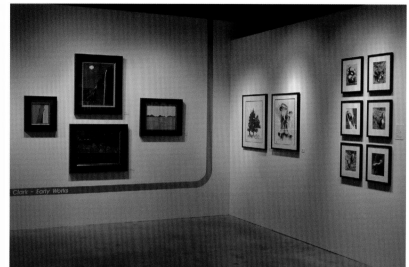

Works created by Kirk Clark dating back to 1956.

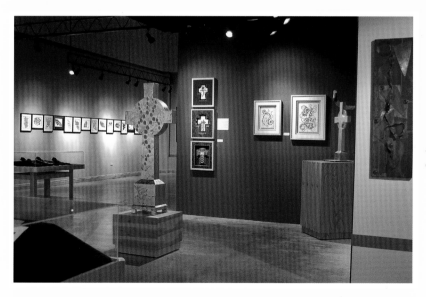

Selected sculptures by Kirk Clark as shown in the Celebration of Spirit exhibit.

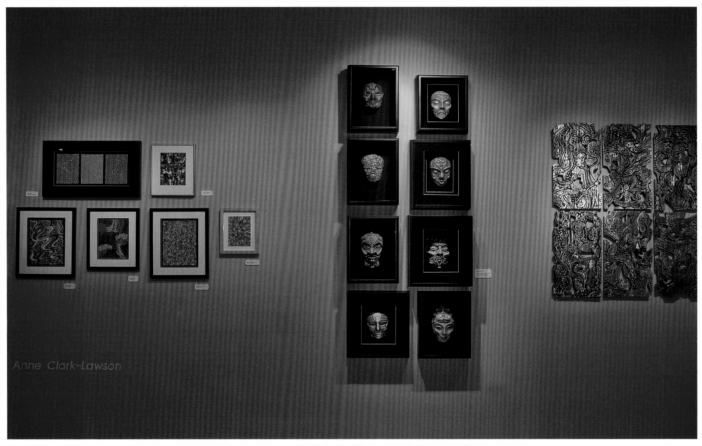

Selected drawings, masks and sculptures by Anne Clark-Lawson
as shown at the Celebration of Spirit exhibit.

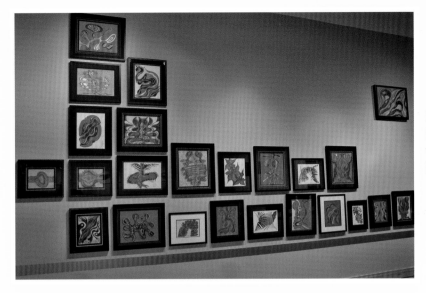

In his *Shockwave* series, Kirk Clark reveals his interpretation of God's creative origins with resonating images when initiated by the "Big Bang".

A young admirer enjoying the video *Celebration of Spirit* during the exhibit at IMAS.

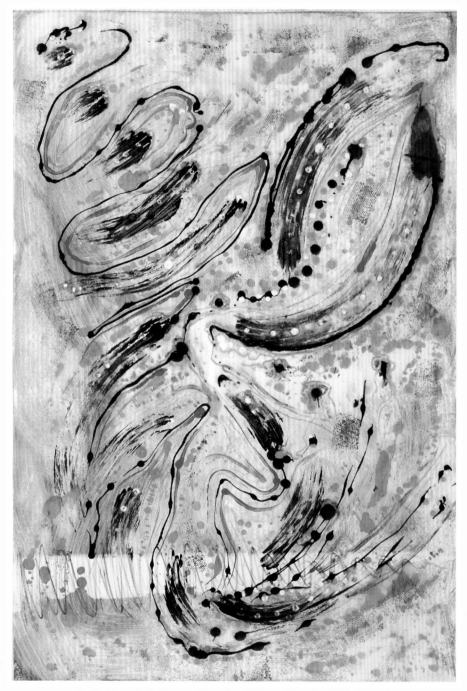

K. Clark • *Mind's Eye* (Ojo Mental) • 2005 • Monotinta • 44 x 30 in.

CELEBRACIÓN DEL Espíritu

KIRK CLARK

Reconocimiento

Quiero agradecer a las siguientes personas quienes me ayudaron de forma inmensurable durante este proyecto:

• Museo Internacional de Arte y Ciencia, McAllen, TX: Serena Rosenkrantz, actual directora del museo, por invitarme a exponer; Yvonamor Palix, Curadora Internacional quien organizó dicha exhibición retrospectiva- inspiración y gran visionaria de lo que esta exhibición puede y debe ser; María Elena Macías Urzua, curadora del IMAS y amiga querida; y al excelente personal del museo quienes trabajaron duro para renovar el espacio para la exhibición.

• Universidad de Texas – Pan Americana en Edinburg, Texas: El Dr. Steven Schneider, editor, poeta e inspiración. También agradesco el gran apoyo de la comunidad artística de la Universidad de Texas – Pan Americana en Edinburg, Texas. Agradesco también a la administración y los artistas compañeros por el cuidado que le han dado a las obras que mis padres donaron a la Universidad, y al generoso apoyo a mi trabajo artístico atraves de la invitación a exponer mi obra en la galería Charles and Dorothy Clark en el campus.

• South Texas College en McAllen: Richard Smith, talentoso pintor e instructor de pintura en el South Texas College en McAllen, Texas, quien transformó un salón de clases en una bella galería para mi exhibición del Universo de Abajo hace algunos años.

• Universidad de Texas, Austin: Quiero agradecer a Jonathan Bober, curador de grabado y dibujo del museo Blanton de la Universidad, quien ha hecho tanto por preservar la tradición y colección de Charles y Dorothy Clark

• De México: Inés Deleón, artista y amiga de Saltillo, quien me presentó a mis maravillosos amigos, Jaime Guevara, Director de la Universidad Tecnológica de Coahuila; Verónica Murillo, directora de mercadotecnia de la universidad y el resto del personal de la Universidad en Ramos Arizpe, México. Quiero agradecer de forma particular al Gobernador de Coahuila, Enrique Martínez y Martínez, y a su maravillosa esposa, Lupita, quienes han sido excelentes anfitriones de mis exhibiciones de arte en México durante los últimos años.

• Un agradecimiento especial al Dr. Peter Dabrowski, Conductor de Sinfónica, cuya música me ha inspirado más allá de mis mayores expectativas. Me enseñó a visualizar el color y las formas de una sinfonía.

• Quiero agradecer a Tom Wheeler, artista por excelencia, y querido amigo, cuyo arte y enseñanza me han inspirado, así como a Michael Vigil y a Tanya Vigil, los propietarios de Graphic Impressions en Taos, Nuevo México. Su paciencia es sumamente apreciada. Gracias a Edward Griego, videografo, por crear el excelente documental para la esposición.

• Gracias también a Esperanza Chapa, diseñadora de gráficos, de Copy Zone; Ruth Hoyt, fotógrafa y correctora de color; Eduardo Luziarga, fotógrafo; y a David Deleón, fotógrafo y diseñador de sitios web.

• Gracias a mi asistente, la muy trabajadora, DeAnna Garza quien me "tuerce el brazo" de forma efectiva; agradesco también a mi asistente administrativa, Nancy Dooley y a la directora de marketing de Clark Chevrolet, DeAnn Cohrs por su gran ayuda.

• Quiero agradecer a Jeri, mi amada esposa y a nuestros hijos, Alex y Daniel quienes han sido tan pacientes y comprensivos conmigo en cuanto a la necesidad que tengo de crear arte. También agradesco a mi talentosa hija Anne Clark – Lawson cuyo arte y amor me inspira profundamente. Que Dios los bendiga y los conserve a todos!

Espíritu comprometido, Kirk Clark

Prólogo
por Kirk Clark

La exposición *Celebration of Spirit* (Celebración del Espíritu) en el Museo de Arte y Ciencia (IMAS) en marzo del 2006, fué inspirada en el arte representando tres generaciones de la familia Clark.

Serena Rosenkrantz, actual directora del Museo de Arte y Ciencia de McAllen me sorprendió cuando me llamó para invitarme a exponer mi obra en el museo. Yo contesté "si" apresuradamente, poco sabia lo que el decir "si" significaría en los próximos meses. Había conocido a Yvonamor Palix, hija de un Diplomático Mexicano quien solía visitar McAllen a menudo. Nos hicimos buenos amigos.

La experiencia de Yvonamor como galerista y curadora de exposiciones tanto en Europa como en México me impresionó al igual que su gran conocimiento de la escena de arte contemporáneo internacional. No podía esperar para preguntarle si aceptaría curar mi exposición en el I.M.A.S. Ella acceptó la invitación y el museo estuvo de acuerdo en que ella era la persona indicada para esta responsablidad.

My asistente, DeAnna Garza, Yvonamor y yo fuimos invitados a visitar el museo para ver el espacio designado. Yvonamor no aceptó la primera sala de exposición propuesta por el museo, ni la segunda y pidió ver un espacio aún mas grande para poder configurar una retrospectiva entera de mi obra mas toda la obra que había sido donada al museo por mis padres.

Nos mostraron un espacio que había sido abandonado y tenía unos 3600 pies cuadrados y que albergaba en ese momento una instalación gigantesca de un guzano mas un par de ballenas! Este fué el espacio elegido. Afortunadamente, compartimos el deseo por el espacio y la experiencia y conocimiento en museografía de Yvonamor nos tranquilizó. El museo hizo un plan para remover estas gigantescas creaturas y

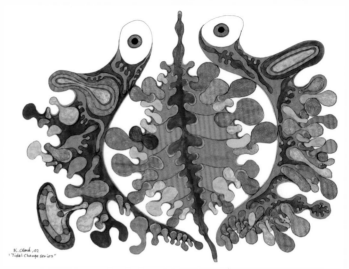

Kirk Clark • *Tidal Change Series* (Serie Cambio de Marea) • 2002
Pluma y tinta • 11 x 8 in.

me pasó el presupuesto de lo que costaría física y económicamente restaurar la galería. Decidí que sería una aventura que me gustaría emprendar y le dije al director que procediera con el proyecto.

Yo estaba encantado de saber que Yvonamor incluiría a las tres generaciones de la Familia Clark en esta exposición dividiendo la exposición en tres areas: una selección de las obras regaladas por mis padres al I.M.A.S., las muchas series de obras que componen mi retrospectiva incluyendo mis mas tempranas obras-un oleo realizado a la edad de 10 años y una cantidad de obras producidas por mi hija, Anne, quien recientemente habia regresado al Valle desde Denton, Texas, con su esposo Aarón y mi pequeño nietecito, Ryan.

Se me pidió escojer el título de la exposición. Decidí llamarla *Celebration of Spirit - The Clark Legacy* (Celebración de Espíritu- El Legado Clark). Este título refleja

la celebración en que mi familia vivió con el arte y el espíritu que compartimos.

Para mí era importante que le dedicaramos la exposición a mis padres, quienes fueron de los fundadores del museo hace como 50 años. El museo aceptó después nombrar la sala de exhibición, La Galería Clark en su honor.

A medida que progresabamos con el proyecto, comprendimos que la renovación del la galería costaría lo doble de lo que originalmente se tenía planeado. Pensandolo poco, determiné que esta oportunidad no se presenta muy amenudo, así es que después de analizar las opciones decidimos hacer la inversión y continuar. Después de todo, esto es parte del legado de nuestra familia a las artes.

El personal del museo, DeAnna e Yvonamor, trabajaron sin descanzo con el constructor y su equipo para transformar la galería en una bella vitrina. Me recuerda la transformación de cenicienta. La exhibición revela la relación íntima que cada uno de nosotros comparte con el arte. Tanto la selección de obras de arte como el diseño del espacio y de cada una de las areas captura lo original y la esencia de cada una de las obras exhibidas.

Me he considerado un poeta emergente, pero no me había visto como escritor y estoy disfrutando mucho el desafío. Fué una gran tarea coordinar la selección de obras, terminar la obra de renovación de la galería y

completar el libro, incluyendo su extensa ilustración. Soy afortunado por rodearme de gente competente quienes realmente adoran lo que hacen.

La exposición en I.M.A.S. se inauguró el 9 de marzo del 2006, una gran cantidad de público tanto local como de México entre oficiales, patrocinadores, estudiantes y amigos estuvieron presentes en este momento tan significante. No podía estar mas felíz con el resultado. La exposición fue glorioza. Estaba orgullozo de tener a mi familia conmigo en la inaguración de la exposición.

Recibimos una postal de mi Tía Lydia Van Gelder de California, quién me conmovió al compartir su visión sobre la exposición y al comentar que estaba segura de que mis padres estarían sonriendo desde el cielo.

Fué realmente el mérito de los esfuerzos de quienes me ayudaron a realizar esta exposición cuando el museo propuso prolongar la fecha de la exposición de junio hasta septiembre del 2006.

Reconocimos que había una historia que contar. En esta publicación, deseo reconocer las contribuciones personales que mis padres hicieron como filántropos, en particular para el Museo Internacional de Arte y Ciencia. También quiero compartir, como éstos maravillosos padres tuvieron influencia en mi y en mi carrera al igual que en mi hija Anne. El resultado de éste esfuerzo es este libro que está usted leyendo hoy.

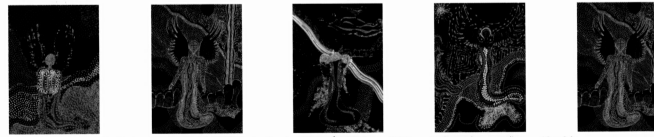

Kirk Clark • *Angel's Path Series* (Series Camino de los Ángeles) • 2005 • Acrílico sobre cartulina • 12 x 9 in.

Introducción
por Yvonamor Palix

Me habia dedicado a dirigir dos galerias de arte una en Paris y la otra en Mexico DF durante casi quince años, ademas de asesorar y comprar arte para diversos bancos y colecciones internacionales, pero fue mi experiencia como curadora que le atrajo a mi querido amigo, Kirk.

Al comenzar mi año sabático en 2005, Kirk Clark me pidio dejar el descanzo y accepte su invitación como curadora de su exposición en un Museo de Texas.

Admito que si no fuera por la curiosidad innata que siempre me ha impulsado, como el hilo de Ariadna a descubrir universos tan singulares como aquellos creados por artistas de gran extravagancia y perseverancia, no estaría escribiendo hoy estas líneas. Mi encuentro inicial con Kirk Clark fué hace un par de años cuando comencé a visitar el Valle del Río Grande, después del nacimiento de mi sobrina Odette. Esperaba retirarme ahí de los foros de arte y dedicarme plenamente a la nada, por lo menos un rato.

Cuando me presentaron a Kirk me dijeron que conocería a un alma muy original y bondadosa, un género raro de hombre de negocios. No imaginé que conocería a un personaje de la era moderna digno de un relato de Og Mandino.

Su oficina (o su "caja de Pandora", para aquellos que la han visto) refleja una personalidad vibrante de colorido, historia y un desorden casi infantil. Con el tiempo, descubriría el orden dentro del desorden un patrón intrincado de exhibición y forma de archivar único de Kirk. En su oficina, me sumergí en una atmósfera de memorias y recuerdos reflejados en los muchos objetos originales que lo rodeaban. Había insectos extraños bajo vitrinas, pinturas y dibujos de diversos estilos, tótems, artefactos indios, joyería de piedra, máscaras, fotografías y libros.

Cuando entré a su oficina, Kirk estaba sentado tras una gran mesa, un escritorio informal que le daba la sensación a uno de llegar al comedor de casa. Sus brillantes ojos llenos de vida, irradiaban conocimiento, y su cálida sonrisa al estrecharme la mano con tal cordialidad me hizo sentir como si estuviera entrando a la casa del Mago de Oz en la Ciudad Esmeralda. Jamás me hubiera imaginado que este hombre era un magnate de la industria automotriz.

Después de sólo dos minutos de conversación, estábamos envueltos en una atmósfera cargada que le es familiar a aquellos que se alimentan de la energía conceptual y la teoría. Los temas de nuestro intercambio volaron desde el movimiento Cobra hasta la influencia del arte primitivo en el cubismo; desde los constructivistas suizos hasta el Arte Bruto.

Sentí una energía muy similar a aquella experimentada en la inauguración de una feria internacional de arte o durante las visitas previas a las subastas en Nueva York. Me recordó también a las interminables discusiones que tenía con Achile Bonito Oliva, el respetado historiador y curador italiano, ex-curador de la Bienal de Venecia y promotor de movimientos importantes tales como la transvanguardia, el arte espacial y fluxus junto con su colega francés, Pierre Restany.

¿Cómo era posible que un lugar apartado de los grandes centros cosmopolitas, me fuera a topar con un implacable fanático apasionado del arte disfrazado de sereno hombre de negocios? Toda la escena fue bastante surreal. Abrió una ventana de reflexión a tantos niveles para cada uno de nosotros.

Nuestra conversación del desayuno esa mañana, que se prolongó hasta el almuerzo, y después fue seguido por una serie de encuentros de arte que durarían de quince minutos a horas interminables a la vez, florecieron en un intercambio

maravilloso de ideas y conceptos relacionados con el arte, las humanidades, la religión e incluso la política. Estaba encantada de tener un amigo en el sur de Texas que fácilmente podía contactar por correo electrónico o en persona, cuya experiencia e implacable imaginación me podían transportar a los rincones más recónditos del universo del arte.

Kirk emanaba espíritu y conocimiento en diversas áreas. Su pasión por todos los temas se endosela por una preocupación humanista y una devoción a la espiritualidad llena de frescura misteriosa.

Kirk me pidió que lo introdujera a la obra de algunos artistas con los que yo trabajo y cuya obra me parecía históricamente importante, me convirti en su consultora de arte. Su percepción de una obra de arte siempre es espontánea pero a la vez, aguda. Es raro el momento en el que lo cautiva una obra de arte que no contiene singularidad en la técnica o en el concepto y que no sea una obra significativa para el artista en sí, que refleje el dolor o la belleza durante el proceso creativo.

UNA FORMA DE VIDA

Llegué a aprender esa relación única que Kirk tiene con el arte heredada de Dorothy y Charles, sus queridos padres. Al escucharlo hablar de ellos como pareja de muchas pasiones, pronto entendí que su inherente necesidad de crear, coleccionar y promover el arte, no sólo el suyo sino cualquier arte que atrajera su discerniente vista, era un rasgo genético de su familia.

De niños, Kirk y su hermana observaban los ires y venires de sus padres por todo el mundo, cuya pasión por el arte fue dictada por su colosal meta de alcanzar lo inalcanzable: observar y absorber el proceso creativo integral de los artistas que habían conocido y admirado.

Tanto el tiempo, la energía, como la inversión financiera que dedicaron durante sus vidas a seguir esta misión se convirtió en una forma de vida para toda la familia. Inevitablemente, Kirk estaba destinado a heredar esta energía y canalizarla por

medio de su propia personalidad y espíritu. Continuaría el legado como artista y discerniente coleccionista de arte.

El sentido de responsabilidad y devoción con el cual los Clark se abrieron paso por la ruta de su colección ciertamente es original por muchas razones. En una era donde las cicatrices de la guerra aún no habían sanado, en una zona donde el arte contemporáneo no era una prioridad, sus aventuras para traer las formas más modernas del arte a esta región del sur de Texas fueron tanto audaces como ilustrativas.

Los Clark representan una especie de familia De Medici del Sur en este aspecto. Su comisión a los artistas y las sorprendentes colecciones de grabados de vanguardia que coleccionaron y donaron a muchas universidades, museos y otras instituciones representan el gesto generoso y desprendido de auténticos mecenas del arte. Compraron arte muy bien seleccionado para donarlo unicamente.

Solo se quedaron con memorias interminables de experiencias con artistas, corredores de arte, curadores de arte e historiadores, algo para ellos de mayor valor personal. También documentaron cuidadosamente todas sus actividades relacionadas con estos esfuerzos.

Los Clark acumularon obras de muchos artistas altamente reconocidos hoy día. Sin embargo, en esos tiempos, poco se sabía en qué dirección irían las carreras de Max Bill, Eduardo Chillida, Jorg Imendorf, Antoni Tápies, Sig Mar Polk. Para ellos, la frontera desconocida era el futuro del arte contemporáneo. Lo que lograron fue difícil e improbable, incluso si hubieran tenido las herramientas para pronosticar y los consultores expertos con los que hoy contamos.

La era de la posguerra trajo consigo grandes aventuras para los estadounidenses en todos los campos, incluyendo las artes. Movimientos y estilos se abrieron paso en el escenario internacional vía Nueva York y las principales instituciones de arte. Las obras de muchos artistas individuales y los movimientos de arte acentuaron este periodo en el tiempo; sin embargo, los Clark se apartaron de los valores artísticos

convencionales de la época. Tuvieron el valor de forjar su propio sendero y establecer su propia colección por medio de su investigación e instinto.

UN TESORO DE EXPERIENCIA

Dorothy y Charles Clark vivieron sus vidas y coleccionaron arte con pasión. No todos los artistas con los que se toparon y cuyas obras coleccionaron se volvieron famosos o se establecieron en el mercado del arte. Al contrario, algunos artistas nunca fueron conocidos, pero los movimientos que descubrieron con ellos en sus estudios y viajes a tierras lejanas para conocerlos se convirtieron en un tesoro de experiencias y expresiones únicas para esta formidable pareja. Cada obra coleccionada representa una historia, una anécdota o una sorpresa inesperada.

Su colección incluía miles de obras finas hechas por artistas prominentes de aquel entonces, así como artistas que serían reconocidos más adelante. La pasión de los Clark fue más allá de solo coleccionar. Involucró mucha investigación, documentación y finalmente la donación generosa a instituciones y museos a lo largo de los Estados Unidos. El deseo principal fue contribuir continuamente al desarrollo del arte en su comunidad y el de despertar el interés de otras personas en esta magnífica y gratificante pasión.

La estupenda investigación y profesionalismo con el que Charles y Dorothy Clark acumularon y preservaron su colección de grabados, amerita editar un libro completo, con tanta documentación sobre cada pieza de arte, hasta llegar a necesitar un local tipo museo, construido en su propio hogar para tener un almacenamiento de preservación adecuada de las obras.

Kirk ha continuado esta aventura a través de su propia obra y a través de su propio ojo exigente pero a la vez considerado, coleccionando las obras de artistas establecidos así como de jóvenes talentos emergentes. Con sus donaciones a organizaciones de caridad y el obsequio de obras de arte a instituciones, continúa el legado de sus padres.

Anne, la hija de Kirk, ha emprendido su propia expresión artística experimentando con diversos medios y conceptos, por ende desarrollando su propio estilo. Ella y Kirk comparten un ideal en común, uno de composición estética y estructura proveniente de un instinto casi innato. Ninguno de los dos teme enfrentarse a medios desconocidos de arte. Al contrario, el riesgo parece ser el común denominador en las obras tanto del padre como de la hija.

Se podría decir que el hilo conductor de una generación a la otra en la familia Clark sería su disposición a tomar riesgos con sus obras de arte y sus valores estéticos. De cualquier forma, es aparente que en las tres generaciones existe la audacia y tenacidad tanto para coleccionar como para crear, un impulso que se puede definir como un movimiento divino.

¿Para quién coleccionan? ¿Para quién crean? ¡Todo está dado! Al final del día, no queda nada más que su experiencia. En la sociedad actual, es excepcional encontrar ya sea

Kirk Clark • *Atomic Jesus & Shamanic Conversion* (Jesús Atómico y Conversión Chamánica) • 2003-2004 • Pintura acrílica en cerámica • Dimensiones variadas

coleccionistas o artistas de búsquedas tan sublimes y propósitos tan desinteresados, cuya creación y colección de arte deriva su mayor realización al obsequiarla.

UN ESPÍRITU COMPROMETIDO

Visitar el universo de Kirk Clark es entrar a un inmenso laberinto de imágenes e ideas entrecruzadas y combinadas de manera única. Al sumergirse en un elemento de la obra de Kirk Clark, de pronto surge otro elemento, como el estilo, sujeto o concepto que toma al espectador por sorpresa y lo plasma en la inmensidad de la creatividad del artista.

La gran cantidad de aspectos de las obras de Clark, tomados desde un punto de vista estético, son exclusivos en cuanto a su experiencia, formación y filosofía. Un elemento no depende de otro para hacer que la obra funcione. Él no tiene un temario predeterminado como artista, más que la manifestación externa de su esencia en un momento en particular.

Sería bastante gracioso y entretenido el notar las diversas influencias en su obra, pero tal gesto sería muy limitante porque Kirk Clark hace erupción como un volcán dormido en un interminable mar de procesos creativos. Su extraña actitud e imaginación impredecible son lo que distingue su arte.

A través del contacto personal con el artista, uno llega a entender el motor de su vida: el crear. En una época en donde, según Donald Kuspit, predomina el arte escatológico, es refrescante y novedoso el encontrarse con un artista cuyo motor sea el elevar la espiritualidad del espectador. Kirk Clark crea por necesidad. Esto se ve reflejado a través de la pasión, espiritualidad, perseverancia y consistencia, elementos con los que sus obras son creadas. Si uno puede o no identificar un elemento de arte Op, huellas de arte cinético, o vestigios de postmodernismo en sus obras, tales influencias no son más que una huella de su propia imaginación creativa.

La mayor influencia que tuvo Kirk Clark fue la pasión de coleccionar arte por parte de sus padres, cuya perseverancia por descubrir nuevas fronteras artísticas inspiró a Kirk como a tantos otros. Él aprendió de ellos a valorar la iluminación proveniente del contacto con otros artistas creativos y la iluminación espiritual, o momentos *Satori*, del acto creativo por si mismo.

REPETICIÓN

En varias de las series de Clark, como *Tidal Change* (Gran Cambio), *Satori* y *Shock Wave* (Onda Expansiva), uno puede percibir una calidad casi obsesiva en cuanto al proceso de elaboración de dichas obras. Estas obras hacen surgir las siguientes preguntas: ¿Son acaso una búsqueda implacable de la forma a través de lo abstracto? ¿O son meras distracciones de la verdadera esencia de la obra que no pueden ser materializadas y por lo tanto deben ser trabajadas una y otra vez, o se trata sencillamente de una obra maestra que no debe ser terminada?

¿Acaso el estilo repetitivo en estas obras indica una frustración persistente o un deseo de liberación? ¿Pueden estas obras reflejar un yo interno inclusive desconocido para el artista – tal como "el otro yo" en un dialecto Jungiano? De cualquier forma, en todas las obras de Kirk Clark el estilo y la acumulación de las pinceladas sin fin se convierten en el elemento redentor.

Así como en las pinturas e ilustraciones de Francis Bacon, la sustancia repetitiva del psyche del artista puede representar el gesto satisfactorio de recrearse a uno mismo a través de lo abstracto, por lo que el gesto se convierte en un acto inventivo. De manera casi subconsciente, la repetición continua del artista por una cierta imagen a través de la cual él es representado conlleva sustancia y existencia a si mismo, de tal forma que derrama el dolor con el que este acto es provocado.

Con respecto a esto, Goya nos viene a la mente también, aunque en su caso, el tema de sus pinturas eran tanto su dolor como su consuelo, y en su caso la repetición se convierte en el tema sangriento, como la masacre en campos de batalla o cuerpos de animales abiertos en descomposición destinados a la putrefacción.

Sería un simplismo el reducir estas obras a un nivel psicoanalítico, ya que casi todo el arte es una especie de epifanía. Es exclusivo no sólo del carácter del artista, sino también del estado de subsconsciencia del artista durante la sesión de producción.

UN BALET DE SÍMBOLOS

En otras de las series de Clark, uno percibe un balet de símbolos de flujo libre. Se deja mucho a la interpretación del espectador porque el estilo y el medio son suficientes para dejar la obra estéticamente aceptable. El artista es lo suficientemente valiente y audaz para implicar que la belleza no es un elemento temible y se va hasta el extremo de enmarcar sus obras de manera elegante y vistosa.

Unos cuantos títulos escogidos para sus series están asociados con reinos místicos conocidos por la humanidad desde el origen de la vida humana. En *The Universe Below* (El Universo de Abajo) y en *Incubus* (Íncubo), uno descubre un mundo biológico maravilloso colorido y travieso en vez de un enfoque Darwiniano a la naturaleza – un universo de vida y reproducción – tal como lo sugieren los títulos.

Los tantos colores que acompañan estas series de vida orgánica ficticia son fascinantes. ¿Es esto una manifestación de la belleza de la vida o simplemente un tributo a la naturaleza? Él hace hincapié en la estética de la ciencia y crea estas formas como metáforas para una realidad perdida. ¿Puede ser esto simplemente una reflexión enmudecida del comienzo de la humanidad? Él nada en las aguas de la ciencia para alimentar su curiosidad insaciable sobre el origen de la humanidad.

LA IMAGEN ESPIRITUAL

En su serie *Santos*, uno es transportado de lo abstracto a lo figurativo a través de la diversión y la alegoría. ¿Porque plasma a estos personajes de una manera más humana, y aún así representa a su *Atomic Jesus* (Jesús Atómico) en una representación exclusivamente orgánica o simbólica? La

imagen espiritual se encuentra presente definitivamente en la mayoría de las obras de Clark. Él persistentemente mantiene las preguntas resonantes de fé a través de su forma de plasmar a Jesús en la serie de Santos.

En el protestantismo, la representación de figuras es rara, de cualquier manera en las representaciones de Kirk uno se encuentra constantemente frente a preguntas surgidas en la religión sobre la realidad versus aquellas de historia. Estas preguntas han sido respondidas en el pasado por artistas a través de su propio lenguaje artístico, desde Miguel Ángel, Leonardo Da Vinci hasta Murillo y El Greco. Todos estos artistas manifiestan su fé y por eso sus obras han sido juzgadas a través del tiempo como inspiraciones divinas con originalidad estética. De esta manera las representaciones simbólicas realizadas por Clark denotan una cierta estética barroca que va de la mano con su propia historia religiosa.

Curiosamente, en su serie de Santos así como también en algunas de las series de *Angel's Path* (Camino de los Ángeles), uno puede observar una característica rara atribuida al periodo Bizantino, en el cual la Sagrada Familia es plasmada sin belleza. Santos, de Clark va de Demonios a Ángeles en una interpretación visual exclusiva y genuina. Llega a un balance al ilustrar que la creencia en hadas es el único vehículo hacia la realidad, a pesar de eso las imágenes de estas mismas tienen un número infinito de interpretaciones en sus obras.

EXPERIENCIA VIVIDA

El gran número de estilos que Kirk Clark emplea para la elaboración de sus pinturas, dibujos y esculturas nacen de su propia intuición y complejidad. Alguna vez mencionó que la variación de las pinceladas dependía del cansancio de su mano. Como muchos artistas, él depende de ambos, su yo interno para la inspiración y profundidad conceptual, y de su yo físico y experiencia en la técnica para la representación.

Esto nos lleva a la serie de escultura, donde la técnica y espontaneidad ejercen el papel principal en su proceso

creativo. Las esculturas *Shock Wave* (Onda Expansiva) son obras de la imaginación del artista unida al riesgo en la técnica; los grabados en aluminio, cobre y acero son finalmente determinadas por el grabado mismo. Aquí, Clark usa la técnica que ha aprendido y aplica su propia inventiva instintiva para completar las piezas.

Originalmente formado como escultor, sus piezas reflejan comodidad y confort. Su libertad de cualquier restricción visual se convierte en una ventana de escape en su misión creativa. El contenido conceptual de la obra y la experiencia técnica son elementos propios del artista, aunque el resultado final depende de la alegría, humildad y sorprendente resultado arbitrario de esta misma.

La cantidad de series realizadas por Clark representan capítulos de su odisea espiritual así como las memorias de las experiencias de una vida. Él transpone muchos de sus ideales al mundo creado por su imaginación y combina la realidad con la fantasía en una perfecta coreografía visual. Kirk Clark es tanto un artista humanístico como espiritual. Como hombre, Kirk comunica sus ideas y pensamientos de la vida, el amor. Lo etéreo lo comunica a través de su propio lenguaje, su arte.

La obra de Kirk Clark, con sus muchos estilos e influencias, es una representación de la humanidad y nuestra singularidad en un universo habitado por ángeles que guían al artista en un camino solitario y sin fin dictado por su arte. En esta exhibición el espectador es llevado por la mano de uno de los ángeles de Kirk y sutilmente inducido a la imaginación de un artista cuyo espíritu no puede hacer otra cosa más que comprometerse completamente. Por esto, la celebración del espíritu comienza…

SOBRE EL LIBRO

Este libro que acompaña la exhibición retrospectiva de Kirk, comenzó como una simple idea que evolucionó hacia un producto rico en investigación y análisis. El reto de articular el camino estético de la vida de un artista con el emocional, es uno con el cual el artista mismo, rara vez llega a enfrentarse en vida. Normalmente, éste es un evento que tiene lugar después del fallecimiento del artista y que es llevado a cabo por los críticos y aquellos que han vivido cerca de él. En el caso de *A Celebration of Spirit* (Celebración del Espíritu), Kirk Clark ha ahondado física y literalmente en su pasado para encontrar sus raíces estéticas lo que se refleja dentro de las palabras e imágenes que componen este libro.

Su proceso personal fue algunas veces catártico; su perseverancia fue implacable; su dedicación fue devota; aún a pesar de todos los obstáculos y retos de un proyecto tan ambicioso, Kirk fue siempre agradecido, cálido y considerado con todos los que nos embarcamos en esta gran aventura con él.

En la biografía de San Francisco de Asís escrita por, G.K. Chesterton el autor comenta "Es de una forma cínica que el hombre ha dicho 'Bendito sea el que no espera nada, ya que no será decepcionado.'" Fue en un sentido totalmente felíz y entusiasta que San Francisco dijo, "Bendito sea el que no espera nada, ya que disfrutará de todo".

Kirk Clark comparte el optimismo de San Francisco y pone en práctica su extraña filosofía, cosechando la dicha de la vida a través del arte, solo para compartirla con el mundo.

Kirk Clark • *Universe Below* (Universo de Abajo) • 005 • Pluma y tinta sobre papel • 14 x 11 in.

La herencia artística de Charles y Dorothy Clark
por Kirk Clark

Soy afortunado. Nací el 2 de mayo de 1946, siendo mis padres Charles y Dorothy Clark. Fueron los padres más cariñosos, cuidadosos e interesantes que cualquier niño pudiera tener. Su amor por la vida y del uno por el otro, además de una fascinación por las artes y los artistas, sería una gran influencia en mi vida al pasar los años.

Mamá nació en Lodi, California, Papá en Peoria, Illinois. Ambos fueron artistas talentosos. Papá estudió dos años en el Instituto de Arte de la ciudad de Oklahoma, donde recibió un reconocimiento artístico y ganó un concurso por el diseño de una tarjeta navideña que sería usada por la ciudad. La tarjeta navideña se convirtió en la tarjeta oficial de la ciudad de Oklahoma. Mi madre era una californiana de origen holandés y también estudió arte pictórico y teatro, en la Universidad del Pacífico en Stockton, California, donde obtubo su título en inglés y literatura con una acentuación en el arte.

DOS ARTISTAS SE CONOCEN

Mis padres se conocieron en California, donde Papá estudiaba en la escuela de vuelo, para convertirse en piloto de B-17. Se encontraron en un evento social en la base de la fuerza aérea. Fue amor a primera vista.

Hubo un romance intenso, una boda en un registro civil en Coeur d'Alene, Idaho. Mi abuelo paterno voló desde Peoria, Illinois para la boda. Al poco tiempo, terminó la escuela de aviación y bombarderos antes de entrar a la guerra como piloto de B-17 y obtener el rango de Capitán.

AÑOS DE GUERRA

El 19 de mayo de 1943, el B-17 de mi padre, fue el blanco del fuego anti-aéreo disparado desde la tierra sobre Kiel, Alemania. Cuando el Sanguinario Tangiers le disparó a la

sección trazera de su B-17, Papá sacó a los miembros de la tripulación antes que él mismo saltara con paracaídas. Tuvo una caída libre de alrededor de 30 mil pies antes de abrir su paracaídas en el último momento, se columpió dos veces bajo éste, ya abierto, antes de caer con fuerza en tierra. Sintió un fuerte dolor. Más tarde se dió cuenta que se había roto dos vértebras y se había oprimido un disco en la espalda.

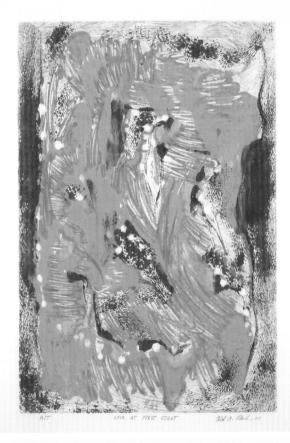

Kirk Clark • *Love at First Sight* (Amor a Primer Vista) • 2004
Monotinta • 29.5 x 22 in.

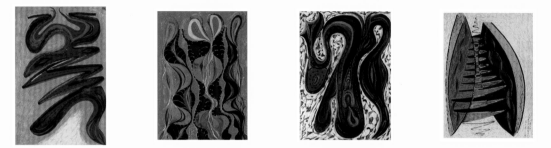

Kirk Clark • *Shockwave Series* (Serie Onda Expansiva) • 2005 • Pluma y tinta sobre papel • Dimensiones variadas

Mi Padre fué capturado por los alemanes y lo llevaron inicialmente a Stalag Luf III. Sobrevivió estas marchas mortales que costaron la vida de muchos prisioneros de guerra estadounidenses y británicos.

Mi padre fué liberado por el General Patton y sus tropas. Recibió la Cruz de Vuelo distinguido con dos grupos de hojas de cedro. Su rango final fué de Mayor.

Su experiencia de guerra afectó su vida posterior de muchas formas que no conocimos hasta después de su muerte en 1990. Descubrimos que Papá, como muchos veteranos de esos tiempos, sufría del síndrome de estrés post-traumático. Ese descubrimiento explicó muchas cosas.

Le tomó varios años recuperar su salud y su vigor, después de que fue prisionero de guerra. A finales de los años 40, mis padres se mudaron de California a McAllen. Después de su recuperación física, Papá regresó a McAllen para unirse a su padrastro, J.V. Carpenter en el negocio de automóviles.

UNA PASION COMPARTIDA POR EL ARTE Y LA VIDA

Mis padres compartían su pasión por la vida, el arte, los artistas, y por su familia. Una vez que se establecieron en McAllen, siguieron su interés por el arte y cambiaron el interés de el estudio de arte por el coleccionismo de este, particularmente por impresiones de ediciones limitadas a finales de los años 40.

A principios de los años 50, mis padres no eran ricos. Cada pieza de arte que coleccionaban requería de una cuidadosa consideración.

El arte era algo fascinante para mí cuando era niño. No entendía las técnicas que Papá describía en relación con las imágenes, pero estaba fascinado con ellas. Más tarde, en mi adolescencia, logré una apreciación por los aspectos técnicos de los grabados. El arte traía alegría a la casa de los Clark.

Hacíamos un viaje a Lodi, California cada dos años, para visitar a los padres de mi madre, los Van Gelders. Fue en esos viajes donde Mamá y Papá empezaron a explorar la escena artística de California.

Mis padres comenzaron a adquirir piezas de arte modestas, acuarelas por Joshua Meador y diversos grabados de artistas en California. Estas adquisiciones comenzaron a alimentar la pasión de mis padres por el arte convirtiendose en coleccionistas serios, e investigando y viajando para conocer a los artistas.

Más tarde contarían cientos de artistas, directores de galerías, curadores de museos, estudiantes y el público en sí entre aquellos que venían a admirarlos por su entusiasmo, excelencia académica y su ojo experto para el arte, esto sin mencionar su gran generosidad. Pienso que el arte y la investigación se volvieron terapéuticos para Papá a lo largo de su vida de pos-guerra.

EL MUNDO DE LOS NEGOCIOS

Cuando mis padres regresaron a McAllen, el padrastro de mi padre, J.V. Carpenter lo puso a trabajar en el taller lijando autos. Papá se tuvo que ganar su transferencia al departamento de ventas de autos y camiones nuevos. La lesión en su espalda durante la guerra volvía más ardua la tarea de lijar autos. Afortunadamente, se graduó a un trabajo en donde usaba su cabeza y no solo sus manos. Papá era licenciado en economía y comercio exterior de la Universidad de Michigan, en Ann Arbor, Michigan.

EL PRINCIPIO DE LA COLECCIÓN DE ARTE

Pronto, Papá y Mamá viajaron a Lodi otra vez. En su estancia en California empezaron a comprar el trabajo de algunos artistas californianos. Uno de los artistas que les llamó la atención era el acuarelista Joshua Meador. Meador se convirtió en uno de los acuarelistas de más renombre en California, y su trabajo se volvió de mucho valor de colección a lo largo de los años. Éste fue el principio de 40 años de coleccionar, escribir acerca del arte contemporáneo y de dar conferencias.

Con frecuencia, mis padres coleccionaron los trabajos de edición limitada en papel. Ambos, tenían buen ojo para la composición en el espacio y el color. Papá intentaba atrapar a los grandes artistas en la etapa más incipiente posible de sus carreras. Recuerdo que en todos nuestros viajes relacionados con el arte, Papá preguntaba a los artistas establecidos quienes serían los siguientes artistas. Papá, con la ayuda de Mamá, empezaba a rastrear historiales en subastas, historia de ventas en galerías, y monitoreaba las opiniones de otros artistas.

Jakob Bill, hijo de Max Bill, uno de los fundadores importantes del movimiento del constructivismo suizo, fue un ejemplo de un joven artista sobresaliente que obtuvo reconocimiento nacional en Suiza al paso de los años. Mi padre, frecuentemente identificaba el trabajo de los artistas nuevos que tenían alguna cualidad.

EL ESPACIO DE ARTE

Dorothy Norris, una buena amiga de mis padres, diseñó una extención a nuestra casa. La extención fué con el propósito de proveer espacio apropiado para almacenar adecuadamente los grabados que aún no estaban enmarcados, así como para pinturas y hacer la función de biblioteca de investigación.

Todo espacio adicional, tenía un propósito y funcionaba perfectamente. Tenía un largo escritorio fijo que casi atravesaba el cuarto con dos cortes, uno era para Mamá y otro para Papá, dándoles su propia área de trabajo y con un librero justo en frente de ellos que también ocupaba el cuarto de extremo a extremo. El cuarto de arte era un lugar serio para el estudio. En el cuarto de arte, no se nos permitía jugar.

Realmente admiraba a mi padre por trabajar arduamente todo el día en la oficina, luego llegaba a casa a cenar rápidamente y se iba al cuarto de arte con Mamá a trabajar en sus investigaciones y a estudiar durante dos o tres horas. Cuando los artistas venían a casa, pasaban al cuarto de arte/biblioteca de arte, y se rompía el hielo. Su entusiasmo era contagioso. Sé que yo me contagié.

Kirk Clark • *Shockwave Series* (Serie Onda Expansiva) • 2004 - 2005 • Pluma y tinta sobre papel • Dimensiones variadas

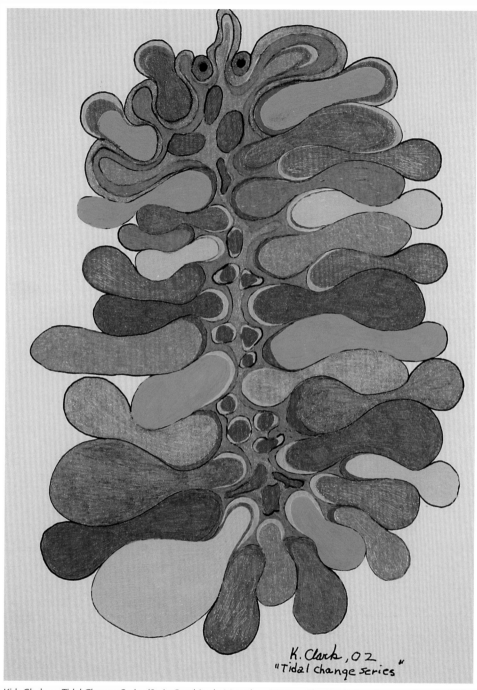

Kirk Clark • *Tidal Change Series* (Serie Cambio de Marea) • 2002 • Pluma y tinta sobre papel • 8 x 10 in.

Explorando movimientos artísticos europeos

EXPRESIONISMO ABSTRACTO ALEMAN

Uno de los intereses artísticos iniciales de Papá fue el Expresionismo Abstracto Alemán, Papá no hablaba alemán, pero aprendió estudiando con un diccionario inglés/alemán para poder estudiar los manuscritos originales del movimiento artístico que estaban escritos en este idioma.

En aquel tiempo yo no comprendía porqué un hombre que había ido a 24 misiones de bombardeo sobre Alemania, y que había sido prisionero de guerra durante casi dos años, sentía atracción por el arte producido por la cultura que lo mantuvo cautivo y apenas vivo.

ESCUELA AUSTRIACA DE LO FANTÁSTICO

En algún momento de las últimas etapas del intenso estudio de Papá del movimiento artístico alemán, comenzó a explorar un movimiento artístico de Austria llamado la Escuela Austriaca de lo Fantástico. El Profesor Ernst Fuchs fue el fundador del movimiento que cautivó su atención. Fuchs era un escultor maestro, pintor y hacía grabados.

Mis padres habían ido a París, Francia para la apertura de la exhibición de Ernst Fuchs en 1962. Papá, que siempre hacía su tarea antes de ir a una apertura artística, asombró al Profesor Fuchs con su conocimiento del arte de este último.

Años después, en 1999, Jeri, mi esposa, y dos de mis hijos, Alex, de doce años, y Daniel, de ocho, estaban de viaje por Europa conmigo, y teníamos programado detenernos en Viena. Yo estaba decidido a empezar temprano el recorrido y me reuní con un guía, Rudi Evers. Me preguntó cuáles eran los artistas que más me interesaban. Rápidamente le respondí que el Profesor Ernst Fuchs. Su voz cambió y con una gran sonrisa me preguntó, "¿Conoce el trabajo del Ernst Fuchs?" El guía dijo, "¿Sabe que va a pasar por la casa y museo del Profesor Fuchs mañana en su camino a Salzburgo?" No lo sabía.

El guía sacó su teléfono celular y llamó de inmediato y logró comunicarse. Habló con la nuera del Profesor Fuchs, quien era la administradora de el museo/galería de Fuchs. Ella acordó una visita de treinta minutos a media mañana al día siguiente. Yo no podía creer que íbamos a conocer a Ernst Fuchs.

EL MUSEO DE ERNST FUSCH EN EL BOSQUE NEGRO

A la mañana siguiente fuimos directamente al Museo del Profesor Fuchs en El Bosque Negro. La puerta la abrió una bella joven que nos dio la bienvenida. Nos advirtió que el profesor tenía una agenda muy ocupada y que ella estaría muy agradecida si no nos excedíamos en los treinta minutos de nuestra visita. Le aseguré que no lo haríamos.

Miramos hacia el extremo del Museo y vimos a un hombre alto vestido con una túnica y un turbante color ocre, seguido de cerca por un séquito, anonadados todos con sus palabras. Fuchs tenía gravitas. Era un hombre impresionante. Sonrió al acercarse a nosotros, extendió su mano grande y firme.

"PORSUPUESTO QUE RECUERDO"

"¿De casualidad recuerda a mis padres, Charles y Dorothy Clark, de McAllen, Texas?" le pregunté. Le dije en seguida que ellos me habían platicado que conocieron al Profesor Fuchs en París durante la apertura de su exhibición en 1962. Fuchs sonrió y dijo, "Pero claro que recuerdo a Charles y a Dorothy Clark, nunca he conocido a nadie antes desde entonces que supiera más acerca de mí que yo mismo."

Fuchs tuvo la gentileza de llevarnos en un recorrido del museo. Terminamos pasando tres horas con Fuchs y pasamos un rato increíble. La nuera manejó muy bien a la

gente que esperaba y que quería ver al Profesor en cuanto nos fuéramos nosotros. Estábamos muy agradecidos por haber logrado esa maravillosa conexión.

Algunos años más tarde, mi hijo mayor, Charlie, visitó al Profesor Fuchs. Charlie, convenció a Fuchs de darle muy buenos descuentos en varias obras, una de ellas me la regaló, una bella Biblia ilustrada coloreada a mano por Fuchs. Ese ha sido uno de los mejores regalos que he recibido jamás.

CONSTRUCTIVISMO SUIZO

Desde principios de los años sesenta, hasta mediados de la misma década, el interés artístico de mis padres gravitaba hacia el Constructivismo Suizo, movimiento Concreto, muy influenciado por el Bauhaus y el lugar ideal para los artistas creado por la neutralidad suiza durante la Segunda Guerra Mundial. El Profesor Max Bill era el principal arquitecto de Suiza y un reconocido artista. Su hijo, Jakob, tuvo gran influencia del trabajo de su padre y fue un exitoso artista también.

Camile Graeser definió el arte Concreto Suizo en 1944, "Concreto significa renunciar a la presentación de un mundo óptico figurativo en el arte – significa crear un mundo nuevo y claro de imágenes, erigir, construir y desarrollar ritmos en una base geométrica – quiere decir pureza, ley y orden."

Suzanne Bollag tradujo del alemán al inglés. Esta definición se usa en su introducción para la exhibición del Constructivismo Suizo que Mamá y Papá organizaron para la Universidad de Texas en Austin, a principios de los 70.

Mis padres conocieron a Suzanne Bollag de Zurich, Suiza. Suzanne era la dueña de la Galería Bollag en Zurich y se convirtió en una amiga querida de la familia. En sus viajes a Suiza, Suzanne llevaba a mis padres a que conocieran artistas al rededor de Zurich. A mis padres les atrajo mucho el grupo de artistas que Suzanne representaba. Mamá y Papá pensaban que estaban en una verdadera tienda de golosinas.

Jurg Janet y Franz Loressa, quienes eran dueños y directores de la Im Merker Presse en St. Gallen, Suiza, se hicieron buenos amigos de mis padres, estoy seguro, de que quienes conocieron a mis padres, lo hicieron a través de Suzanne Bollag. La Im Merker Presse producía y vendía ediciones limitadas de grabados de los mejores artistas contemporáneos de Europa para venderlas y distribuirlas por el mundo.

Mamá y Papá se hicieron miembros de un grupo selecto de coleccionistas que estaban de acuerdo en comprar un grabado de cada uno de los artistas que estaba trabajando durante el año. Ansiaban recibir su grabado mensual. Cada Navidad la imprenta invitaba a un artista a diseñar una tarjeta navideña original de edición limitada que se les enviaba a los suscriptores. Tuve la oportunidad de visitar a Jurg y a Franz con mis padres en varias ocasiones. Era difícil para Mamá y para mí mantener el ritmo de Papá, cuya energía no tenía límites.

VISITAS A GALERIAS EN EUROPA

A fines de los años sesenta, empezamos a pasar la mayor parte de nuestras vacaciones en Europa. Viajamos a Zurich donde nuestra querida amiga, Suzanne Bollag, hizo posible que nos reuniéramos con artistas en su galería, y también a St. Gall, donde nuestros amigos Jurg Janett y Franz Larese llevaban artistas para que crearan grabados en sus talleres. Pudimos ver la interacción entre los artistas y maestros en grabado además de los resultados finales producidos en las imprentas.

La primera vez que nos reunimos con el Profesor Max Bill fue en 1970 en Zumikon, Suiza afuera de Zurich. Su colección personal de constructivismo inicial y de obras de artistas concretos llenaría un pequeño museo. Tres años más tarde, regresamos a Zurich y a la casa de Max Bill, esta vez con el hijo del profesor, Jakob y su nuera Chantal. El trabajo de Jakob muestra la influencia de su padre, pero es distintivo y tiene mérito propio. Siguieron reuniones con el Profesor Fritz Wotruba en la Academia de Viena."

Durante ese viaje, recuerdo también haber visitado a Becky Schuster Jones en la Academia de Viena. Becky era la única estudiante Americana de arte que había recibido una beca completa para su licenciatura y postgrado, durante todos los años que estudiara ahí. Becky es actualmente instructora de arte en el Colegio del Sur de Texas, es también una maravillosa fotógrafa y artista, así como madre de una linda niña y esposa de Foss Jones.

Siguieron las reuniones en la Im Merker Presse con Asgor Jorn, el principal artista de Dinamarca de aquel tiempo. Mamá y Papá tuvieron una visita de ocho horas con él en St. Gall. Desde entonces Mamá y Papá coleccionaron el trabajo de Jorn.

Mis padres fueron a Munich durante el viaje de 1970 a visitar al Profesor Toni Stadler y a su esposa, Priska Von Martin. Ambos eran principalmente escultores. Otros artistas que Mamá y Papá conocieron durante ese periodo fue Par Gunnar Thelander, líder de un grupo de artistas llamados "Los Nueve".

Philip Von Shantz era director del Moderna Museet en Estocolmo durante ese periodo, Giuseppe Santomaso, de Venecia, es otro artista de la Im Merker de gran talento y encanto. Otto Dix, el gran artista alemán impresionó mucho a mis padres. Esta reunión tomó lugar tres años antes de que falleciera Otto.

Kirk Clark • *Angel's Path* (Camino de los Ángeles) • 2005
Pluma y tinta sobre cartulina • 10 x 8 in.

Kirk Clark • *Angel's Path* (Camino de los Ángeles) • 2005
Pluma y tinta sobre cartulina • 10 x 8 in.

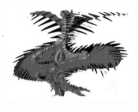

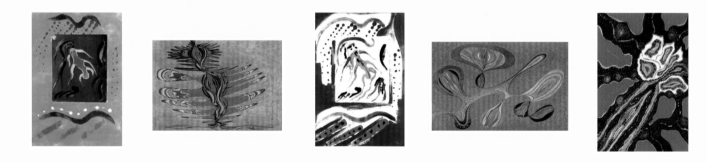

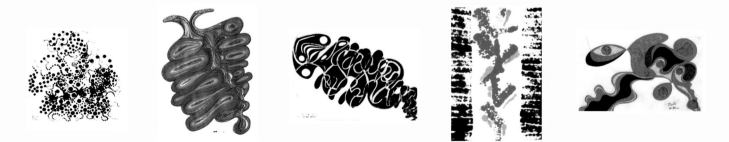

Kirk Clark • Diversas obras, dimensiones y técnicas • 1964-2005

Exposiciones y Obsequios de Arte

IMPRESIONES DE EDICIÓN LIMITADA

A mediados de los año sesenta la colección de arte de mis padres, especialmente los grabados de edición limitada se acercaban a los mil. Donaron muchas de estas obras a más de treinta museos y universidades durante los años 60. El espacio en su casa era limitado en ese momento y estaban obsesionados con el almacenamiento adecuado y el cuidado de su colección.

El 10 de noviembre de 1966 Mamá y Papá tuvieron una exhibición de su colección emergente en el Banco Estatal de McAllen, donde Papá formaba parte de la mesa directiva. El banco le pidió a mi padre que adquiriera algunas obras de arte para que se exhibieran en el banco. Fue muy divertido para Papá y muy lucrativo para el banco.

El 30 de julio de 1967, Mamá y Papá donaron obras a varios museos, que incluían el Museo de Arte de San Francisco, la Universidad de California, Berkeley, la Universidad de Nuevo México en Albuquerque, NM, y el Museo Andrew Dickinson White, y en la Universidad de Cornell, Ithaca, Nueva York. Sus obsequios representaron una amplia sección de trabajo artístico, principalmente de grabados de edición limitada.

Algunos de los artistas cuyos trabajos fueron donados por mis padres incluían los siguientes: Max Ernst, alemán; Lucio Fontana, italiano; Ger Lataster, holandés; Ernst Fuchs, austriaco; Sam Francis, estadounidense; Victor Passmore, inglés; Corneille, holandés; Hans Hartung, alemán; Dorothy Boman y otros mas. Los obsequios fueron muy bien recibidos por cada uno de los museos.

EL PAPEL CRITICO DE LOS MUSEOS

Mis padres reconocieron el papel de importancia crítica de los museos en particular e hicieron todo lo que pudieron para apoyarlos con obsequios de arte y otros donativos. Se dieron cuenta que los museos tienen el potencial de ser instituciones vivientes que ofrecen a sus comunidades una vista única hacia el pasado, capturan el presente y enseñan acerca de las posibilidades para la humanidad en el futuro.

Los museos son más que repositorios de historia y cultura, organizaciones vivientes que con la participación adecuada de un liderazgo y de la comunidad se pueden convertir en el corazón de cualquier comunidad y en un destino para jóvenes y viejos para experimentar una amplia gama de lo mejor de la humanidad. Los museos respiran sensibilidad, una vitalidad de emoción, ayudan a enfocar la conciencia en la calidad de nuestras vidas. Nuestros museos merecen nuestro apoyo y merecen lo mejor que les podamos dar en tiempo, talento y tesoro.

REGALOS ESPECIALES

El 24 de Septiembre de 1967, mis padres donaron cuarenta y dos óleos, acuarelas y grabados de edición limitada a la Universidad de Texas A&I en Kingsville, Texas, incluyendo un portafolio de artes gráficas, con muchos grabados de edición limitada de Nueva York. Las obras eran de naturaleza exploratoria y experimental.

En marzo de 1969, La Universidad del Pacífico recibió tres grabados y una pintura donados por mis padres. Mamá tenía muy buenos recuerdos de sus años en la Universidad del Pacífico, en Stockton, California, donde se graduó con honores.

Le pregunté a Papá una vez, "Papá, hay algo en tu colección que quieras tanto que no lo regalarías?" Papá dijo, "Hijo, no tengo nada que me pertenezca y que no esté dispuesto a regalar. No creo poseer nada. Solo soy administrador de mis posesiones. Dios me ha dado la

oportunidad, a través del amor a la vida, el amor a Dorothy, a el estudio, los viajes y el coleccionar arte de todo el mundo."

EXPOSICIÓN EN AUSTIN EN 1968

Mis padres trabajaron duro en enero de 1968 para preparar una exposición de artes gráficas contemporáneas en el Museo de Arte de la Universidad de Texas en Austin. Mi padre curó esta exhibición. Sé el gran placer y la emoción que le brindó a mis padres el estar involucrados en la organización de ésta, particularmente por tratarse de esta universidad.

LA SELECCIÓN DEL COLECCIONISTA, UNIVERSIDAD DE MICHIGAN

En abril de 1971, curaron la exposición llamada *Collector's Choice* (La selección del coleccionista), del 1º de abril hasta el 27 de junio en la Universidad de Michigan. La exhibición incluía a los siguientes artistas: Horst Antes, Garo Antresian, Jakob Bill, Max Bill, Lee Bontecou, James Boynton, Kirt Bundell, Eugenio Carmi, Eduardo Chillida, Karl Dahmen, Allan D'Arcangelo, Piero Dorazio, Angel Duarte, Wojciech Fangor, David Folkman, Sam Francis, Ernst Fuchs, Fritz Genkiger, Terry Gravett, Howard Hack, Asger Jorn, Karl Kasten, Konrad Klapheck, Rainer Kuchenmeister, Arnold Leissler, Thomas Lenk, Richard Lindner, Joan Miró, Peter Nagel, Werner Nofer. Wolfgang Opperman, Joshua Reichert, Giuseppe Santomaso, Toni Stadler, Antoni Tápies, Mark Tobey, Fritz Wotruba, y Paul Wunderlich.

La gran mayoría de estos grabados se donó a la Universidad de Michigan en el momento de la exposición. Papá era egresado de la Universidad de Michigan y estaba encantado de formar parte del consejo de Bellas Artes en la misma universidad.

EXPOSICIÓN DE ARTE CONTEMPORÁNEO EN HOUSTON

Mi padre me invitó a Houston a reunirme con Pierre de Montebello, el director del Museo de Bellas Artes de Houston. Un hombre joven que había trabajado en el Departamento de Arte de la Universidad Pan American en Edinburg, Texas. Nuestro encuentro con de Montebello fué memorable ya que se impresionó con nuestra propuesta de grabado contemporaneo.

Después de unos meses, la exposición abrió en el Museo de Bellas Artes de Houston. La exposición fue bien recibida y tuvo una buena asistencia. Yo nunca olvidaré esa cita. Esto me enseñó varias de las lecciones más importantes de la vida, incluyendo, el estar totalmente preparado, y siempre saber lo que se está haciendo.

GRÁFICA ALEMANA EN LOS AÑOS SESENTA EN LA UNIVERSIDAD EN AUSTIN

El 17 de febrero de 1974 abrieron su exhibición, *German Graphics of the Sixties* (Gráfica Alemana de los Sesenta), en la Galería Archer M. Huntington, Museo de la Universidad de Arte en la Universidad de Texas en Austin. Esta exposición se diseñó para documentar la resurgencia de la actividad de las artes gráficas en Europa central, incluyendo la totalidad de Alemania después de la Segunda Guerra Mundial.

Mamá y Papá echaron un vistazo a la década de los años sesenta para ver lo que se producía en las artes gráficas alemanas. Papá fue el curador invitado de la exposición. Donald Goodall era el Director del Museo y Marian Davis era la Curadora.

La exposición fué profesionalmente aclamada. Se incluyeron obras de mas de 100 artistas. Es una colección impresionante del arte Gráfico Alemán. Mamá y Papá dieron una reseña biográfica de cada artista y una lista de todas las galerías de Alemania que manejaban Gráfica Alemana de los años sesenta, así como un listado de todos los talleres alemanes.

La investigación, el catálogo y la exposición fueron una gran empresa. Donaron la exposición y la investigación a la Universidad de Texas como un conjunto completo de enseñanza.

LA UNIVERSIDAD ESTATAL DE LOUISIANA

Mis padres patrocinaron una exposición de grabado contemporáneo de su colección en la Galería de la Unión de la Universidad Estatal de Louisiana del 7 al 26 de noviembre de 1974. Mis padres estaban encantados con el hecho de que un miembro de la facultad de arte de la Universidad de Michigan, Sydney Garret, tomara un puesto en la Universidad Estatal de Louisiana (LSU). Papá preparó una propuesta para una exposición de grabado contemporáneo en la LSU que mis padres donarían a la universidad en honor a su nuevo director.

EXPOSICIÓN DE ARTE CONCRETO SUIZO EN LA UNIVERSIDAD DE TEXAS, AUSTIN

La siguiente muestra que mis padres organizaron fue de *Swiss Concrete Art in Graphics* (Arte Concreto Suizo Gráfico). Esta exposición se llevó a cabo a mediados de los años setenta en la Galería Archer M. Huntington en la Universidad de Texas en Austin. Esta exposición puede haber sido la mejor de mis padres. Solo la historia lo dirá.

El Arte Concreto Suizo les brindó a mis padres una alegría muy intensa. La investigación previa que hicieron mis padres en cuanto al Expresionismo Abstracto Alemán, con sus muchos movimientos y complejidades, generó muchos desafíos y les tomó considerable energía intelectual a los dos.

Suzanne Bollag escribió un maravilloso ensayo en el catálogo para la exhibición suiza en la Universidad de Texas en Austin. Mamá y Papá estaban particularmente inspirados con esta escuela de arte debido a su naturaleza no representativa, su base matemática subyacente y sus fórmulas para un orden social inherente.

Otra cosa interesante es que la exposición representaba el arte de tres generaciones de artistas suizos, mientras que mantenía una increíble consistencia a lo largo de las obras.

GRABADOS CON DEDICATORIA EN LA UNIVERSIDAD DE TEXAS, AUSTIN, 1976

Desde el 5 de diciembre de 1976 al 13 de febrero de 1976 se exhibió en la Universidad de Texas en Austin una muestra muy interesante. La exposición se llamó, *Personal Dedication Prints, from the Collection of Charles & Dorothy Clark* (Grabados con Dedicatoria, de la colección de Charles y Dorothy Clark). Me conmovieron las palabras escritas en el prefacio por el director del museo, Donald Goodall acerca de mis padres y de su conexión personal con los artistas cuyo trabajo admiraban y disfrutaban tanto.

LOS ARCHIVOS DEL INSTITUTO SMITHSONIAN

Recuerdo que poco después de la conclusión de esta maravillosa exposición, el Museo Smithsonian en Washington, D.C. envió un gran camión a McAllen, lo cargaron con los archivos de correspondencia personal, que eran bastantes, llenos con copias de cartas escritas por Papá a distintos artistas, directores de galerías, curadores de museos, artistas de grabado y coleccionistas así como cartas de respuesta, y lo llevaron de regreso a Washington, D.C. Transfirieron todo esto a microfilm para que formara parte de los archivos nacionales y regresaron meses después.

EXPOSICIÓN DE ARTE CONCRETO EN LA UNIVERSIDAD PAN AMERICANA EN 1977

Poco después del cierre de la exposición de Grabado con Dedicatoria en la Universidad de Texas en Austin, en 1977, la Universidad Pan American sostuvo una exposición de grabado selecto de artistas del concreto en el salón Centro de Recursos de Aprendizaje. Ed E. Nichols, un instructor de arte altamente respetado en la Universidad Pan American organizó la exposición.

"MAS GRANDE QUE LA VIDA"

A Papá le dió un derrame cerebral en 1987 y nunca recuperó del todo su energía, lo que lo frustraba mucho.

Hasta el derrame, siempre lo veía más grande que la vida misma. Fuera de una pérdida de memoria a corto plazo, su mente permaneció aguda hasta su muerte de un ataque masivo al corazón el 21 de febrero de 1990. Mamá cuidó de todas sus necesidades hasta ese momento, sacrificando incluso su vida personal. Era un verdadero ángel.

Ella y yo lloramos juntos la pérdida de Papá. Habían sido mis mejores amigos durante toda mi vida. El entierro de Papá fué en la Iglesia Episcopal de la Trinidad, en Pharr, Texas, a la cual nuestra familia había asistido durante treinta y tres años.

Mamá empezó a asistir a la oficina medio día y me ayudaba con el correo del negocio. Revisaba las salas de espera de servicio para asegurarse que los clientes estaban bien atendidos. Nos mantenía a todos funcionando.

UNA ESTRELLA

A Mamá la invitaron a hablar acerca de los años en que estuvo coleccionando junto a mi padre. Tenía muy buena memoria y un agudo sentido del humor. Empezamos a hacer anuncios de automóviles juntos, a inicios de los 90. Era una gran actriz y nos reíamos mucho en el set de producción de la televisión. Mamá se convirtió en una celebridad local y era un increíble vocero para nuestro negocio Chevrolet en McAllen, Texas. Siempre salíamos en pantalla juntos y se convirtió en estrella. Fué un día muy triste cuando ella se reunió de nuevo con mi padre en 1997.

IN MEMORIAM DE CHARLES CLARK, UNIVERSIDAD DE TEXAS, AUSTIN 1991

La Universidad de Texas en Austin produjo una fantástica exposición de arte en enero de 1991 la cual se llamó *Charles Clark in Memoriam* (En Memoria de Charles Clark), Grabados Europeos y Americanos desde 1960. Jonathan Bober fue el curador en la Universidad de Texas, Austin.

Mis padres le tenían mucho cariño a Jonathan y apreciaban el esfuerzo hecho por él, Becky Duval Reese, directora interina,

Mark Petr, estudiante graduado que escribió de forma brillante en el catálogo sus impresiones de la historia del coleccionismo de mis padres. En el momento de la exposición in memoriam a mi padre, el espacio de grabado de la Universidad fué nombrado la Sala de Grabados Charles y Dorothy Clark.

Al ver el catálogo de la exposición, me llenó de emoción. Cada ilustración del trabajo del artista trae memorias de su viaje juntos por el arte. Fue una exposición maravillosa, una muestra de amor y de apreciación a mis padres. No había un ojo sin lágrimas en la galería, eran lágrimas de alegría por las memorias de un hombre sobresaliente, sabio, generoso y amoroso. Gracias U.T., Austin. Todos son maravillosos.

ADMINISTRADORES DE ARTE

Mis padres facilitaban el conocimiento artístico y lo difundían como misioneros, de continente a continente. Su generosidad los guiaba por el camino de la administración. Mi padre se veía como un administrador de arte.

Él y Mamá le daban valor a su colección a través de su investigación y visiones internas. Este valor agregado de la investigación y la experiencia de la colección directa le añadía una cualidad especial a sus colecciones y donaciones. Papá disfrutaba mucho el regalar bloques de grabados junto con su investigación para que los regalos se convirtieran en unidades de enseñanza en las universidades y museos que los recibían.

Mis padres fueron el gran ejemplo de lo que se puede lograr con un presupuesto modesto, inspirados por un apasionado deseo por aprender y enseñar acerca del arte, de los artístas y por dar algo de gran valor a la comunidad.

Su deseo de compartir sus descubrimientos con otros, tantos como prestaran atención y escucharan, era un verdadero milagro para mí. Su compulsión era investigar, revelar conexiones e influencias entre artistas, y desarrollar conocimiento acerca de una escuela de arte, coleccionar arte que representara el movimiento, y después donarlo a un museo o universidad que sabían que disfrutaría de la obra.

A la manera de un artísta - Autorretrato
por Kirk Clark

APRENDIENDO DE LA VIDA Y EL ARTE

Me desafiaba la pasión de mis padres por el arte, este desafío, era de aspecto inspirador. Francamente, me di cuenta que en la casa Clark, más valía estar con el programa, o te podías quedar atrás.

A los 9 años de edad, me empezó a interesar el dibujo. Pasaba más tiempo dibujando que el resto de los niños de mi edad. Debí traerlo en mi DNA. A los diez, ya estaba pintando mis primeros óleos en lienzos, tres de los cuales están en mi exhibición retrospectiva. Principalmente intentaba hacer paisajes, uno de ellos tenía un lado surrealista.

Mi primera pintura llevaba el título de Ciprés Solitario. La pintura muestra un árbol de ciprés solitario ubicado en una roca que ve hacia el Océano Pacífico en un trayecto de 17 millas entre Monterrey, California y Carmel, dos de mis lugares preferidos en el planeta. La segunda pintura se llamaba "Caída de Fuego" y muestra la caída del fuego ceremonial en el Parque Nacional Yosemite de California.

Ingresé a la escuela preparatoria en McAllen en 1960. Debo admitir que no era un estudiante particularmente disciplinado. Parecía que me iba bien en los cursos que me interesaban y que me iba muy mal en aquellos en los que no tenía interés. Tuve buenos resultados en mis clases de arte, historia, comunicaciones y en el debate de la preparatoria.

PRIMERA VENTA DE ARTE

En mis años de preparatoria pensé que posiblemente hubiera un artista dentro de mí. De hecho, recuerdo un autorretrato, mi primero, como estudiante de secundaria y lo ingresé en un concurso de arte durante la Fiesta Citrus en la ciudad de Mission, Texas en 1962. Mi pintura, que

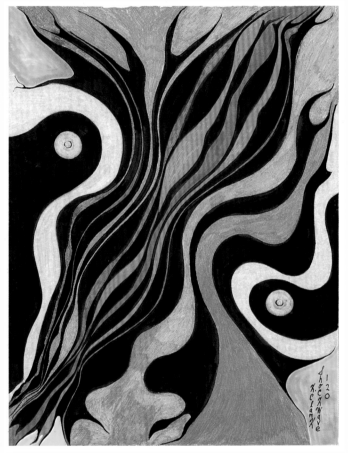

Kirk Clark • *Shockwave 120* (Onda Expansiva 120) • 2004
Pluma y tinta sobre papel • 11.5 x 9 in.

llamé *Armageddon* (Armagedón), obtuvo el primer lugar en la división de pintura abierta.

Una mujer de una liga local de arte se acercó y me preguntó, "¿Cuánto quieres por tu pintura, hijo?" Le dije que apreciaba su interés pero que la pintura no estaba en venta. Ella era persistente, y preguntó, "¿Si lo estuviera, cuánto

pedirías por ella?" Le dije, "No lo sé." Ella era decidida y dijo, "¿Aceptarías $300 por ella?" Casi me desmayo, pero me controlé y le dije, "Trato hecho."

Se fue con mi pintura y yo guardé tres billetes de cien dólares en el bolso de mi pantalón de mezclilla. Me sentía en las nubes. Era más dinero de lo que había tenido en toda mi vida. Las cosas empezaron a cambiar cuando llegué a casa y empecé a pensar en la venta de mi pintura que había sido galardonada. Pienso que en ese momento me di cuenta que también llevaba dentro de mí a un hombre de negocios.

Aquella primera pintura que vendí, aún es memorable para mí. La hice en estilo cubista, surrealista en naturaleza y se caracterizaba por unos ojos que embrujaban, ojos que veían el fin del mundo. Nunca sabes cuanto va a significar para ti una obra de arte que estás creando hasta que la hayas vendido o regalado.

VISITA DE ESTUDIO A EUROPA

Mis padres me dieron la oportunidad de tomar un curso de tres semanas viajando por Europa cuando tenía 16 años. La Asociación Nacional de Agencias Automovilísticas patrocinó el viaje. Pasé un rato maravilloso en Inglaterra, Holanda, Francia Alemania, Austria, Italia, Suiza y España. Antes de irme de viaje, Papá me dio $150 y una de sus tarjetas de presentación. Dijo, "Escribí los nombres de las galerías que quiero que visites en París."

La letra era tan pequeña que tuve que usar una lupa. Había más de 100 galerías escritas en la parte de atrás de la tarjeta. Papá me dijo que quería que visitara todas las galerías que había anotado antes de que gastara un solo dólar en una obra de arte. No sabía la tarea que sería visitar todas las galerías. Francamente, miraba por las vitrinas y ponía por lo menos un pie dentro de muchas de las galerías para poderle decir a Papá que las había visitado todas.

Recuerdo que la primera galería que visité tenía ediciones limitadas de grabados de Joan Miró. Llevé la imagen de mi

Miró preferido al resto de mis visitas a galerías. Regresé a la galería y compré el grabado de Miró por sesenta dólares.

Cuando regresé a McAllen al final del viaje, ansiaba mostrarles a mis padres lo que había comprado. Llevaba las piezas en tubo de cartón a mi regreso. Cuando llegamos a casa, del aeropuerto de McAllen, le entregué a Papá sus treinta dólares de cambio, y luego les mostré a mis padres los grabados recién adquiridos. Ellos estaban encantados con mis compras. Hoy en día, cada uno de esos grabados vale miles de dólares. La experiencia que me transmitieron mis padres para adquirir obras es invaluable.

TEMPRANA INTRODUCCION AL NEGOCIO AUTOMOVILÍSTICO

Durante mis años de preparatoria, trabajé los veranos en la agencia de autos de la familia. Vendí mi primer auto a los dieciséis años. Había trabajado en el negocio por dos semanas antes de que la venta ocurriera. Dudé si algún día vendería un auto.

Papá me llamó a su oficina. Me dijo, "Hijo, aprecio el esfuerzo que estás haciendo por ser una persona exitosa en este negocio. Sé que puedes estar frustrado, ya que no has hecho tu primera venta aún. Me gustaría compartir algunas ideas contigo. Primero, Dios te dio dos orejas y una boca. Aprende a hacer preguntas que sondean y después mantente callado hasta obtener una respuesta.

Averigua lo que el cliente quiere lograr. Sé acomedido y entrega lo que el cliente quiere con entusiasmo y gratitud. Relájate y disfruta conocer gente. Hijo, las personas de ventas típicamente responden a los clientes en una de tres maneras, con simpatía, apatía o empatía. Solo la empatía funciona en las ventas. Tienes que poder ponerte en los zapatos del cliente y después proporcionarle un plan de acción para satisfacerle sus necesidades de transporte. ¡Buena suerte, hijo!"

Papá tenía razón. Practiqué y el segundo día después de que visité la oficina de mi padre, vendí mi primer auto. Vendí cincuenta y dos autos en los siguientes cincuenta y dos días,

incluyendo aquella primera venta. Era la primera persona en llegar en la mañana ese verano y el último en irme. Fui el vendedor del mes en mi primer mes de trabajo. Me gustó la sensación de vender autos. Me volví adicto al negocio de los autos y aún siento el mismo entusiasmo hoy en día.

APRENDIENDO DE LOS GRANDES MAESTROS

Mis padres me enseñaron muchas cosas. Una de las más importantes fué el estudiar a los grandes maestros del arte. Como consecuencia, he amado la historia del arte y continúo disfrutando del estudio de los grandes maestros. Me enseñaron también uno de sus secretos de coleccionismo,

buscar a los artistas que estaban emergiendo y cuyo trabajo mostraba una madurez y comprensión de los medios, del tema y de la técnica.

Desde mis primeros años como artista, tuve muy presente el trabajo de Miguel Ángel, Leonardo Da Vinci, Pablo Picasso, Joan Miró, y muchos más artistas de alta estima. Solo ocasionalmente intentaba copiar su trabajo, pero en las ocasiones que lo hacía, me quedaba una gran sensación de respeto por los maestros. Me motivaba a practicar, practicar y practicar. También me hacía ser más prolífico como artista, siempre queriendo ver mi trabajo terminado, creando un deseo de llegar a la siguiente obra lo más pronto posible.

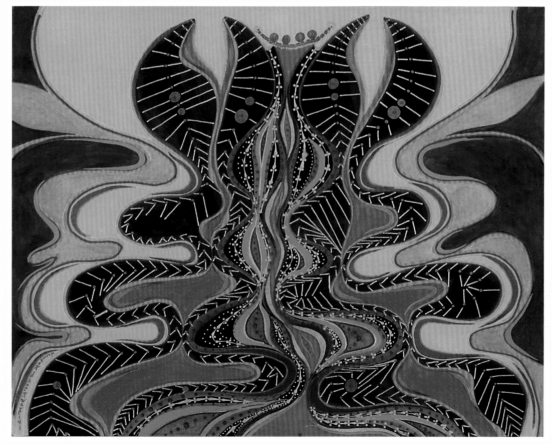

Kirk Clark • *Shockwave Series* (Serie Onda Expansiva)) • 2004 • Pluma y tinta sobre papel • 13 x 16 in.

La Universidad de Nuevo México

Al acercarse mi graduación de preparatoria me dispuse a obtener al menos un título en los estudios de arte. Me encantaba Nuevo México y quería asistir a la Universidad de éste estado, debido a su excelente reputación como escuela de bellas artes. Estaba fascinado cuando me aceptaron.

La universidad tenía una amplia gama de intereses académicos que incluían comunicacion empresarial, mi segunda área de estudios de licenciatura y estudié también inglés, antropología y ciencias políticas. Entré a la universidad en 1965. Estaba ancioso por iniciar mi carrerar de arte.

LAS MARAVILLAS DE LA ESCULTURA

El director del Departamento de Arte en ese momento era Charles Maddox, un conocido escultor de Venice, California. Era maestro de arte cinético. Maddox fue inspirador, duro y enérgico. Maddox me influenció para que me convirtiera en escultor, junto con Steven Dubov, así como William Goodman, escultores con los que tuve la suerte de estudiar y quienes me inspiraron durante mis años en la Universidad de Nuevo México.

La escultura me ofrecía un desafío especial. Al principio la idea me intimidaba. Estaba acostumbrado a trabajar en un espacio confinado en un lienzo como pintor, controlando la superficie bidimensional con cada toque del pincel. La escultura era un reto distinto en sí.

Una vez que superé el miedo inicial de ser un escultor, me enfoqué en explorar mis opciones al desarrollar un estilo que me daba algo de esperanza y éxito. El departamento de escultura estaba abierto a todas horas, y yo estaba ahí la mayoría del tiempo. Mis estudios académicos con demasiada frecuencia reflejaban mi afinidad por la escultura.

Tube la fortuna de estudiar con William Goodman, profesor de escultura y soldador máster. También era impresor pero su fuerte era la escultura. Fue una gran inspiración y un amigo para mí. Una vez que me convertí en un buen soldador, estaba listo. Me encantaba soldar y me sentía cómodo tomando asignaturas más desafiantes.

EL COMIENZO DE UNA LARGA AMISTAD

Fue en ese tiempo cuando conocí a mi querido amigo Dick Hyslin, quien estaba trabajando en su Maestría en artes en cerámica en la UNM, bajo la tutela de Carl Pak, un ceramista mundialmente reconocido.

Kirk Clark • *Satori Series* (Serie Satori) • 2003 • Pluma y tinta sobre papel • 10 x 8 in.

Kirk Clark • *Satori Series* (Serie Satori) • 2003 • Pluma y tinta sobre papel • 10 x 8 in.

Una noche ya tarde, en el estudio de escultura, Dick me vió luchando con parachoques, mi material preferido con el que intentaba producir una escultura. Dick se presentó y ofreció su ayuda para superar esos obstáculos técnicos que enfrentaba. Estaba muy agradecido.

Una parte divertida de la historia de nuestra amistad es la conexión que Papá y yo hicimos entre Dick y Rudy Pharis, quien era Decano de el Departamento de Bellas Artes en la Universidad Pan Am en 1969. Rudy estaba intentando reclutar a un artista que tuviera experiencia con el barro, con el conocimiento para construir hornos, quien podía dirigir un departamento de artes de barro o cerámica. Dick vino a McAllen con su amigo Joe Bova. Joe era un ceramista increíblemente talentoso, que se convirtió en presidente del Departamento de Arte en la Universidad del estado de Ohio.

Se quedaron en nuestra casa en McAllen mientras Dick asistía a la entrevista de trabajo. Rudy contrató a Dick en el acto. Fue maravilloso. He admirado a Dick como amigo, artista y como administrador exitoso. Mi amistad con Dick ha continuado durante más de cuatro décadas y espero que se siga creciendo por muchos años mas.

ESCULTURAS DE PARACHOQUES EN UNM

Me pidieron que exhibiera mis esculturas de parachoques en varias exposiciones de estudiantes universitarios. Una de mis esculturas fué seleccionada por la universidad para su colección permanente. Disfruté mucho la escultura, particularmente porque podía ir al estudio a cualquier hora a trabajar. Fuí y seguiré siendo un búho nocturno.

LLENAR LOS ESPACIOS

Observando por un telescopio o microscopio.
Estudio el universo y produzco algas.
Sentir la similitud de la creación.
Patrones de caos divinamente concedidos,
emergiendo y declinando, vida cambiante.
Colores, formas, van y vienen.
Llene los espacios entre átomos,
con su conocimiento, espíritu colmado.
K.C.

Negocio y Arte – Una buena combinación

ARTÍSTA MUERTO DE HAMBRE

Después de trabajar con Charles Maddox y William Goodman, consideré convertirme en artista de tiempo completo. No me podía recuperar del temor de ser un artista muerto de hambre, y nunca me arrepentí del camino que tomé como empresario/artista. La verdad, la mayoría de los artistas temen el rechazo de su trabajo, admito que soy uno de ellos, aunque me he vuelto más duro recientemente.

Finalmente decidí trabajar en la compañía Charles Clark Chevrolet en McAllen, Texas, con mi padre, un hombre al que admiraba mucho y continuar creando mis obras de arte durante mi tiempo libre. Disfruto ambas actividades. También disfruté a mi madre mucho, era mi ángel y lo sigue siendo.

Me gradué un viernes, a mediados del año 1969. El siguiente lunes Papá me dio la oportunidad y el desafío de convertirme en gerente de autos usados. Se me dio poca instrucción. El muchacho universitario debía mostrarle a su padre y a sus asociados lo que había aprendido en la universidad. No es frecuente que a los gerentes de autos usados los confundan con artistas. Creo que se podría decir que rompí el molde.

Los primeros seis meses de trabajo fueron muy estresantes. Finalmente me sentí más confiado y evité meter a la agencia en demasiados problemas financieros. El departamento sí operaba en números negros, afortunadamente.

NUEVO GERENTE EN EL DEPARTAMENTO DE AUTOS USADOS

En algún momento entre 1971 y 1972, Papá necesitaba un gerente de autos nuevos y me dijo, "Hijo, tú eres ahora el gerente de autos nuevos y usados, hasta el momento en que encuentres quien te remplace como gerente de autos usados." Contacté a mi querido amigo, Trev Sparks, quien estaba dando clases en Texas, en la Universidad A&I en Kingsville, y le pregunté si quería ser nuestro gerente de autos usados. Él había crecido en el negocio de autos usados. Su padre, R.T. Sparks me ayudó a aprender acerca del negocio de autos usados en los meses críticos que siguieron a mi graduación universitaria. Le estaba muy agradecido a R.T. y estaba seguro que su hijo Trev resultaría ser invaluable.

Trev fue invaluable como gerente de autos usados en Clark Chevrolet. Disfrutamos mucho trabajando juntos hasta el momento en que se unió a su padre, R.T. en Moxie Motors, un negocio de venta de autos y camiones usados, muy exitoso, a unos cuantos metros de Clark Chevrolet, que continúa operando con éxito hoy en día. Estoy muy agradecido por su amistad y apoyo.

EL LOGOTIPO PERFECTO

En 1974, estaba fascinado con la portada del catálogo de arte de la Universidad L.S.U.; era rectangular en dimensión con la esquina superior derecha y la esquina inferior izquierda en negro con el resto de la portada en blanco. En la esquina inferior derecha estaba el nombre Clark impreso cuatro veces en forma de cuadrado, en letras negras en un campo blanco. Me gustó mucho.

Entre más trabajaba con el nombre Clark, más parecía que evolucionaba naturalmente hacia el logotipo que había estado buscando. Llevé mis bosquejos con un artista local que se especializaba en logotipos y le pedí que alineara el nombre Clark repetido cuatro veces, en un cuadrado, de manera que las "L" se alinearan como para formar una cruz suiza en el interior del logotipo.

Hizo un trabajo maravilloso, y realmente creo que hoy en día no hay ninguna agencia automovilística que tenga un mejor logotipo. Se me ocurrió que Louis Chevrolet, el fundador de la Chevrolet Motor Division, era suizo. Me pareció que la cruz suiza que se formó dentro del logotipo era realmente poderosa. Le pedí al diseñador que pusiera el "corbatín" de Chevrolet en medio de la cruz suiza y ahí estaba.

El nombre Clark con cuatro lados, con la cruz suiza y el "corbatín" de Chevy en el medio, esto era simbólico en cuanto al compromiso total de la familia Clark con Chevrolet. Ese logotipo sencillo ha funcionado todos estos años. Estoy convencido de que no hay sustitución para un diseño excelente.

GUIADO POR EL ESPIRITU DE DIOS

Un sentido de anticipación me jala diariamente a realizar la mejor creación de arte que pueda hacer. Este deseo de crear, me mantiene avanzando en mi trabajo y en mi arte.

Mis años de colegio fueron particularmente formadores. Las instrucciones bajo las enseñanzas de los escultores, Charles Maddox, William Goodman, Stephan Dubov y Dick Hyslin, fué una gran bendición.

Estoy muy agradecido con mi creador por reconectarme con el arte. Siento que mi espíritu creativo es guiado por el espíritu de Dios. Casi nunca me siento a dibujar algo que ya tenga en mente. Generalmente, me llega una sensación, una compulsión por dibujar, pintar, grabar o esculpir en metal o piedra.

Kirk Clark • *Dark Dream* (Sueño Oscuro) • 2005 • Monotinta • 30 x 22 in.

ENIGMA DE LA OBSCURIDAD

Tiene miedo a lo desconocido,
lo oculto en las sombras?
o se imagina la posibilidad
que la alquimia de la creación
soporte sus necesidades y deseos?
Viendo imágenes del cielo, resplandeciente
o examinando un tentáculo de barco.
Ambos dentro del plan de Dios.
K.C.

Arte Variado

EXPLORANDO LA ANTIGUA POECIA CHINA

A mediados de los años noventas quería salirme de mi zona de confort aprendiendo algo que fuera difícil. Decidí tomar un curso de escritura de ficción en el Instituto de Arte de Taos con el Profesor William Melvin Kelly. Bill era profesor de literatura en la Universidad Sarah Lawrence en Nueva York. Es autor de *Un Tambor Distante*, un relato de la vida en Harlem.

El Profesor Kelly me enseño a escribir Bagua, un antiguo estilo de poesía china. El Bagua es una forma de arte marcial cuyos movimientos se basan en los principios matemáticos que guían dicha poesía. El uso de ocho líneas, con cinco palabras por línea resulta en trece elementos. El número trece en chino significa iluminación.

Me tomó tres días escribir mi primer bagua. Había estado escribiendo material para anuncios durante muchos años antes de tomar la clase. Usé el pentámetro yámbico para medir mis comerciales. Intenté escribir baguas al mismo ritmo al que estaba acostumbrado. No funcionaba para los baguas. Hoy, me encanta escribir en el estilo bagua. Me divertí mucho en clase. He escrito al menos miles de baguas de una miríada de temas desde ese curso.

UNA IDEA VIENE – POEMA O ARTE?

Algunas veces cuando me siento, una idea viene a mi mente y me siento obligado a sacarla. Algunas veces quiere ser un poema y a veces quiere ser una obra de arte. No lucho con lo que siento. Si se quiere expresar como poema, escribo un poema. Si quiere ser una obra de arte, hago una obra de arte.

Cuando estoy en Taos, Nuevo México, para sesiones concentradas de creatividad, normalmente escribo un poema un día o termino un dibujo, a veces más, pero es raro que sea menos. Parece que encuentro mi centro y mi bienestar ahí.

Rezo todos los días por el perdón de mis pecados en pensamiento, trabajo o acción. Cuando termino de rezar, siento la necesidad de escribir o empezar una obra de arte. Si la idea elige ser una obra de arte, me imagino que la siento en un cómodo sillón al final de una habitación fresca, poco iluminada, con una sábana blanca de pared a pared y de piso a techo. Respiro profunda y lentamente para aclarar mi mente.

EN TAOS CON MI HIJA ANNE

Debo darle a mi talentosa hija Anne, un sincero agradecimiento por haberme sugerido hace unos años, mientras asistía a la Universidad Estatal de Texas del Norte en Denton, Texas, que fuera con ella a un curso de escultura avanzada en el Cañón de Taos impartido por el vicepresidente del consejo del Departamento de Bellas Artes, Don Shoal, un maravilloso escultor en madera.

Anne y yo éramos como la tortuga y la liebre. Yo me levantaba temprano, ella se levantaba tarde. Yo comenzaba mi proyecto temprano y terminaba tarde. Ella empezaba tarde y terminaba temprano. Ella parecía adherirse al refrán, mídelo dos veces, corta una sola vez. Me parecía difícil creer el fabuloso resultado que ella había creado. Ella sigue llena de talento y disfruté verla trabajar. Es rápida y precisa.

Estoy muy agradecido con mi hija Anne por insistir en que fuéramos juntos a los cursos de escultura en Nuevo México. No sólo nos reconectó como padre e hija, sino también de artista a artista. Desde que Anne tenía dos años y medio, supe que era una artista, mezclaba colores extraordinarios. Aún lo hace. Supongo que también lo llevaba en su ADN.

THOM WHEELER Y EL COLADO DE ARENA

Estando en Nuevo México asistiendo a una de las clases de escultura en el verano, conduje frente a una interesante

galería/estudio propiedad de Thom Wheeler. En el transcurso de un tiempo, Thom y yo nos volvimos buenos amigos. Me invitó a volver y trabajar en su estudio y fundición. Comencé a hacer colado de arena por primera vez en años y me encantó el proceso. Progresé rápido, trabajando con Jim, un empleado de la fundición con veinticinco años de experiencia, y Thom. Nuestras sesiones son muy divertidas. El consejo de Thom ha sido muy generoso y yo lo aprecio mucho.

Verdaderamente no pienso mucho en lo que voy a hacer en el proceso de colado de arena en cuanto a crear una imagen. Sólo extiendo todas las herramientas y objetos encontrados que creo que pueda usar y cuando empiezo, me muevo muy rápidamente a lo largo del proceso. El colado es muy divertido desde la perspectiva del artista. Me encanta hacer impresiones en la arena.

PRODUCIENDO GRABADOS

Thom sugerió que conociera a Michael Vigil, artista y grabador maestro. Lo hice y concreté que comenzáramos a aprender a hacer grabados en su taller, Impresiones Gráficas. Empiezo a creer que los grabados son mi fuerte como medio. Creo que hacer grabados, particularmente mono-grabados, es muy divertido e intuitivo. Estoy muy envuelto en la creación de grabados ahora trabajando con Michael. Supongo que comencé el proceso desde la perspectiva de un escultor, sin miedo y lleno de gran anticipación. Siempre ansío mi siguiente sesión de grabado con Michael.

PINTANDO MOSAICOS EN McALLEN

Una noche, conducía por la calle en McAllen y noté un auto conocido que se me acercaba. DeAnna Garza y su esposo Roy, me estaban rebasando, me hicieron señas para que los siguiera y eso hice. Se reunirían con Cody Sparks y su esposa Michelle a una noche de arte y vino y me invitaron. Nunca rechazo ni el arte ni el vino, así que los seguí.

Me condujeron a Colors and Clay, una preciosa tienda donde puedes pintar tejas y objetos moldeados de distintas formas y precios. Ponían la obra al fuego en un horno cuando se completaba la pintura en la cerámica. Me encantó y comencé a pintar mi primera teja. Pinté una o dos criaturas submarinas y descubrí que me gustó mucho. Me volví un cliente asiduo.

Un día estaba pintando en un mosaico de 10 centímetros. Había creado una forma que se parecía a una gaviota volando directo hacia mí. Una de las alas parecía tener un poco más de arco, así que desde el primer punto en la base de la V, hice una serie de puntos que se curveaban hacia abajo a la izquierda y luego de vuelta a la derecha. Entonces me percaté, esto empieza a parecer un crucifijo. Luego hice un círculo de puntos encima, representando una cabeza. De la cabeza hice líneas de puntos hacia arriba, para reflejar un aura. Eureka, había pintado mi primer Jesús Atómico. Me dije a mi mismo, vaya, ¿cómo hice eso?

UN RAYO DE LUZ

La respuesta era clara, pero me sentí un poco incómodo acerca de adónde iría a parar todo esto. Comencé a leer acerca de la crucifixión de Cristo. Comencé a contemplar la compresión de tiempo entre los microsegundos antes de la muerte de Cristo en la cruz, el momento exacto de la muerte, y el momento exacto tras la muerte. Desde que era un niño, me imaginaba que en el momento de la muerte de Cristo, hubo un estallido de luz cuando el alma dejó el cuerpo y volvió a Dios Padre en el cielo.

Entonces me di cuenta. Había creado con ayuda celestial considerable un símbolo de esa compresión de tiempo entre la vida, la muerte y la vida después de la muerte. Mientras contemplaba la naturaleza atómica de todas las creaciones de Dios, me pregunté, "¿Qué separa a la humanidad del resto de las creaciones de Dios?" La única respuesta que se me ocurrió fue, el espíritu. Consulté la Biblia para ver cómo describía el espíritu.

Descubrí que en la mayoría de las veces, en la Biblia se describe al espíritu como una luz. Como ejemplo, "Dios envió

su luz hacia el mundo para salvarnos de nuestros pecados." Comencé a leer y a estudiar acerca de la naturaleza dual de la luz, tanto su partícula como su naturaleza ondulante. Leí acerca del principio de la incertidumbre de Heisenberg y un descubrimiento muy curioso.

Si un científico estuviera determinado a comprobar la naturaleza de partícula de la luz, la luz parecería sentirlo y se revelaría más a menudo como tal. Recíprocamente, el científico que intentara comprobar la naturaleza ondulante también era compensado. La luz se revelaría con más frecuencia como onda.

¿Así es como funciona el poder de la oración en un universo cuántico, físico? creo que así es. He llegado a creer que el dicho bíblico, "como pensare el hombre, así es él", puede ser una de las revelaciones más poderosas que nos da en la Biblia. Discutía esta teoría con Thom Wheeler en una de mis visitas a su estudio. Me dijo, "Me parece que has descubierto al Jesús Atómico." Pensé, "vaya, eso sí que me sienta bien."

PINTANDO A LA MANERA PUNTILLISTA

Realicé la mayoría de mis pinturas en el estilo puntillista, haciendo puntos con las cerdas del pincel, lo cual, no es una tarea fácil. Un sábado por la mañana, una maestra escolar pasaba caminando y me vio esforzándome por hacer puntos redondos. Me dijo, "¿Sabes?, hay una forma mucho más fácil de hacer esos puntos."A lo que contesté, "Oh, por favor, dígamela." Me dijo, "Volteé el pincel y use la punta redondeada del pincel."

Funcionó de maravilla, y he estado volando con esa técnica desde entonces. Comencé una serie de mosaicos pintados llamada *The Universe Below* (El Universo de Abajo). Esta serie despegó. Combinaba una vista del espacio exterior a través del telescopio Hubble, con una vista de buceo sobre un arrecife de coral. No tengo idea de porqué comencé esa serie, pero me alegra haberlo hecho,

porque me condujo a otras series que me obligaron a explorar la creación de Dios del universo y abarcar la teoría del big bang.

MOMENTOS SATORI

Satori es una palabra japonesa que significa iluminación instantánea. Esos momentos de satori son los que parecen salir del éter. Suelo preguntarme, ¿por qué no lo pensé antes? Con más frecuencia, la respuesta es; no estaba listo para esa iluminación antes de que la recibí. Tendría que decir que todas mis series de arte hasta ahora han comenzado como momentos satori, momentos plenos de espíritu. Ha sido maravillosamente divertido aprender de estos conceptos y desarrollarlos en línea, espacio y color.

Kirk Clark • 2004 • Monotintas • Dimensiones variadas

Kirk Clark • 2004 • Monotintas • Dimensiones variadas

Exposiciones

ATOMIC JESUS (JESUS ATÓMICO) EN TAOS, NM

Thom Wheeler me ofreció una exposición individual el la Galería Zane-Wheeler en Febrero del 2002. La exposición se llamó *Atomic Jesus* (Jesús Atómico), lo cual yo sabía que sería un poco controvertida. Fué un éxito rotundo con cientos de invitados. Le agradesco mucho esto a Thom quien ha sido mi mentor y amigo.

THE UNIVERSE BELOW (EL UNIVERSO DE ABAJO), McALLEN, TX

Mi segunda exposición individual fue el 16 de septiembre de 2002, en la galería de arte de la Universidad Comunitaria del Sur de Texas, en McAllen. Cuando me mostraron la galería por primera vez, estaba muy conciente de que la galería había fungido como aula de clases y sus muros de bloques de concreto estaban desnudos como una celda de prisión. Jeri y yo estuvimos fascinados en fundar la creación de una hermosa transformación de la galería antes de mi exposición.

Esa exposición se llamó *The Universe Below* (El Universo de Abajo). Intenté capturar una vista del espacio exterior a través del telescopio Hubble y comprimirlo con una visión de buceo sobre un arrecife de coral. La teoría subyacente es que donde sea que se observe la creación, Dios está presente. Estoy fascinado por la naturaleza fractal del universo y su belleza.

No mucho después de que esta exposición terminara, me invitaron a exponer en la Universidad de Texas, Pan American, en Edinburg, Texas. Esta exposición formaría parte del setenta y cinco aniversario de la Universidad la cual se celebró en el 2002. Decidimos que sería una oportunidad maravillosa mostrar obras selectas que mis difuntos padres habían donado a la universidad en el transcurso de los años, algunos trabajos hechos por Anne, pinturas, dibujos y esculturas en aluminio, junto con una variedad de mi obra.

La exposición se llevó a cabo en la Galería Charles y Dorothy Clark en el campus. Fue una experiencia maravillosa poder ver tanta obra de arte que mis padres habían coleccionado y le habían dado a la Panamericana, junto con la obra de Anne y mía. Definitivamente hubo una conexión, como una tela que conectaba las obras. Fue una noche estupenda.

AMADO PEÑA

Me invitaron en dos ocasiones a exponer mi trabajo con Amado Peña en la Universidad del Sur de Texas en McAllen. Amado es una de las personas más generosas que he conocido. He sido muy afortunado en recibir su invitación a Albuquerque en dos ocasiones (2004 y 2005) a la exposición *Legacy Art Extravaganza* (Extravagancia de Legado de Arte), la cual recauda dinero por medio de la venta de arte donado para becas para jóvenes americanos nativos para que puedan asistir a la Escuela Católica de San Pío en Albuquerque.

ARTE Y POEMAS

En junio de 2004 participé en mi primera exposición de Arte Poético en la galería universitaria de la Universidad de Texas, Pan American. El Dr. Steven Schneider, Presidente del Concejo del Departamento de Inglés, me invitó a participar en la exposición junto con su hermosa esposa Reefka. La exposición consistió completamente de obras de arte y poemas lado a lado, en la tradición de "Ekphrasis" que llegué a conocer del Profesor Schneider.

Fue una oportunidad maravillosa para que yo colgara mis baguas junto a mi obra de arte, y la exposición comprobó ser tanto educativa como divertida. En el verano del 2004, los tres participamos en otra exposición en el Festival Literario del Sur de Texas que se llevó a cabo en el Museo Internacional de Arte en McAllen. Me fascinó participar junto con los Schneider.

LOS ANCESTROS

El 11 de Diciembre del 2004, tube una exposición titulada *The Ancient Ones* (Los Ancestros) en la Galería Michael McCormick en Taos. Fué una exposición divertida y diferente ya que Tanya, la esposa de Michael Vigil, quien es una bailarina nativa de renombre mundial, danzó junto con sus colegas al estilo Azteca.

Tanya me sorprendió aún mas invitando a un Chamán Navajo, Pluma Negra a bendecir la exposición. El Chamán, encendió madera ceremonial de chamisa y con un puñado sagrado de plumas de ágila, abanicó el humo alrededor de mi y todos los invitados. Fué una exposición muy especial para mi.

GALERIA *THOMAS MASTERS* EN CHICAGO

El momento culminante del 2005 fue la exposición en la Galeria *Thomas Masters* en Chicago. 27 Artistas internacionales fuimos invitados a participar. La exposición se entituló *Blue* (Azúl). Los artistas podíamos usar solo ese color en nuestras obras. La exposición fué un éxito rotundo, muy bien recibida tanto por la comunidad de Chicago como la crítica.

Kirk Clark • *Atomic Jesus* (Jesús Atómico) • 2003 • Cobre sobre madera • Colección privada, Torrey Lake, S. Dakota

Exposiciones en México

MATAMOROS, TAMAULIPAS

Algún tiempo después, fui invitado a mostrar mis esculturas junto con un grupo maravilloso de artistas, incluyendo a Dick Hyslin, en el Museo de Arte Contemporáneo en Tamaulipas, México, cruzando la frontera de Brownsville en Matamoros. María Elena Macías Urzúa, una pintora talentosa, quien se encuentra entre el personal del departamento de arte de UT-Pan Am., en Edinburgo, también estuvo a cargo de la muestra.

Mientras estaba la muestra, una artista maravillosa de Saltillo, México, Inés De León, visitó la muestra en Matamoros, México y vio mi obra. Aparentemente se sintió muy atraída hacia ella. Me buscó, y me dijo, "Sr. Clark, usted debería de mostrar su obra en el área de Saltillo, Ramos Arizpe de México, en el estado de Coahuila."

Yo no sabía que pensar. Me sentí halagado y asombrado. Su entusiasmo sobre la idea era contagioso, y acepté. Pasaron varias semanas antes de que ella regresara a McAllen para anunciar que había organizado una muestra en la Universidad Tecnológica de Coahuila.

RAMOS ARIZPE, COAHUILA

El anfitrión de mi exposición sería el Gobernador Martínez y Martínez y su encantadora esposa, Lupita, ambos fuertes admiradores del arte y la Universidad. Él y su esposa son maravillosos y muy amables. Decidí que donaría todos los recursos provenientes de la venta de arte de mi muestra a la Universidad.

Fue encantador trabajar con toda la gente de la Universidad. La exposición se llamó, *Otros Mundos/Other Worlds*. La muestra consistía de más de setenta esculturas, dibujos y grabados, con una sección espiritual especial para *Atomic Jesus* (Jesús Atómico) y la serie de *Santos*, que era una serie de dibujos etéreos que mostraban mi interpretación sobre los Santos que ya habían partido al otro Reino.

FÍSICOS MATEMÁTICOS TOMAN FOTOS RARAS

Yo estaba a cargo de la galería de grabados, entonces me di cuenta de que había un caballero en la galería justo frente a mi. El caballero estaba estudiando mis dibujos muy cuidadosamente. Tenía una bolsa que colgaba de su hombro. Veía mis dibujos, y buscaba dentro de su bolsa hasta que sacó algo de ahí y lo puso a un lado de uno de mis dibujos.

La curiosidad me abordaba. Caminé hacia la galería para conocer al caballero. Me presenté. Me dijo que era un físico-matemático. Me preguntó de dónde vino la inspiración para mis dibujos. Los dibujos que él estaba mirando eran de mi serie *Universe Below* (Universo de Abajo) y de la serie *Shockwave* (Onda Expansiva). Le dije que yo no soy un científico pero que tenía tremenda curiosidad sobre los orígenes del universo y la naturaleza fracturada del universo.

Se veía un tanto sorprendido y dijo, "Pensé que estaría en esto. Estoy haciendo una investigación acerca del origen del universo." Le pregunté, "¿Qué es lo que sacó de su bolsa y pone junto a mis dibujos?" Dijo, "Permítame mostrarle unas fotografías que he tomado mediante un microscopio de electrones durante los últimos días."

Sostenía una foto junto a uno de mis dibujos. Se abrió mi quijada. La fotografía era casi idéntica a mi dibujo, las mismas formas y colores. Se acercó a cuatro más de mis dibujos y juntó fotografías separadas que había tomado mediante dicho microscopio de neutrones y cada una de ellas era una réplica exacta de mi obra. Fue muy extraño, pero muy emocionante.

UN CHAMAN HUICHOL

La esposa del gobernador se sintió principalmente atraída por mis cruces. Le regalé una de mis cruces de la serie *Shamanic Conversion* (Conversión Chamánica). Fué durante este período que la esposa del Gobernador me dió una gran sorpresa. Logró que un antropólogo trajera un Chamán Indio Huichol de Nayarit, México para que yo lo conociera. Esto fué una gran sorpresa y una que valoraré por el resto de mi vida.

Tuvimos una comida en privado con el chamán y el antropólogo. Durante la comida, el tema del *Atomic Jesus* (Jesús Atómico) surgió. El antropólogo introdujo al chamán hacia mi concepto. La primera pregunta que tuvo el chamán fue, "¿Qué es un átomo? El antropólogo le explicó lo que era un átomo y sus varios componentes. El chamán entonces le dijo al antropólogo, "Déme un minuto por favor para considerar lo que me ha dicho."

El chamán dijo que había creado una imagen de un átomo. Hizo la imagen como del tamaño de una toronja y la posicionó como a unos 35 cms de sus ojos. Dijo que permitió que su conciencia entrara en el átomo. Conforme su conciencia fue entrando en el átomo, dijo que para su deleite, había sido saludado por Dios. Se me puso la piel de gallina cuando dijo eso. Aún me siento transportado por la entrevista de cuatro horas que tuve con él. No puedo esperar para verlo de nuevo.

No puedo explicar lo que se siente tener estos momentos de iluminación, los cuales se han vuelto más frecuentes con el tiempo. Es como si la vida se estuviera revelando por sí sola, algunas veces, de maneras muy especiales através de personas muy interesantes.

Jaime Guevara Villanueva, Director de la Universidad Tecnológica de Coahuila, nos trató muy bien durante este viaje en particular, así como la Señora Verónica Murillo, quien maneja la mercadotecnia y las relaciones públicas en la universidad, así como otras grandes responsabilidades, el Lic. Emilio Grimaldo Torres, y el "Arquitecto" Bill, quien coloca mis muestras en México.

PETROGLÍFICOS CERCA DE PARRAS

Después de la inauguración de mi muestra en Parras, Nuevo León, nos llevaron, a mi esposa Jeri, Trev, Donna Jo Sparks y a mi, con otros invitados a un sitio muy especial en lo alto de la montaña del desierto afuera de Parras para ver un sitio antiguo interesante por sus pinturas rupestres. Eran magníficos.

La visita me llevó a estudiar imágenes abstractas, chamánicas, rupestres del sitio así como de otros sitios en América del Norte, África, China, Indonesia, Nueva Zelanda y Australia. Mi primera muestra sobre estas obras fue en la Galería McCormick en Taos, Nuevo México, el 11 de Diciembre del 2004. Encontré un sorprendente número de imágenes similares alrededor del mundo de dónde tomé inspiración para la muestra.

FESTIVAL DEL DESIERTO

La muestra de arte de Real de Catorce fue parte del *Festival del Desierto*. Después, la muestra de Real viajó hasta Saltillo a un lugar muy especial en el Museo del Desierto de Historia Natural, uno de los más bellos museos que he visto en mi vida.

Para mi gran sorpresa y deleite, el Gobernador Martínez había establecido una fundación para apoyar la Universidad Tecnológica de Coahuila utilizando los recursos provenientes de las ventas de mis dos muestras. Hubo una gran conferencia de prensa y el nombramiento de cinco administradores de la fundación.

Me pidieron dar una presentación y una plática a un gran número de dignatarios, prensa y visitantes del museo. Me sentí muy honrado por las amables palabras del Gobernador. Para mi asombro, todos, los sesenta y cinco dibujos, pinturas y esculturas de la muestra se vendieron. Tengo un lazo muy fuerte con las comunidades de Saltillo y Ramos Arizpe. La administración de la universidad ha sido muy amable conmigo. Tengo muchos amigos maravillosos ahí y siempre espero poder verlos de nuevo y mostrarles mi última obra. Es muy divertido y grato.

EL PLACER DE DAR

Me da un enorme gusto el donar los ingresos de las ventas de mi arte y donar mi arte a eventos para reunir fondos para las personas que no tienen que comer, las iglesias, y otras organizaciones no lucrativas de la comunidad y del país.

Agradesco a mi esposa Jeri, mis cuatro hijos y mi nietecito Ryan por su apoyo y entendimiento. Agradesco a Dios por la bendición de mi familia, amigos y empleados, asi como a mi doble carrera de distribuidor de autos y artísta.

Kirk Clark • *Angel's Path* (Camino de Ángeles) • 2005
Pluma y tinta sobre cartulina • 7 x 5 in.

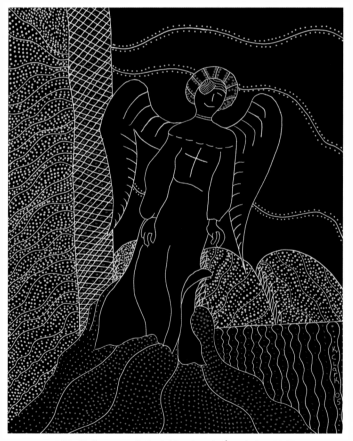

Kirk Clark • *Angel's Path* (Camino de Ángeles) • 2005
Pluma y tinta sobre cartulina • 10 x 8 in.